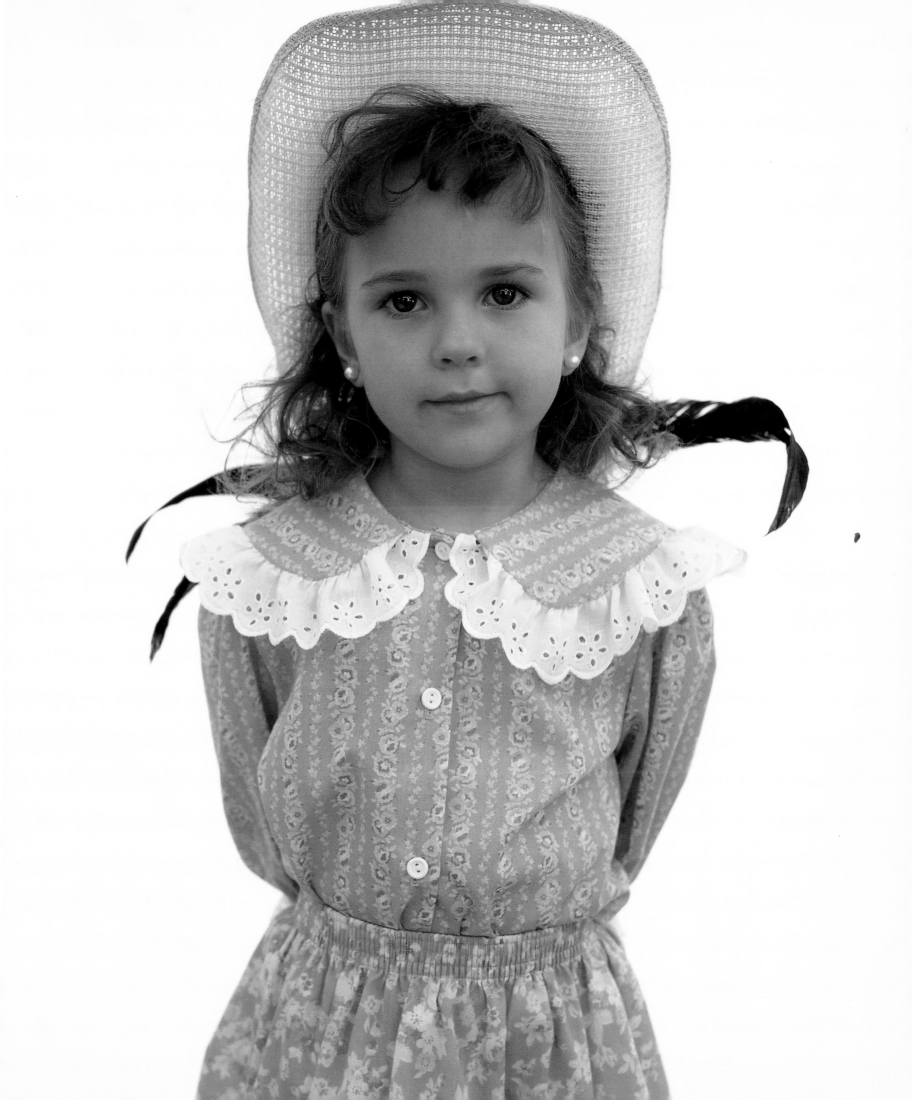

The Face of Texas

T H E

O F T

Stories by Elizabeth O'Brien

M I CH

O' B R

FACE

TEXAS

Photographs by Michael O'Brien

MICHAEL

Bright Sky Press, Albany, Texas

BRIGHT SKY PRESS

Albany, Texas

10 9 8 7 6 5 4 3 2 1
Library of Congress Cataloging-in-Publication Data

O'Brien, Elizabeth, 1953-
The face of Texas : portraits of Texans / with stories by Elizabeth O'Brien ; photographer
Michael O'Brien.
p. cm.
ISBN 1-931721-23-8 (alk. paper)
1. Texas–Biography. 2. Texas–Biography–Portraits. I. O'Brien, Michael, 1950- II. Title.

CT262 .O27 2003
920.0764–dc21
[B]

2002038470

Book and cover design by DJ Stout and Julie Savasky, Pentagram, Austin, Texas
Printed in China through Asia Pacific Offset

For Jesse, Owen, *and* Sam

First, I would like to thank DJ Stout, who assigned many of the pictures on these pages while he was art director of *Texas Monthly* magazine. Without his encouragement, this book would never have been published.

I would also like to thank Brian Lanker and David Zickl for their support. And I appreciate the help of Julie Savasky, Sunday Kornyé, Betty Layton, Tamara Thompson, Brent Buford, Dave Hamrick, Kathy Marcus, Nancy McMillen, Evan Smith, Scott Dadich, Hope Rodriguez, Tom Kennedy, John Loengard, David Friend, Nik Kleinberg, Kathy Ryan, Suzi Bittles, Roy Flukinger, Harper Scott, Bill Albrecht, Matt Lankes, Matthew Sturtevant, Robert Baumgardner, George Brainard, Gil Acevedo, Margaret Blagg, Carol Cates, and Rue and Ardon B. Judd. All of the colleagues and friends mentioned above contributed to the book in various—and significant—capacities.

I am very grateful.

When I stepped off the airplane in Austin for the first time on a spring night in 1985, I felt immediately comfortable and oddly at home. I was living in New York at the time, and *Life* magazine had dispatched me to Austin to photograph Willie Nelson making the movie *Red Headed Stranger*.

I ended up spending more than a month working on Willie's ranch in Spicewood, in the Hill Country just outside Austin, documenting the day-to-day filming. As the days passed, I became more relaxed. Life in Texas was slower—more deliberate—and certainly more peaceful than the frenetic pace of New York. The sky was big, a crisp, hard blue with giant, dramatic clouds. The land was open and immense. The people were larger than life—friendly, informal, and generous of spirit. They seemed present in a way that was foreign to New York, or elsewhere; and I, too, became grounded in the moment.

Simply, Texas didn't look or feel like the rest of the country. Here there was a distinctive presence in the people and the land . . . a culture that was visibly evident. And it was mythic. Being from the outside—from Memphis, by way of Miami and New York—made it easy for me to see what made Texas different. I enjoyed celebrating it with my camera.

Over the years, I kept returning to Texas to work, until I finally decided—after shooting a *National Geographic* cover story on Austin (June 1990)—that it would be easier to move. I settled in Austin in 1993 with my wife, Elizabeth, and our three children, Jesse, Owen, and Sam. It's been our home ever since. I didn't know it then, but Texas had already made its mark on me.

In one way or another, Texas affects us all. The state has produced great men and women, enriching our nation beyond measure. With George W. Bush, a Texan, in the White House, the state has been thrust into particular relief. In this book, *The Face of Texas*, there are all types of Texans: native, adoptive, and those who are just passing through. I remember in particular photographing the late Bob Holloway, a retired judge and dairy farmer from Decatur. When I told him I was originally from Memphis, he smiled and said, "Scratch a Texan and you'll find a Tennessean," calling forth visions of the Alamo. The Lone Star State shapes anyone who has stopped here, whether they have spent a few years or a lifetime.

Although these photographs span more than twenty years and cover a good portion of the state, *The Face of Texas* isn't meant to be either a complete portrait of the state or to represent a balanced cross section of Texas and its people. It is meant to be a celebration of the state through its people. Some are celebrities, others are "regular" folk, but all are unique and interesting in their own right. This loosely woven mosaic from my random wanderings over the years, from one assignment to another, is merely a collection of the people who have touched me. With vividly written stories by Elizabeth, you will see the "light" in each and every one of them.

Photography has been a great life for me. I can't think of another profession that would have afforded me the privilege of meeting so many diverse and extraordinary people and granted me access to so many compelling places. I am truly fortunate. It has been a rich life. I am thankful for the generosity of all the subjects who have stood in front of my camera and allowed me to make their picture. Their photographs and stories tell a tale of an exceptional and mythical place called Texas.

Michael O'Brien

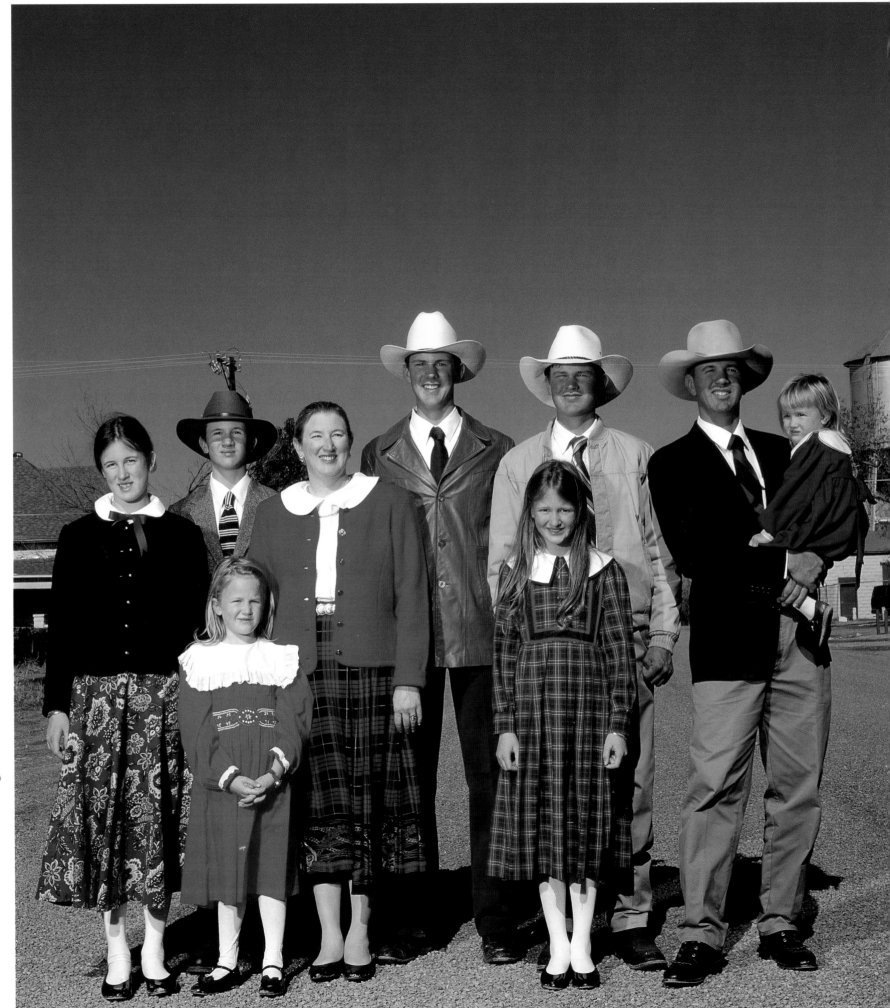

The Largent Family

VAN HORN, 1998

The Largents of Fort Davis, Texas, were photographed for *Texas Monthly* magazine on a Sunday in 1998 in Van Horn, where they had come to sing at the First Baptist Church. The Largent family lives as pure a life as possible at the turn of this high-tech century. Television, video games, the Internet, and fast cars are foreign to their social lexicon.

They live, in the words of mom Emily Largent, a "fairy tale."

"We live on the land and off the land as much as we can," said the rancher's wife, who hails originally from Louisville, Kentucky, and visited Fort Davis years ago, then stayed on to teach in the town's one-room schoolhouse. "I wouldn't trade it for the world."

Emily and husband Roy and their seven children—Roy Rust, Ivan, Tate, Caroline, Emily Anne, Maria, and Hannah—live on a 4,000-acre ranch ten miles west of Fort Davis and two hours north of Big Bend National Park, at the base of Blue Mountain. Like their relatives and neighbors—fellow ranching families—the Largents home-school their children and otherwise raise them as young ranchers-to-be, teaching them more in one year about the land and themselves than city kids learn in a lifetime.

"We're thankful," said Emily, who holds a master's degree in special education. "We don't have to de-program them. We're trying to teach our children life skills, give them a broader picture."

The Largents live in a spacious, adobe-walled, century-old ranch house that has been in Roy's family for years. They raise miniature Hereford cattle and, to a lesser extent, cashmere goats. They also own "a few head" of Shetland sheep, and some horses, dogs, and cats. They keep milk cows for themselves, butcher their own beef, get fresh eggs from their cousins nearby, can gallons of vegetables every year, bake their own bread, and participate in a food co-op for the staples they cannot produce themselves. Self-sufficiency is a necessity, as their ranch is forty miles from a proper grocery.

Their daily routine begins at dawn with barn chores, a big breakfast, and home-schooling. It continues with a hearty lunch followed by more chores—domestic tasks for the girls, ranch work for the boys—a light dinner, and an early bedtime. The girls also learn their share of ranch chores so they can help out in busy times and fill in for the boys when they are gone on ranch business.

Although Emily and Roy say they will support their children's life choices, they believe most of their offspring will ultimately choose the ranching life.

"I think they've got the land in their blood," said Emily. "They're happy here. And as it says in Proverbs: 'A merry heart doeth good like a medicine.'"

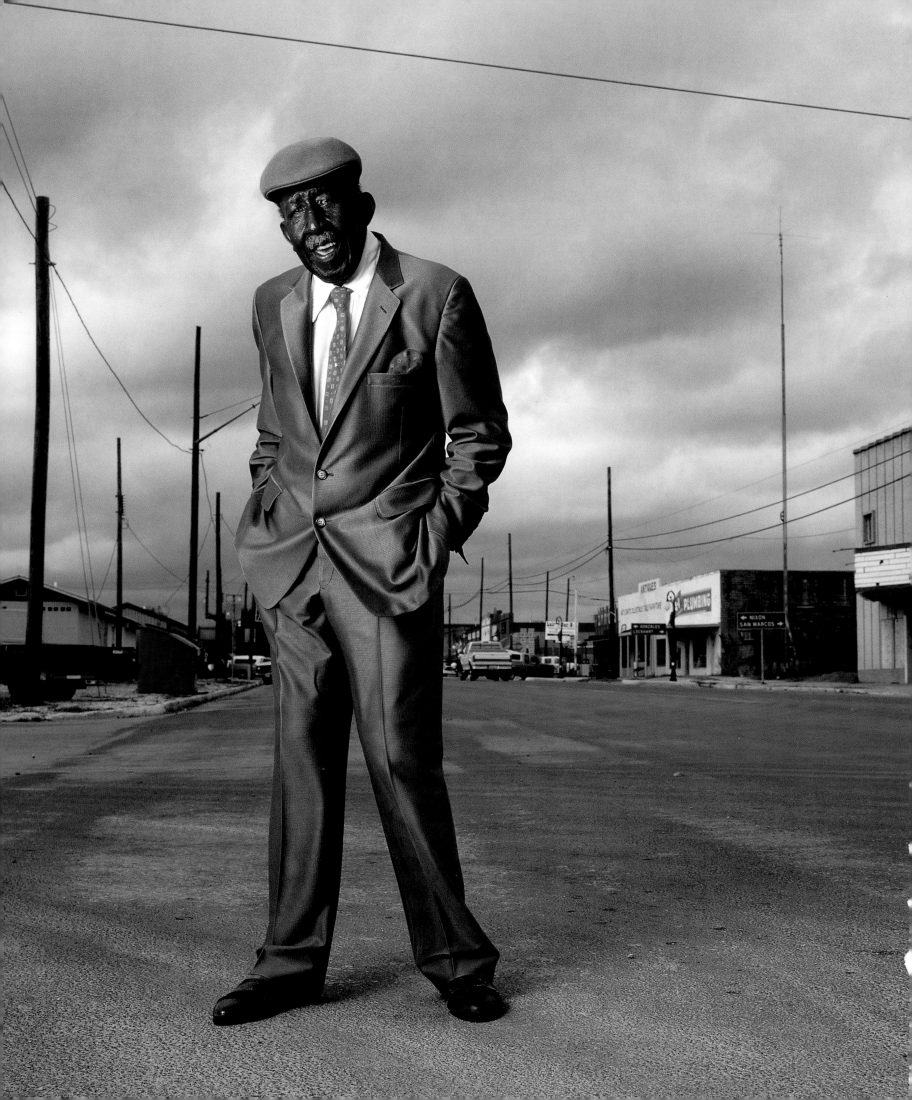

Obie Satterwhite

LULING, 1998

Obie Satterwhite (1916–1999) is sorely missed in his hometown. Known as the "Number One Sports Fan of Luling," Satterwhite rarely missed a football or baseball game at Luling High School. At football games, he could be found in the end zone waiting to cheer for his team's touchdown or out on the field performing with the cheerleaders. At baseball games it was a tradition for Satterwhite—a catcher in his youth—to throw out the first ball. And he was a fixture at pep rallies.

"They looked for Mr. Obie to cheer," said Satterwhite's daughter, Ada Johnson. "He was known for it."

Before he retired, Satterwhite worked at Davis Food Market, where he did the butchering and barbecuing and became famous for his homemade sausage. Later, he worked at H.E.B.

"He sang or whistled while he worked," said Johnson, who directed "Brother Satterwhite" in the Friendship Baptist Church choir, where she plays organ and piano. "He even sang in his sleep. My daddy was one of those rare people who truly loved everybody. He always said: 'God loves everyone and I love 'em, too.'"

Rosemary Murillo
and Douglas Elizondo

BUDA, 1989

Rosemary Murillo celebrated her wedding in June of 1989 at the Flamingo Ballroom in Austin, Texas, where she danced with family friend Douglas Elizondo.

"I can remember it like it was yesterday," said Murillo, now the mother of three children and a customer service representative at JCPenney in Austin. "I really didn't know how to dance, but he led. He was my father's best friend, and I've known him for a long time. It was great. My mother made my dress—of taffeta and lace—and my sister Gracie made the wedding cake."

Elizondo, now confined to a wheelchair, earned his living working road construction.

"He was full of life, like my dad," said Murillo. "My dad was a painter, and they liked to work together fixing up houses. He was very helpful to others."

Murillo's sister, Gracie Murillo, said Elizondo sold their parents the ranch near Creedmoor, Texas, which became their home.

"My dad always counted on him," she said. "They were together all the time. On weekends, they used to kill hogs out in the country." Murillo's father, Anastacio Tijerina, has since passed away.

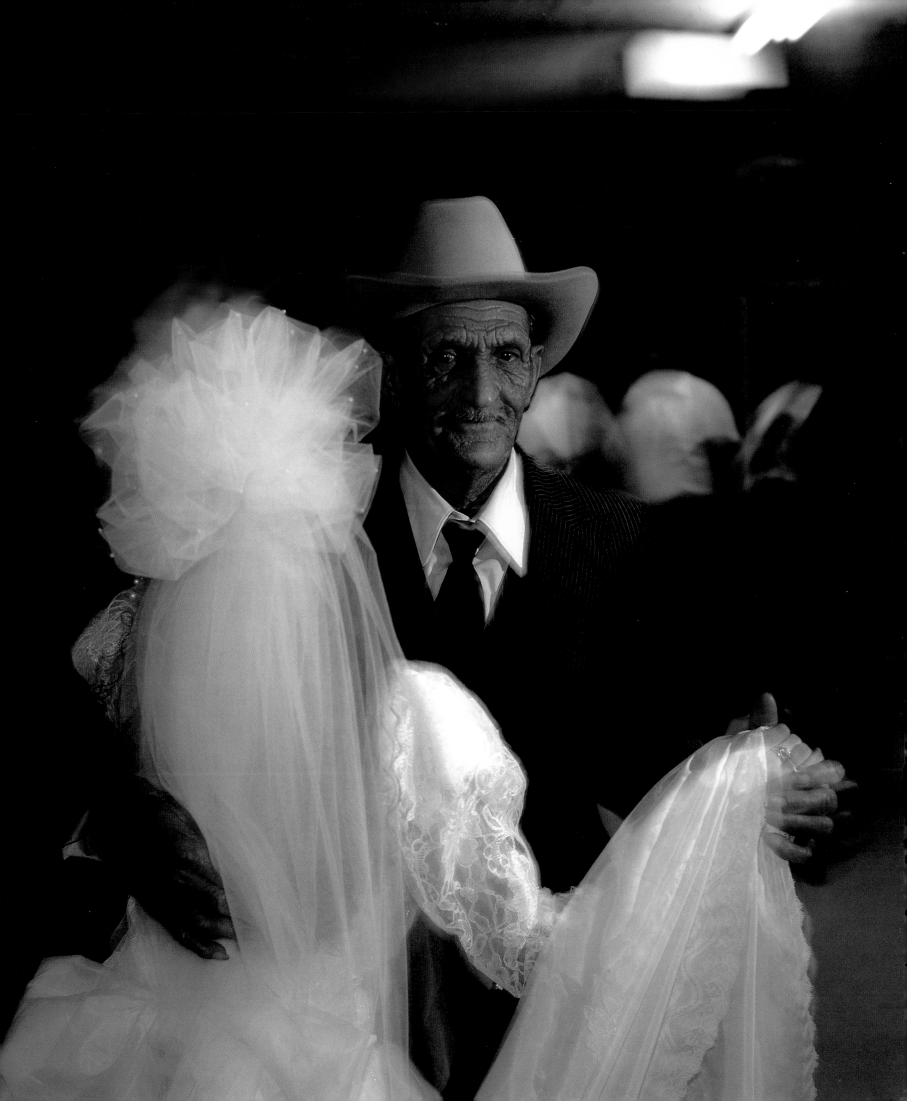

Sloan Teeple *and* Tracey Hanslik

A U S T I N, 1 9 8 9

Sloan Teeple and Tracey Hanslik appeared on the cover of *National Geographic* magazine in June 1990 in a story about Austin, Texas, after being photographed at the Austin High School prom in 1989. Teeple and Hanslik were "sort of" girlfriend and boyfriend; their families were close, as they shared a hunting lease, and the couple spent much of their time together as part of a close-knit group of friends.

"Tracey was my dancing partner," Teeple said.

Thirteen years later, in 2002, each of them had careers in the medical profession. Teeple was living in Shreveport, Louisiana, a third-year resident in urology at LSU Hospital, married and the father of two boys. Hanslik was living in Houston, working as a nurse practitioner; she married in 2001.

Hanslik moved to Houston to pursue her career and to join her brother and sister who lived there. Her sister introduced Hanslik to her future husband, Eric, a mechanical engineer whose parents lived right across the street. Hanslik earned her nursing degree from Baylor University, and after working as a nurse in Dallas, went back to school at the University of Texas at Arlington to get her master's. She works with liver patients.

"I love what I do," said Hanslik, whose job as a nurse practitioner allows her to see patients, prescribe drugs, and otherwise work more independently than she could as a nurse. "My parents knew I'd be in medicine since I was five. I was always very concerned with people's well-being. I was a candy striper at the hospital by age ten."

Hanslik said a course at Austin High that introduced students to medicine and a hospital setting at Brackenridge inspired her to pursue nursing.

"We had a really good teacher, Judy Rose, who was a nurse," said Hanslik. "She was a really big influence. She came to my wedding!"

Initially, Teeple planned to become a veterinarian. But he was turned down by Texas A&M Veterinary School the first time he applied, and friends convinced him he'd make a good doctor. After working in a hospital, he agreed. He graduated from the University of Texas at Austin and was accepted to medical school at UTMB in Galveston. In the meantime, before he changed his mind, he had also applied again to the vet school at Texas A&M and was accepted. But by then, his path was set.

He met his wife, Susan, indirectly as a result of the *National Geographic* cover. A resident of Houston, she was about to enter college at UT Austin. Her father, a longtime subscriber to *National Geographic*, handed her the magazine with Teeple and Hanslik on the cover and said: "Here, read this. It's all about Austin and you're about to move there." She saw Teeple's picture and said, "He's cute!" Once at UT, he saw her at a fraternity party and found out who she was. Later, at a football party in Dallas, she recognized him from the magazine cover and they finally met. They've been together ever since.

Teeple said he plans to move back to Texas to practice medicine.

"Our heart's definitely in Texas," he said. "I'd love to raise my boys the way I was raised. I can't see them going to LSU instead of UT!"

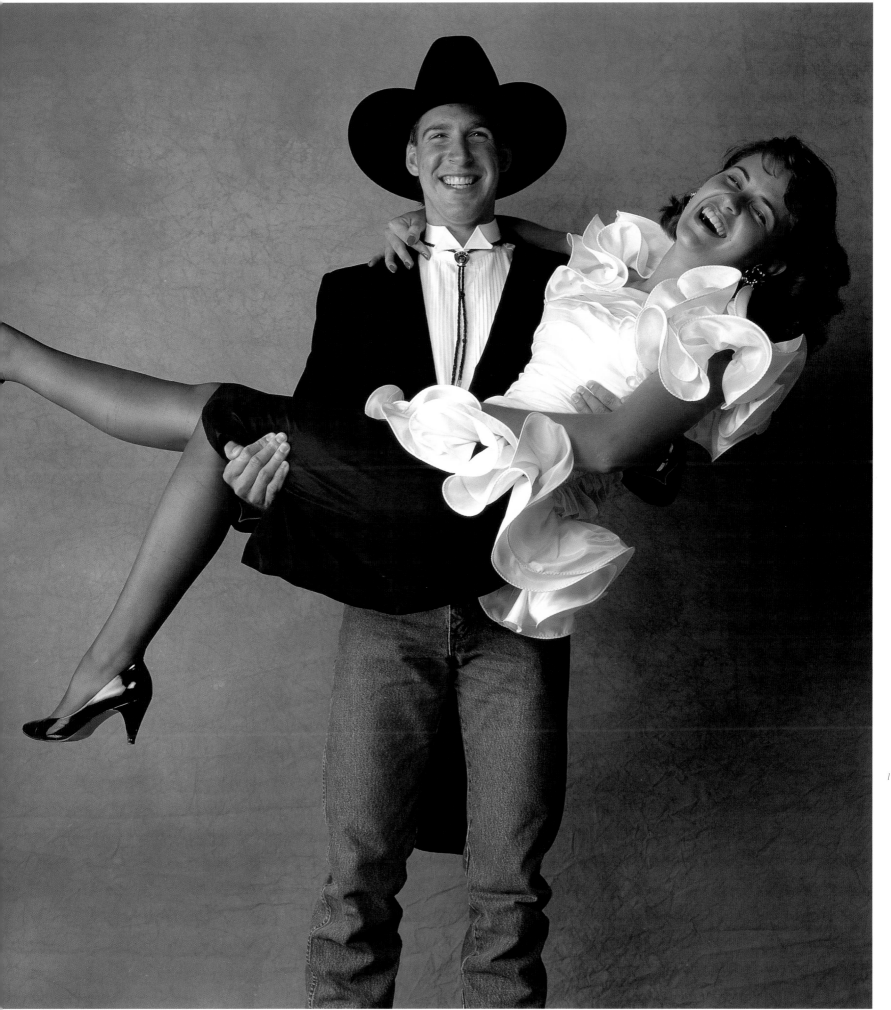

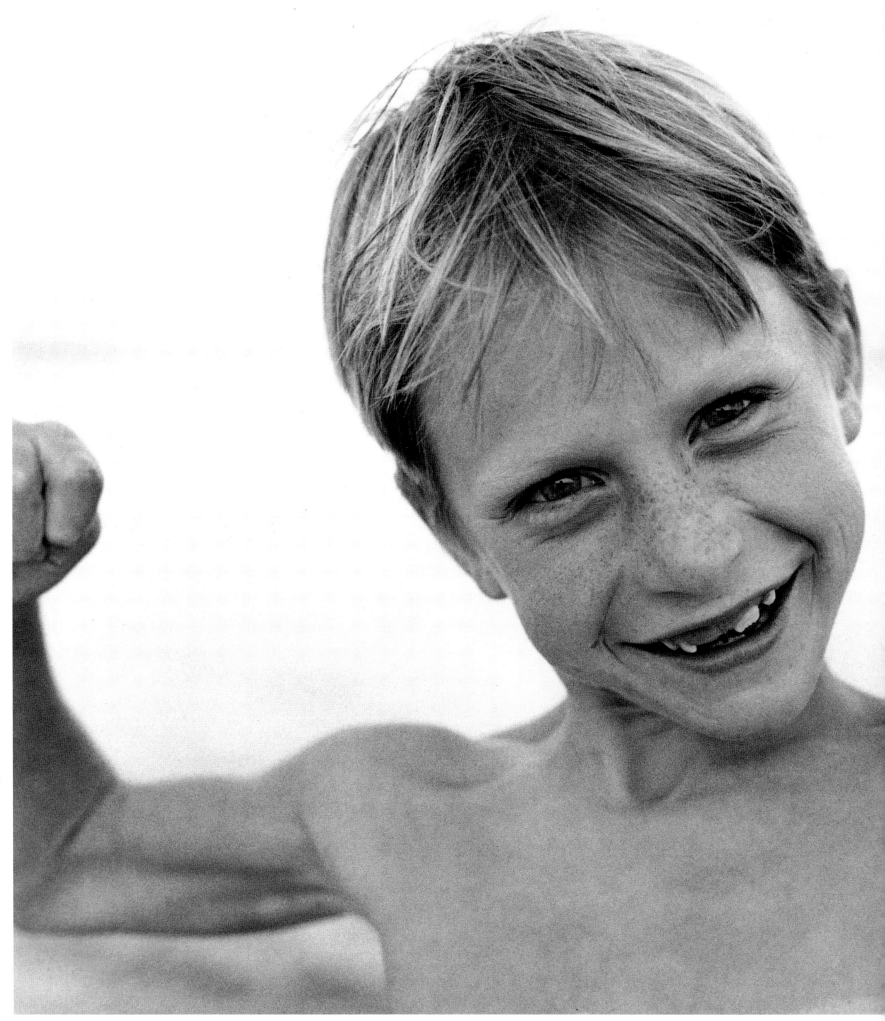

Sam O'Brien

A U S T I N , 1 9 9 8

Sam O'Brien was seven years old when this photograph was taken in 1998. In 2002, he talked about the picture and his life:

"Dad took us to the beach. All of us went swimming, and then Dad was taking pictures of me, and I was acting silly and flexing my muscles. The picture reminds me of Michigan and the summers I've spent there. I love Michigan—the lakes, swimming, and having fun with all my friends.

"My favorite thing to do in the world is to play soccer. I play center mid for Capital Soccer in Austin, Texas. I love traveling and going to tournaments and being with my friends on the team and staying in hotels. I'm good at dribbling past defenders, 'juking them out.' Soccer makes me happy because I'm doing something for the whole team."

Sam is a student at West Ridge Middle School in Austin, where he plays the cornet in the school band. He is rarely without some kind of ball. On Sunday afternoons, he plays golf with his dad.

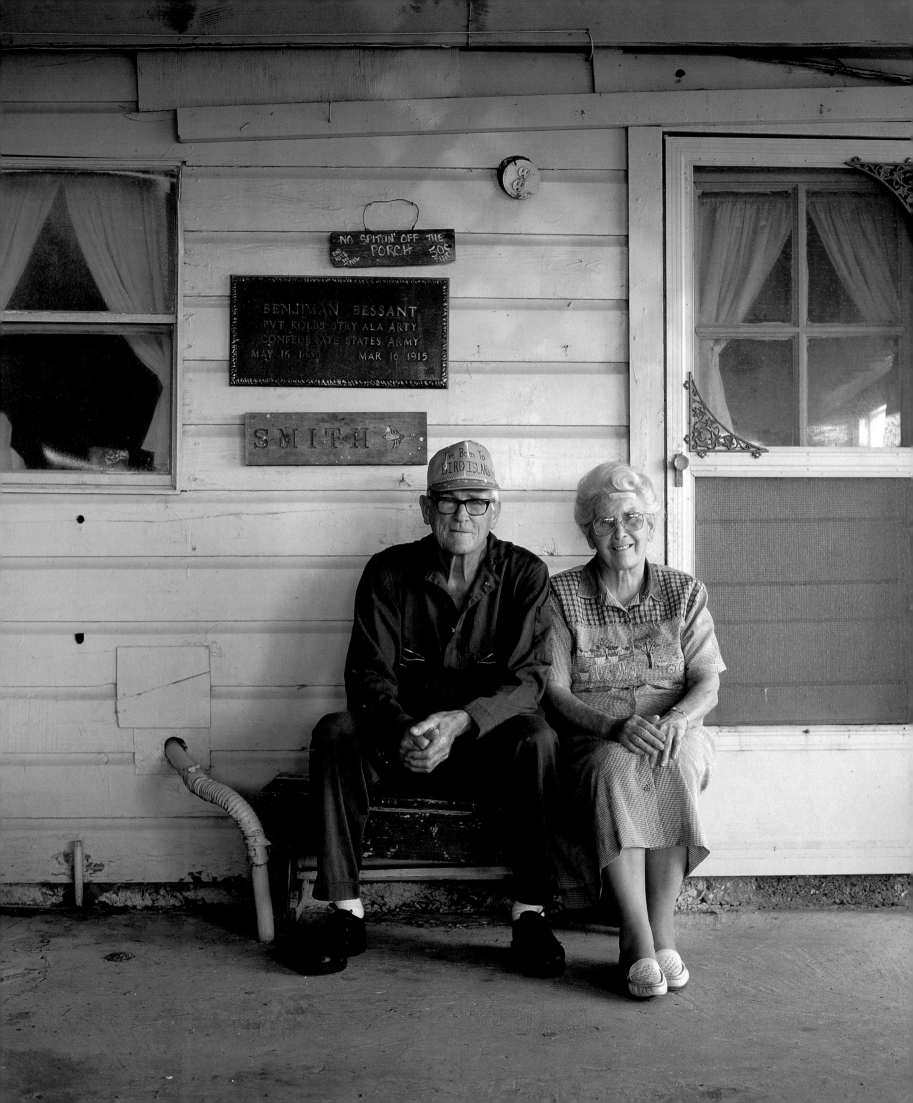

Chester *and* Ilet Smith

Chester Smith is the savior of Sundown Island. Smith, a former Exxon employee, is the Audubon Texas Society warden for Sundown Sanctuary, also known as "Bird Island." The sixty-acre plot, man-made from a dredge spoil in 1962, is home to some 18,000 species of birds, ranging from brown pelicans to laughing gulls and threatened reddish egrets. It is located in Matagorda Bay, just east of Port O'Connor, Texas.

"I'd like to leave nature as good as or better than I found it," said Smith, born in 1921 and raised in Sea Drift, near Port O'Connor, the second of four generations of coast dwellers.

Smith, a "lube blender" for Exxon until his retirement in 1973, admits that he knew little about birds when the Audubon Society first approached him in 1986. But he was an avid outdoorsman, and he knew how to motivate people. He's learned the rest on the job—by doing and by relying on his Audubon friends.

"Chester is now one of the most knowledgeable people on the coast in regard to colonial water birds and their requirements," said Jesse Grantham, director of bird conservation, and the man who took a chance on hiring Smith for Audubon Texas. "He really didn't know much about birds, but he certainly had a great personality and a lot of enthusiasm."

Smith enlists the help of thirty-five faithful volunteers to replant vegetation—particularly thorny hackberry, mesquite, lantana, baccharis, and salt cedar—for the birds' nesting habitat. The conservationists also create ponds for migrating birds; clear debris; build nesting platforms for brown pelicans; treat the land for fire ants, which can be devastating to birds; and generally maintain the island. They have the help of several big concerns, like Formosa Plastics, Devon Energy, the Corps of Engineers, and others, especially in fighting erosion and providing equipment and materials.

In 1998, Audubon Texas presented Smith with the first Chester Smith Outstanding Conservationist award to honor individuals who have dedicated themselves to conservation.

"Twenty-five years ago, conservation wasn't as important as it is now," said Smith, who has a beach house on pilings in Port O'Connor overlooking the intra-coastal canal. "I have lots of good volunteers. I want to preserve the birds for future generations."

Smith said his wife Ilet, who grew up on a farm in Minnesota, has been a true life partner. She raised the couple's seven daughters and one son, sewing all their clothes and taking in outsiders' sewing to make ends meet.

"Ilet has been with me all these fifty-six years," he said. "Now she's gray-haired, and she puts Barbara Bush to shame."

So far, Chester and Ilet Smith have ten grandchildren and four great-grandchildren to enjoy the fruits of his conservation work.

"I'd like my grandchildren to enjoy fishing and hunting like I did," said Smith. "And I'd like to learn the name of every type of vegetation and every seashell on my island."

Bishop T. D. Jakes

As a youth, Bishop T. D. Jakes was known as "Bible Boy." He earned the nickname because of his habit of toting his Bible to school every day and preaching to an imaginary congregation. Jakes, senior pastor of the Potter's House, a multi-racial, non-denominational church with 17,000 members in Dallas, has now become "Bible Boy" for a real audience that numbers in the millions. His T. D. Jakes Ministries, founded in 1994, produces his famous conferences—some 52,000 went to hear him at his Woman Thou Art Loosed conference in August 1998—as well as a dynamic television ministry. His riveting show, *The Potter's House*, airs four times a week on Black Entertainment Television (BET) and Trinity Broadcasting Network (TBN). And his television ministry is reaching as far as Zimbabwe, Uganda, South Africa, and England.

Jakes was born and raised in Charleston, West Virginia, to solid, loving parents who instilled in him the work ethic. His mother, Odith, a home economics teacher, taught all three of her children how to cook, sew, and clean; and his father, Ernest, started his own janitorial company with a mop and a bucket, and grew it to forty-two employees. Young Thomas Jakes worked hard as a boy, selling vegetables from the family garden, throwing newspapers, and selling Avon products door-to-door. When his father lay dying of kidney disease, Jakes helped his mother tend him, mopping blood from the floor around the dialysis machine.

At seventeen, Jakes was called to the ministry. After preaching part-time while he attended college, he eventually founded his own church with just ten members in Montgomery, West Virginia, and began preaching full-time. With his charismatic message of restoration, reconciliation and healing, he became so popular that he relocated to a refurbished bank building in Charleston, where the congregation was 40 percent Caucasian—a testament to his powerful, universal appeal. The congregation grew to 1,000 before Jakes moved to Dallas. Since 1996, he has ministered from The Potter's House to an increasingly international crowd.

Although he's compared with the Reverend Billy Graham, many consider Jakes to be the most gifted preacher on the globe. *Charisma* magazine's Ken Walker wrote that Jakes's message "… is about God's supernatural ability, bestowed by a Lord who is color-blind and cares about each person … [Bishop Jakes] delivers the Word in such a lightning-rod fashion that he makes you believe that all things are really possible with God."

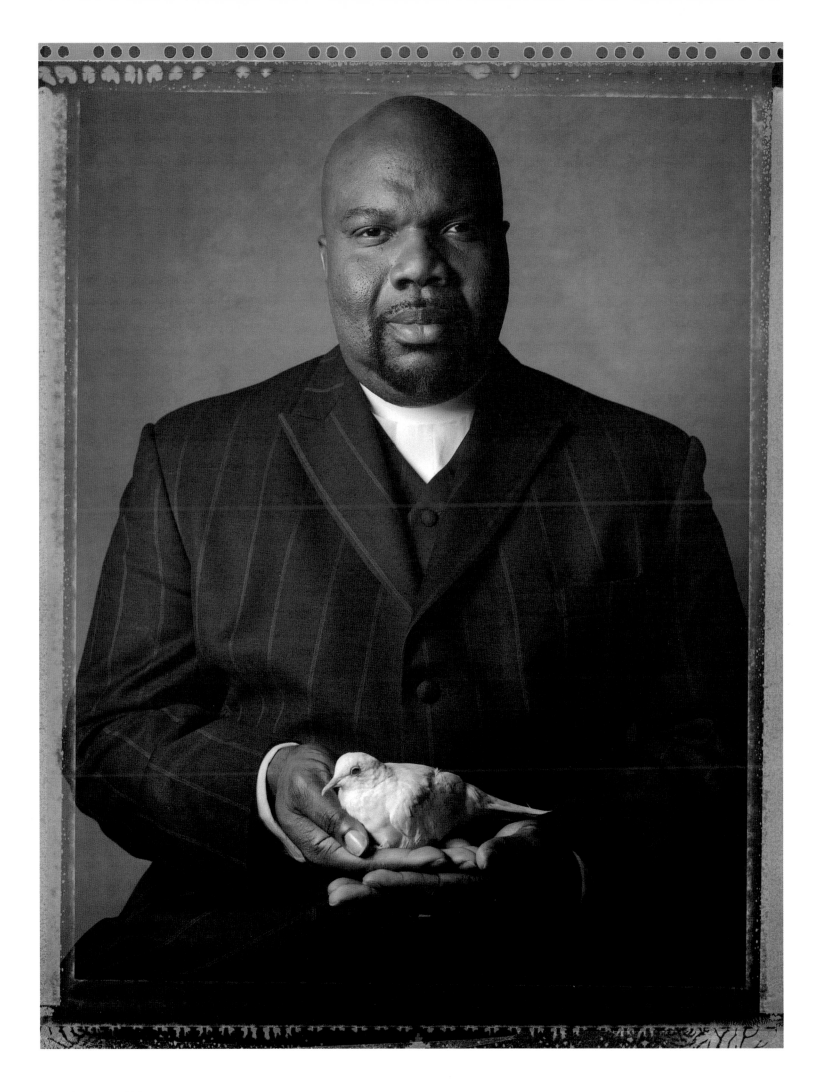

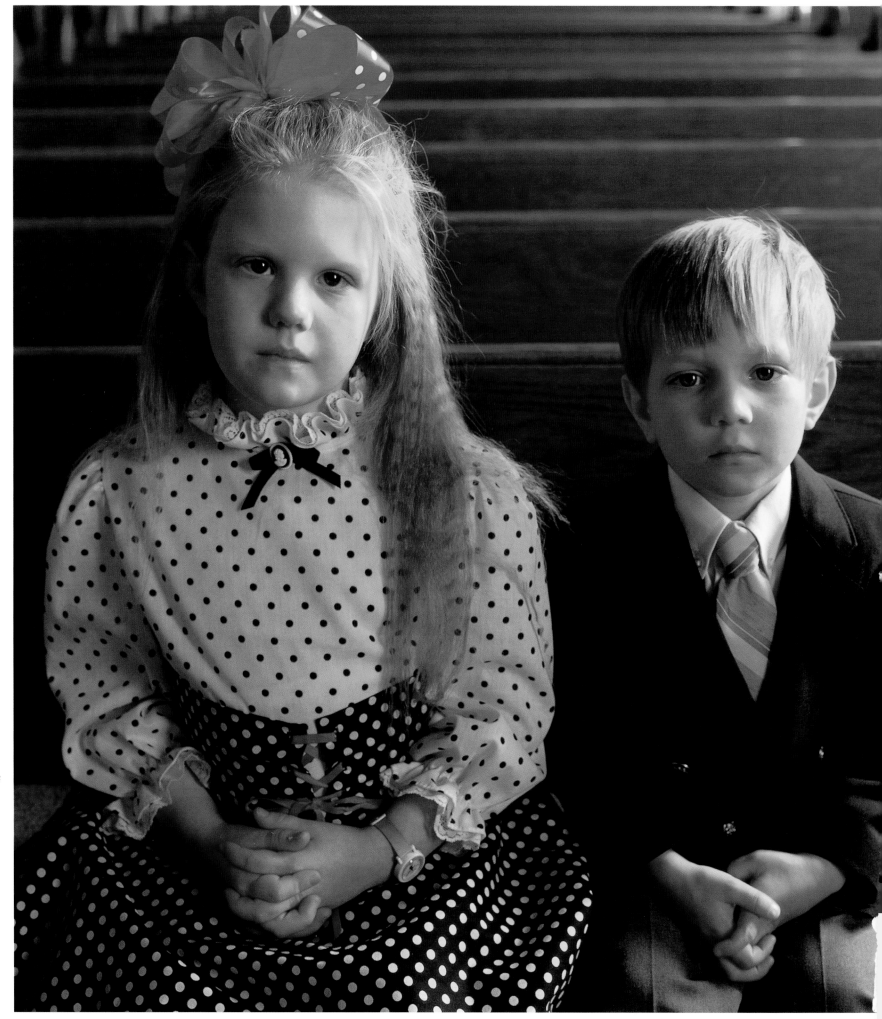

Julie *and* Jeffrey Choate

BETHEL, 1988

Julie and Jeffrey Choate were photographed at church in Bethel, Texas, in 1989. In 2002, Julie, the young mother of a one-year-old son, was working as a prison guard in Venus, Texas. Jeffrey, who stands six-foot-two, was working in a machinist's shop in Whitney, Texas.

Bethel Methodist Church Group

BETHEL, 1988

A group of parishioners at Bethel Methodist Church in the small community of Bethel, Texas—southwest of Waxahachie—poses for a portrait. From left to right: Oscar Curry, Yula Murdock, Jack Taylor, Lois Curry, and Stanley Murdock. As of 2002, all were deceased except Taylor.

The church was founded in 1853 under a brush arbor at High Springs, site of an underground spring that bubbles to the surface, unearthing a trove of Native American artifacts. Parishioners met in a log schoolhouse at Greathouse until 1860, when services were moved to a schoolhouse at Bethel on Baker's Branch Creek. The first meetinghouse, built south of the cemetery in 1872, was destroyed in a storm in 1892. The present sanctuary replaced the second meetinghouse, located north of the cemetery, in 1924. The tabernacle, built in 1907, served for camp meetings and God's acre sales. A parsonage, erected in the early 1900s on E. M. Brack's land at Boz, was moved to the present site in 1952.

Bethel Methodist Church was the site of the first God's, or Lord's, acre sale in Texas. Churches held such sales—for which parishioners, most of whom were farmers and ranchers, pledged the bounty of one of their acres of land to God and the church—to raise money for the pastor's salary, cemetery upkeep, and operating costs. God's acre sales, still held in rural farming communities, are generally held the third Saturday of October, just after harvest. Bethel Methodist's cemetery is populated with the graves of wagon train pioneers, many of whom succumbed to cholera on their journey.

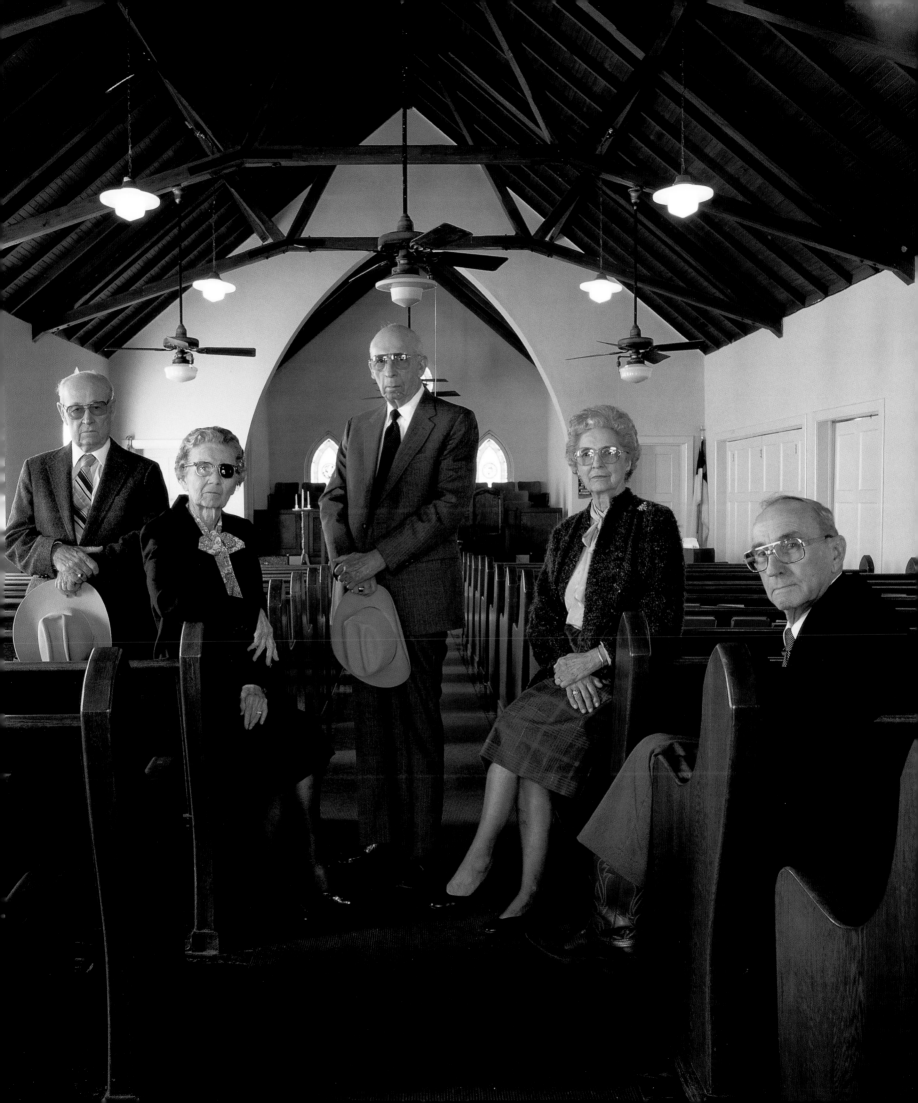

Ruby Sanchez McGill

VAN HORN, 1998

Ruby McGill got tired of being a waitress. So she bought the joint. McGill has owned Ruby's Bar in Van Horn for twenty-three years. Her husband, Don McGill, runs the couple's liquor store next door.

"I like to be around people," said McGill, "and I'm the boss."

When McGill's photograph appeared in *Texas Monthly* magazine—in a story about small-town Texas characters—she became a minor celebrity.

"Everybody who came down the highway stopped and had me sign their book," said McGill, who was born and raised in Van Horn and graduated from Van Horn High. "I've gotten nine marriage proposals from the penitentiary."

McGill spent a decade living in Phoenix, but was happy to move back home.

"It's a good town," she said of Van Horn. "Everybody knows everybody. I was in Phoenix ten years and didn't know anybody."

Ruby's Bar, formerly J. R.'s Bar and the Mint Bar, has been a watering hole since the 1930s. McGill first rented the place—renaming it after her hero, J. R. Ewing on the television series *Dallas*—then saved the money to buy it. Ruby's Bar sells beer and wine and features a pool table, dartboard, jukebox, and lots of Dallas Cowboys memorabilia.

"I'm a Dallas freak," she said.

McGill recently opened a nightclub, Ruby and Don's Lounge, better known as "The Club," on July 4, 2002. It features live music on Friday and Saturday nights.

"All the other bars in town closed," said McGill. "But I still have my little bar."

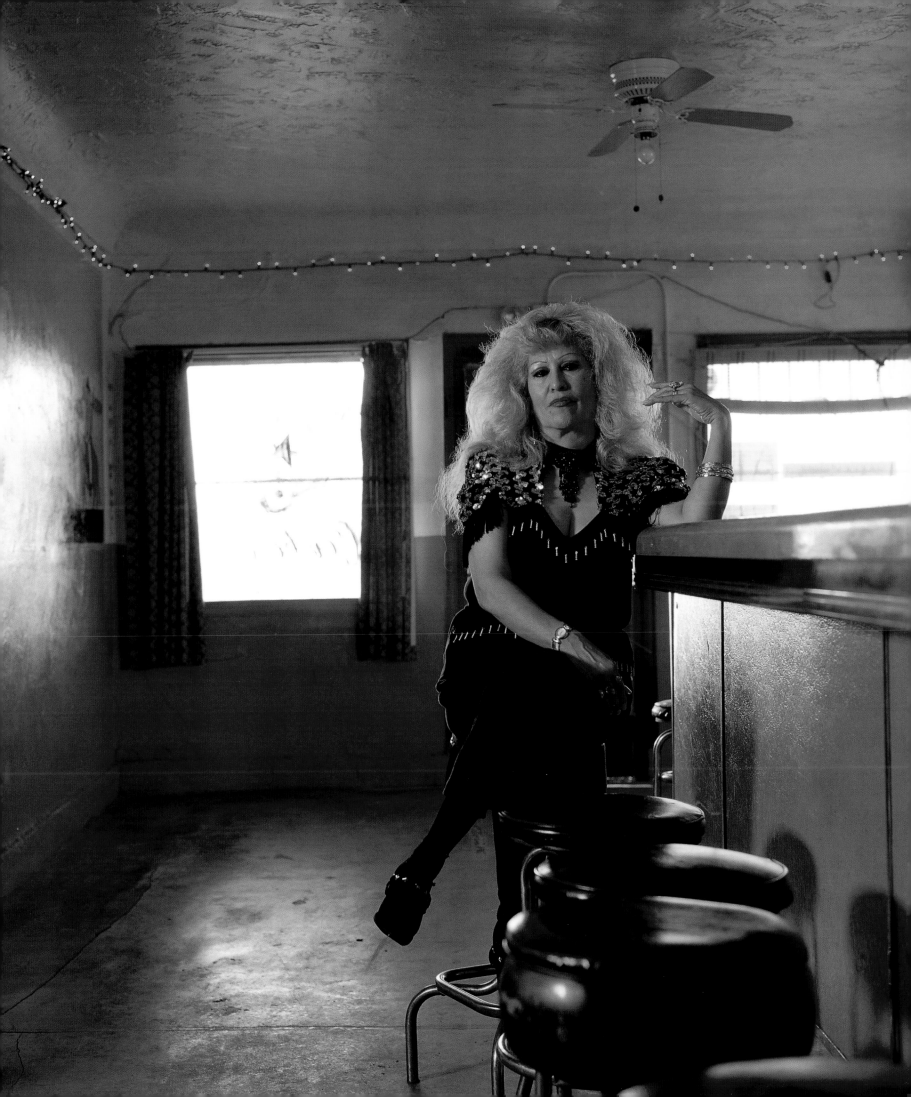

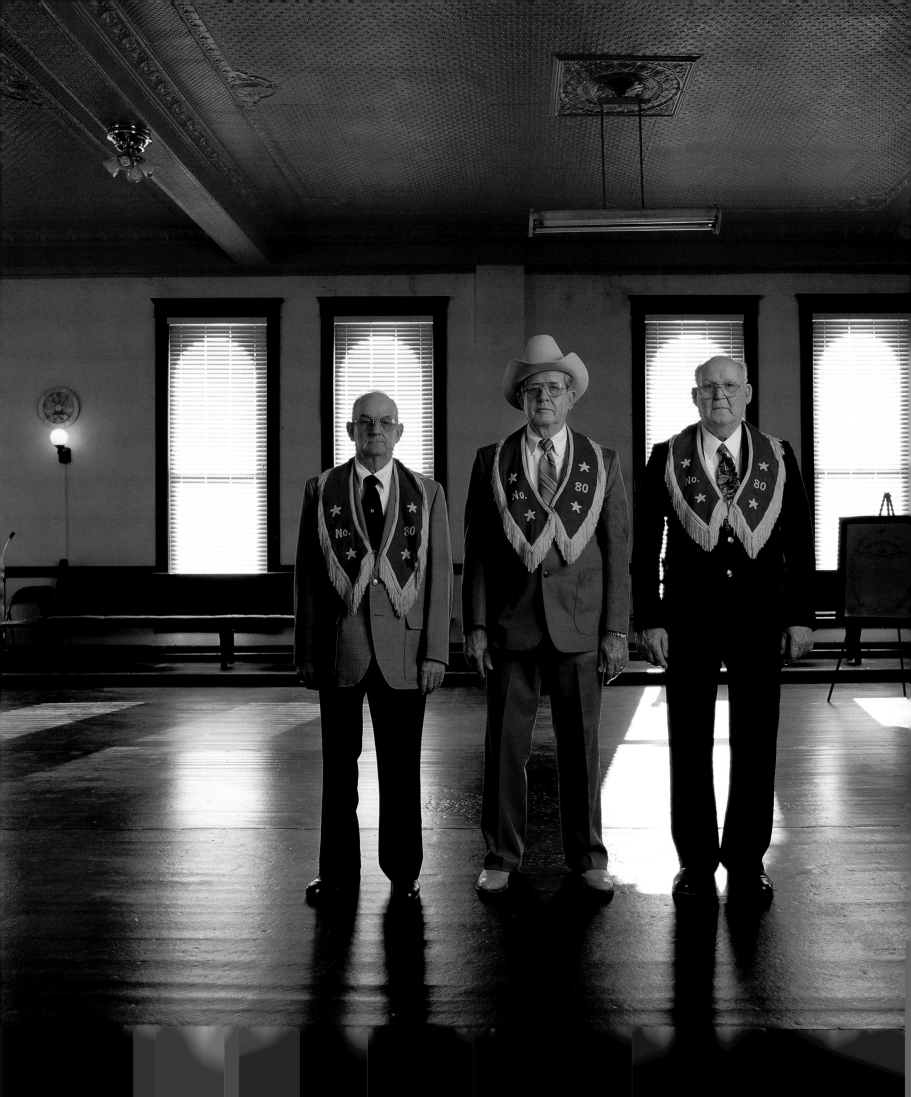

Odd Fellows

W A X A H A C H I E , 1 9 9 8

L. W. Banks, Kels Lowry and R. H. Chiles (left to right) are proud members and trustees of Waxahachie's Lodge #80 of the Independent Order of Odd Fellows, a fraternal organization that carries out charitable enterprises. The Waxahachie lodge raises money for such local concerns as the fire department, Toys for Kids of Waxahachie, and the Waxahachie Care Center.

Chiles, a retired homebuilder and project manager for a company that built feed mills, serves as Noble Grand of Lodge #80, which was chartered July 6, 1871. Banks, like Chiles, has been an Odd Fellow for more than four decades; he had a career as an auto parts salesman. And Lowry, a former postal clerk, has been a member for close to thirty years.

The Odd Fellows have a rich history; in fact, the organization played a key role in Texas statehood. The term "Odd Fellows" came about in the late 1700s in England, when the country was a monarchy. Some commoners, when times were bad for their neighbors, formed an unofficial system whereby they would work together to help the unfortunate families get back on their feet, whether it was rebuilding a barn that had burned or putting in a new crop after a devastating season. Such helpers came to be known as "odd fellows," so named by the general population who thought they were "an odd bunch of fellows" who would behave in such a selfless and seemingly impractical fashion.

The English eventually established the Manchester Unity, an official fraternal organization dedicated to helping their fellow man. In 1819, an Englishman living in Baltimore organized a group of like-minded Englishmen there and petitioned the parent organization for permission to start an independent order in the States. Soon the Independent Order of Odd Fellows spread to other states; in 1838, a lodge was established in Houston—before Texas attained statehood—and the Lone Star Lodge #1 became headquarters for the development of the Republic of Texas.

The Odd Fellows, now a huge international non-profit organization, support such causes as the World Eye Bank and the Arthritis Foundation, and they fund a chair at Johns Hopkins Hospital in Baltimore, Maryland, for research on eye disease. The organization also operates the I.O.O.F. Education Fund, which provides low-cost student loans; and it sponsors a two-week trip for deserving high-school students to New York City to visit the United Nations.

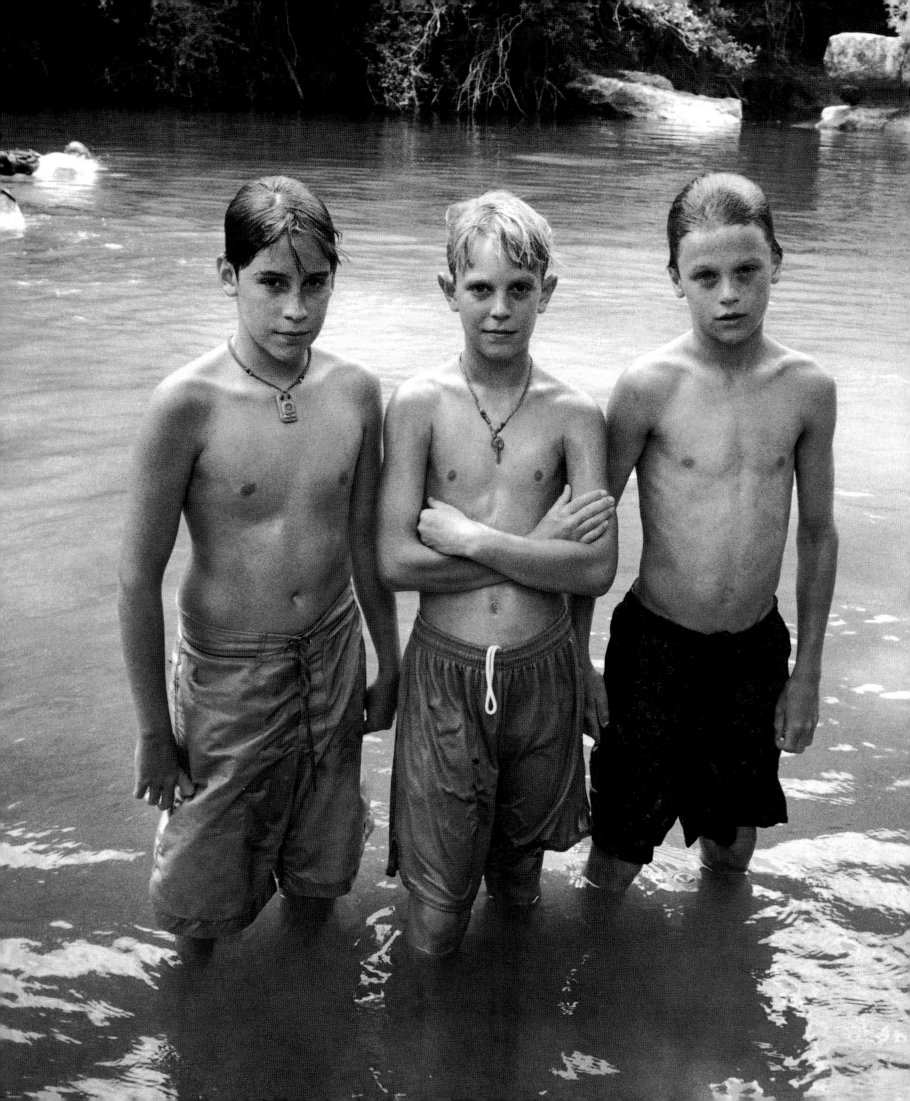

Boys *at the* Creek

A U S T I N , 1 9 9 8

Austin Price, Jeff Armbruster, and Jesse O'Brien spent afternoons, weekends, and summers, from the ages of eleven to fifteen, riding their mountain bikes down to the low-water bridge in the Lost Creek subdivision, an entry point to the Barton Creek Greenbelt in Austin, Texas. The boys rode the trails, hiked the canyons, and swam in the creek, where they whiled away hours fishing and swinging on a crude rope-swing accessible from the top of a boulder on the creek's bank. When they grew tired, they sprawled out in the sun on huge limestone slabs that formed miniature islands in the water.

In 2002, six years after the photo was taken, the boys reminisced.

Austin: "When I look at the picture, I remember fun times at the creek, relaxing and cooling off from the hot Texas sun. We were taking life as it comes. We were happy, at home with nature. I didn't care about the past and I didn't think about the future. Now, I'm thinking about the future, and what I could have done differently in the past. I have to think about school and grades and college. But I still love the creek, and we go down there whenever we can. The friendship is still strong."

Jeff: "I see the good times we used to have at the creek—swimming and fishing, riding our bikes—all in our own little group. We could just have fun. I didn't have to worry about girls and stuff. The creek was a place to get away from everyone; it was so peaceful down there. Now, everything is so hard and you have to think before doing everything; and if you make a bad decision, it's burned into you. We have to study so much instead of playing outside. I don't feel we're as together as we used to be, and I'd like to try and get us back together before college."

Jesse: "The creek was an undisturbed place where we could go and get away from the present and the bonds of suburbia; it was like a porthole to the past, to what the area must have looked like hundreds of years ago. It's a metaphor for adolescence, for freedom. I felt indestructible. I guess I'm not as happy now because everything has gotten more complex than just the creek. I have more things on my mind, more obligations and responsibilities. As an adult, you have to learn to forget, whereas as a child it came naturally."

Austin, Jeff, and Jesse are students at Westlake High School in Austin, where they are preparing to take the SAT and visit college campuses. They spend most of their free time driving around and otherwise tinkering with cars and trucks.

Ila Johnston

S P U R , 1 9 9 8

Retired schoolteacher Ila Johnston renewed her Texas driver's license when she turned ninety-seven. It doesn't hurt that she has a friendly patrolman for a next-door neighbor.

"He said he'd help me," said Johnston, who pilots an Oldsmobile Eighty-eight. "I've never had a wreck or a ticket."

Johnston, born October 5, 1905, has lived in Spur, Texas, since 1922. She was born in Van Zandt County, in a small town called Rast, which is no longer on the map. Her father, whom she describes as a "jack-of-all-trades," worked at many things, including filling prescriptions, farming, ranching, and carpentry. Her mother taught high school.

Johnston earned an education degree from West Texas State Teachers College, now West Texas A&M, and she considers her greatest contribution teaching and working with young people. "I learned to understand them," said the educator, who taught math, civics, and history at Spur High School for thirty-three years. "I learned to do things they liked to do."

To explain algorithms to her math class, she arranged—without the principal's permission—for two cars to transport the students to the town football stadium, where she had them measure the field, using their newly acquired knowledge.

"It meant so much more to them," she said.

Though she never had children of her own, Johnston, a widow, speaks maternally of her former students—"my exes," she calls them.

"I insisted they all go to college one year, to see what it's like. I had one student who told me he didn't need to go to college because he wanted to be a mechanic. I convinced him to try it; I suggested Texas A&M. Now he's an instructor. He still carries his tools around in his car, though."

Johnston still attends the school's pep rallies on Friday afternoons; and she continues to drive with confidence, having taught a good number of the area highway patrolmen.

"I guess I'm not too slow and I'm not too fast," she said, revealing, albeit metaphorically, the secret of her longevity. "If anything ever happened, they'd take care of me."

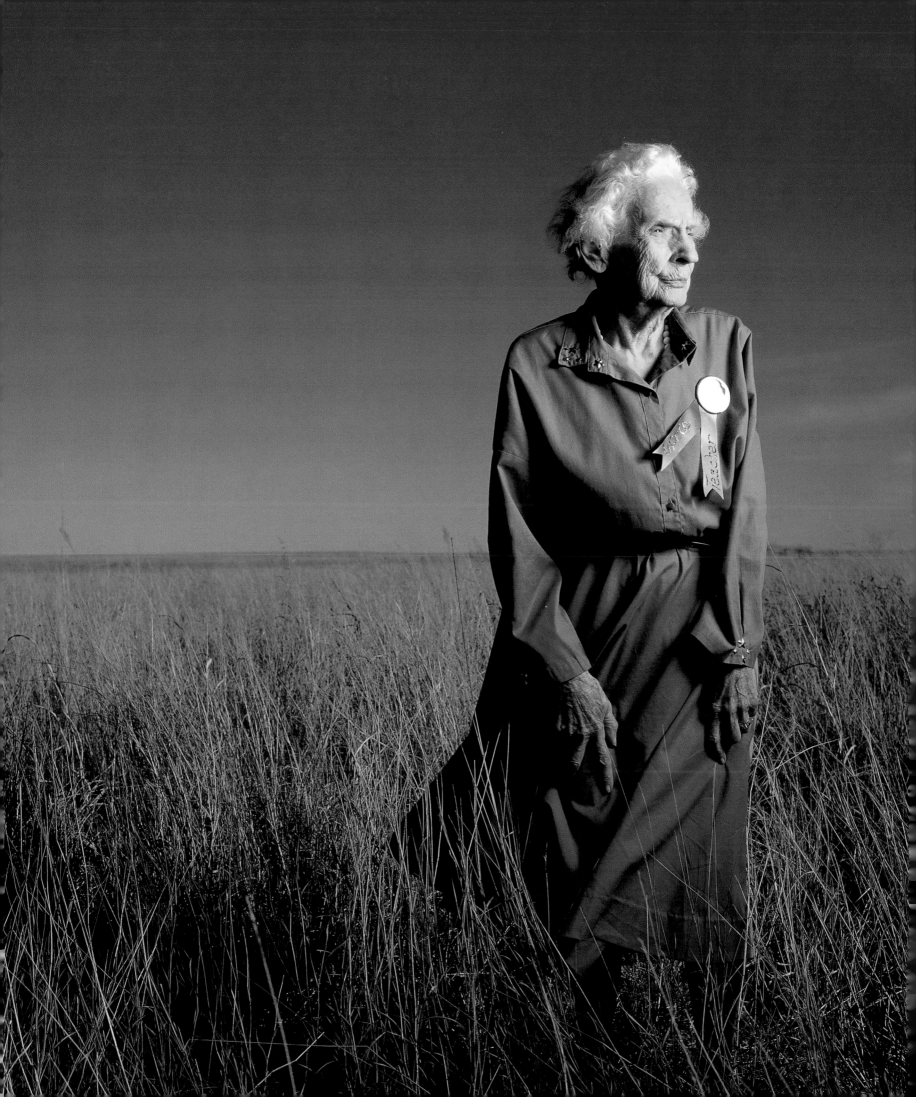

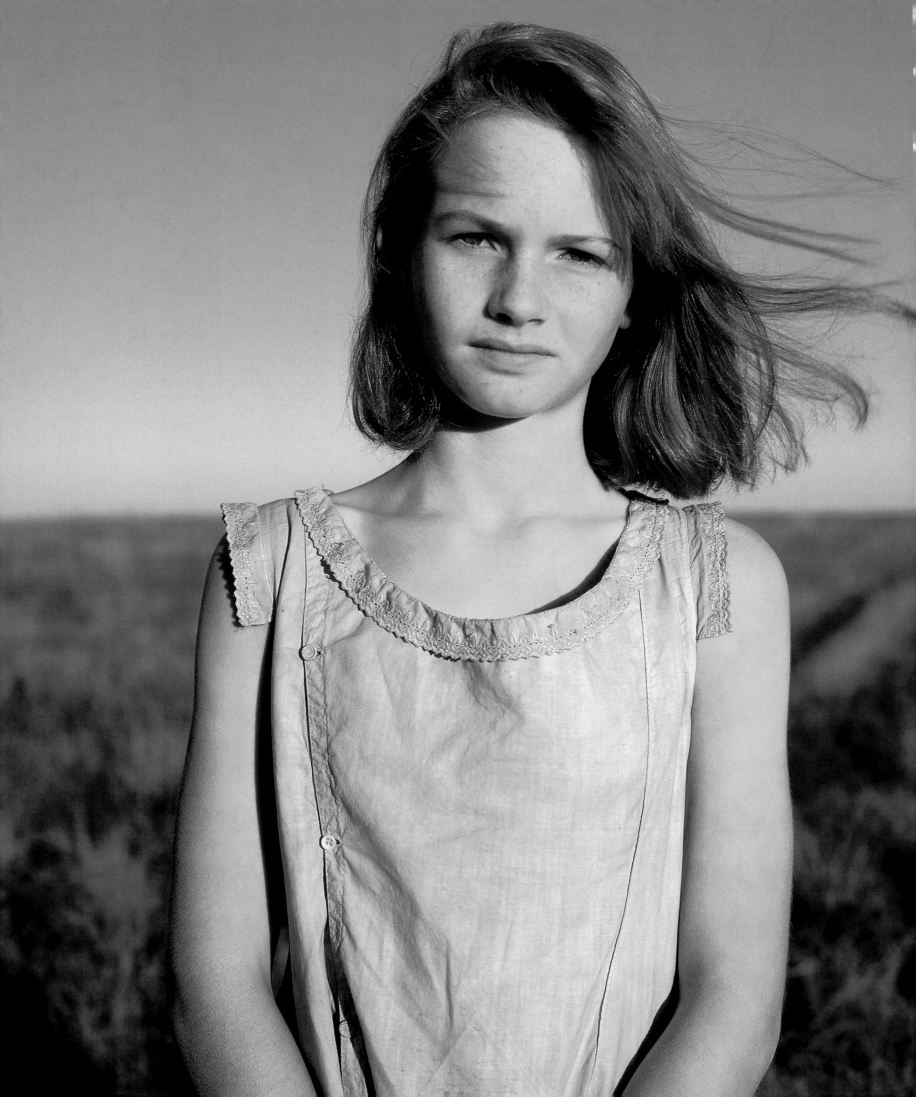

Cara Collier

Cara Collier was just a pre-teen when this photograph was taken for a Nike advertisement in 1990. The Nike crew used her dance studio in Richardson, Texas, to conduct the casting session, and Cara was chosen as a real-life model.

"I was twelve years old, in middle school, and dance was my life," said Collier, who grew up in Plano and Midland. "I did ballet, modern jazz, and tap."

At sixteen, Collier enrolled at the Booker T. Washington High School for the Performing and Visual Arts in Dallas, where she performed with the dance department; but she graduated from Plano High School. Instead of going on to college, Collier began doing web page design and got caught up in the high-tech industry. She ran her own web page for a time, featuring local garage bands, then went to work for various start-up companies.

"By eighteen, I had a corporate job," she said. "I was working in web services and the Internet."

Collier eventually returned to school, at Brookhaven College in Dallas, but after only one semester, she moved to Austin to work for MCI. She spent the next few years back in the high-tech industry, winding up at Pervasive Software, where she worked as an account executive and sales engineer. Then wanderlust got the better of her again.

"I packed up my stuff, left my boyfriend in Austin, and moved to San Francisco," said Collier. "I'm now at the University of San Francisco getting a master's degree in education. But I have a minor in dance, and I'm still performing modern dance."

In 2002, Collier was still carrying on a long-distance relationship with her boyfriend, a computer chip designer in Austin.

"I'm just living life wherever it takes me," said Collier. "I haven't done it by the book. I'm twenty-four and I'm happy."

Emma Feld Mallan

M A R F A , 1 9 8 8

Emma Feld Mallan (1906–2002), a native New Yorker, adopted Texas as her home in 1946. Her husband, a steel magnate, bred Palomino horses, and the couple traveled to Marfa to buy breeding stock for their stable in New Jersey. Mallan chose to stay. The Texas weather suited her young son, who suffered from chronic pneumonia, and she fell in love with the land. In 1950, she inherited the landmark Paisano Hotel— home to the cast and crew of the film *Giant* for six weeks in 1955. Headliners James Dean, Elizabeth Taylor, and Rock Hudson lived at the Paisano for a week, but peeled off from the rest of the group to move into private homes until filming ended. To manage the sixty-room, sixty-bath hotel—a job she held for sixteen years—Mallan called on the social experience from her New York past, when she had entertained titans of the steel industry.

In later years, Mallan led a quiet life on a ranch with her dear friend Margaret Weyrauch, until she was well into her nineties. The pair came into town regularly to visit the post office, have lunch, and get their hair done at Helena's Beauty Shop in the old hotel on Main Street, where framed photographs from *Giant* adorn the walls—a gift from Mallan to shop owner Helena Alsobrook.

"It's a simple life," said Mallan, at ninety-three, "but we like it."

Alsobrook styled Mallan's hair nearly every Thursday morning for thirty years.

"She was a wonderful person, both as a customer and a friend," said Alsobrook. "She was a like a second mother to me. I'd tell her my problems and she'd pray with me. I miss her very much."

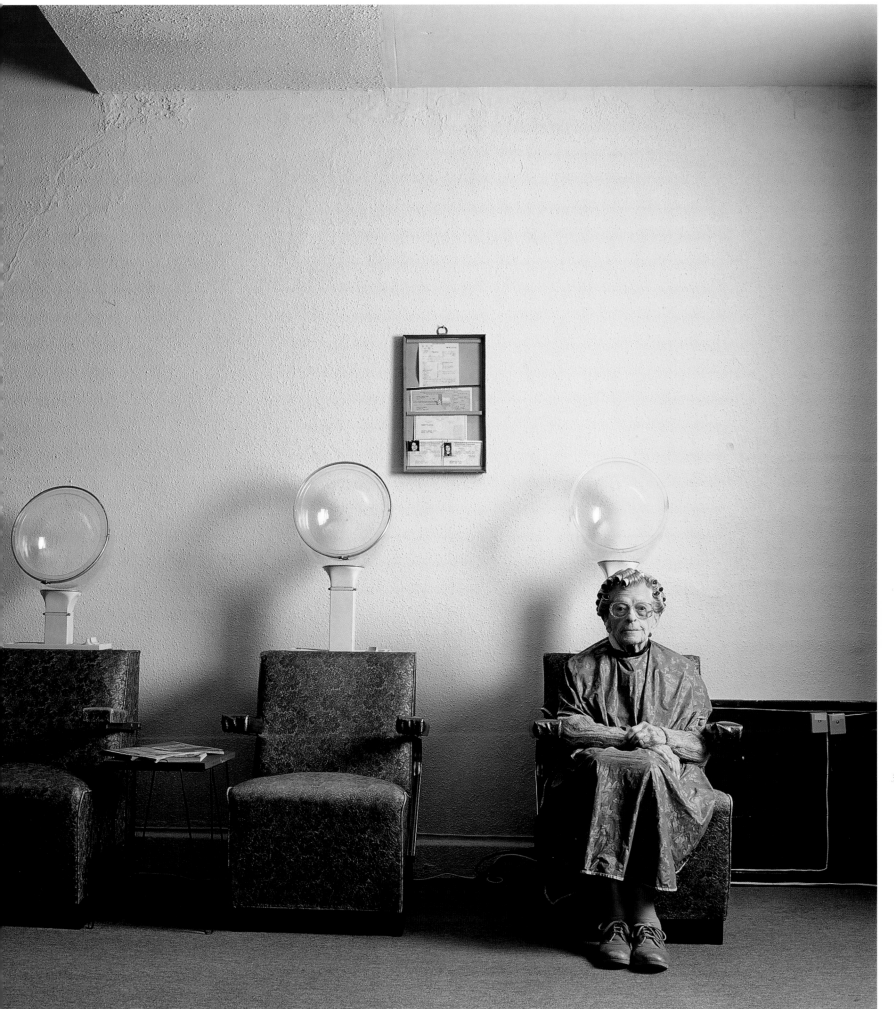

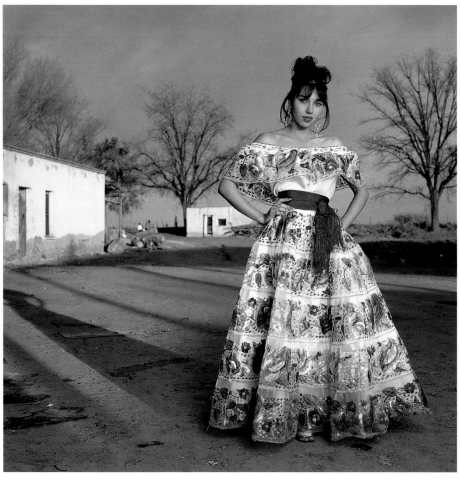

Cynthia Fuentes, *Miss El Paso*

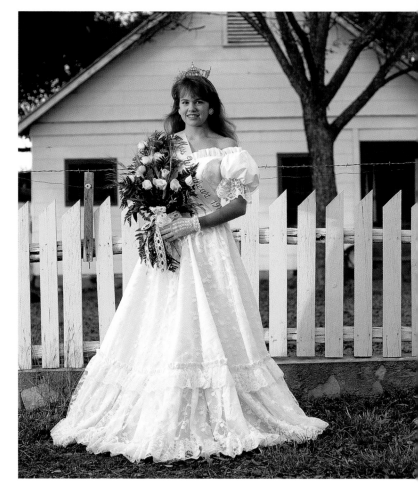

Kellie McWhirter, *Miss Wheatheart*

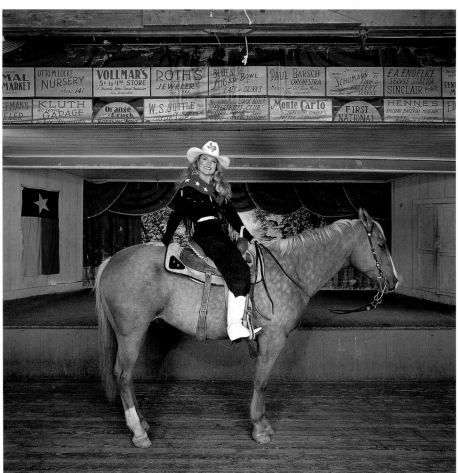

Bobby Kay Tate, *Miss Rodeo Texas*

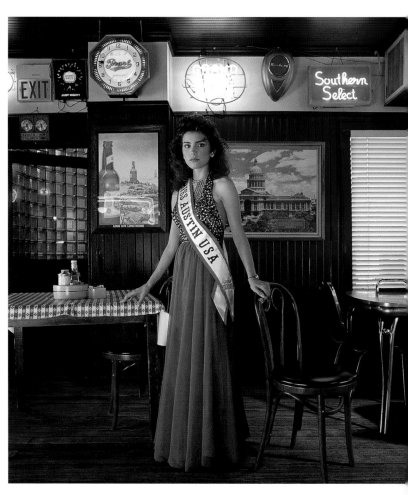

Annabelle Lares, *Miss Austin*

Texas Beauty Queens

Texas has a reputation for beautiful, larger-than-life women, and the state has produced plenty of beauty queens. For many of these women, their fame was heady but short-lived; after the contest, they quickly moved on to obscurity. But for others, like Kellie McWhirter, from Spearman, Texas—Miss Wheatheart—the beauty contest launched a lucrative new life. While at Baylor University, McWhirter entered the Miss Wheatheart contest in 1990 with a girlfriend on a whim, and, to her surprise, walked away with the crown. Upon winning, she continued to compete. With the same friend, Mechelle, who had won Miss Abilene in the meantime, McWhirter went on to the Miss Texas pageant, winning scholarship money in the preliminary competition. She followed that up by winning Miss West Texas, then returning to Miss Texas to win more scholarship money in the preliminaries.

"It was a really good experience overall," said McWhirter, who goes by her husband's last name—Francis—now. "I earned money, which helped out a lot at Baylor; I gained a lot of confidence and learned interviewing skills, which helped later when I went on job interviews. But I got kind of derailed by my husband. And in the grand scheme of things, I'd rather go on with my life—with my husband and daughter."

McWhirter and her husband, Travis, own two businesses and work out of their home in Montgomery, Texas. She runs a mobile home business and he a homebuilding business. But she still keeps a foot in the beauty pageant world, volunteering as director of the teen pageant for Miss Teen Conroe.

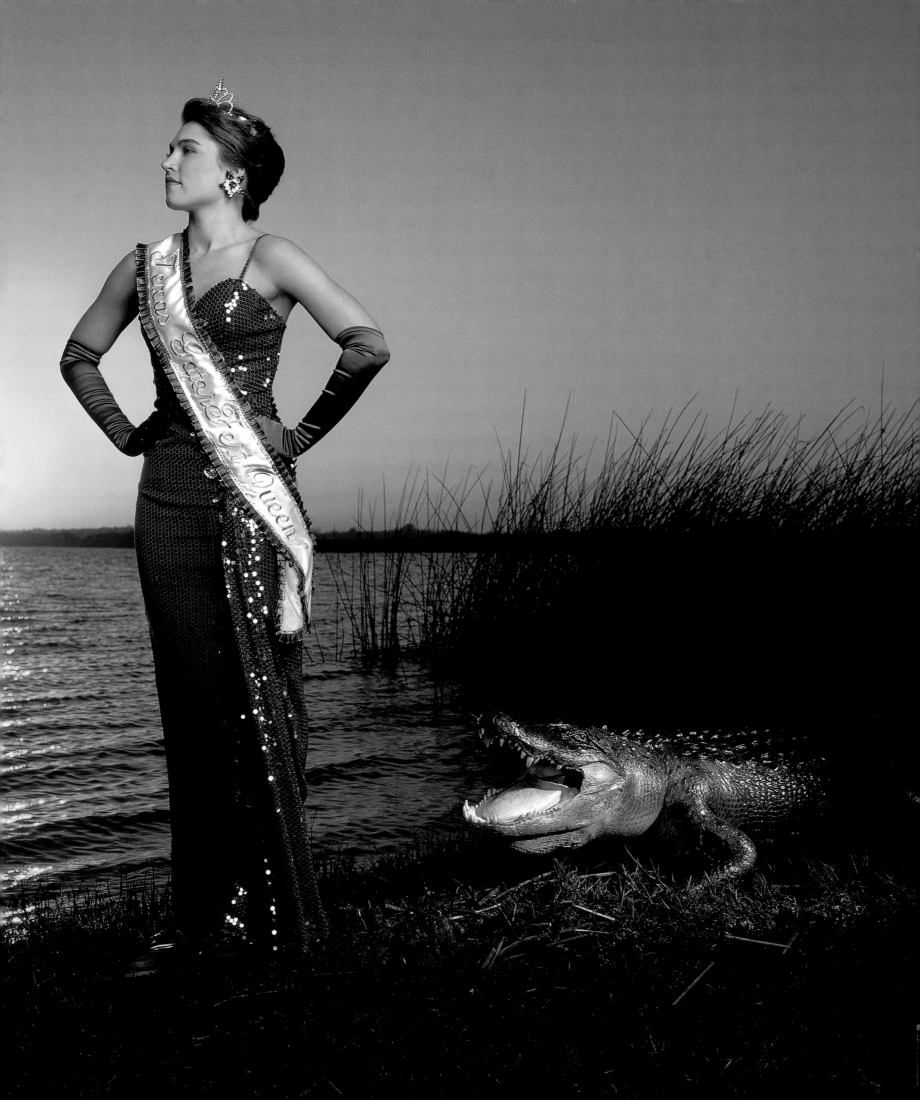

Gatorfest Queen

A N A H U A C , 1 9 8 9

Shannon Perry of Anahuac, Texas, was crowned Gatorfest Queen—the first ever—in 1989. The contest is devoted to finding a "complete young lady" who embodies the spirit of the small town and the annual festival.

Gatorfest, held in September the weekend after Labor Day, was established in 1989 as an Anahuac Chamber of Commerce fund-raiser to celebrate the reopening of the alligator harvesting season in Texas—after the reptiles were removed from the endangered species list. The festival is an action-packed weekend featuring contests for the largest alligator hides, live music and entertainment, street dancing, and the crowning of the Gatorfest Queen—as well as the younger Gatorfest Princess and the even younger Little Gatorfest King and Queen. There's an educational tent featuring a live baby alligator and experts expounding on alligator minutia. And there's plenty of good food, including, of course, alligator entrées of every variety: alligator-on-a-stick, grilled alligator steaks, alligator étouffée, and alligator gumbo.

After competing in the Miss Texas pageant in 1993, Perry went on to attend Sam Houston and Lamar universities and now lives in Houston, where she works for a large insurance company. She's holding out on marriage and kids until she's lived a little.

"It's really rewarding to me," she said of her job. "But people still remember me as the Gator Queen."

43

Kinky Friedman

Kinky Friedman has made a career of being an irreverent, iconoclastic, and boisterous anomaly—a Texas Jew. Born Richard Friedman on November 1, 1944, in Chicago, Illinois, Friedman and his family moved to Houston when he was a year old, then moved again—dividing their time between Austin in winter and Kerrville in summer.

"I was born in Chicago, lived there a year, couldn't find work," said Friedman. "So I moved to Texas, where I haven't worked since."

Friedman—whose nickname presumably came from his unruly, copious head of hair—has had many lives, including counselor at his family's 400-acre ranch camp for children, Plan II Honors Program student at the University of Texas at Austin, Peace Corps volunteer, singer-songwriter for and founder of the cult-famous Texas Jewboys band, prolific writer of mystery novels and other books, *Texas Monthly* columnist, and animal advocate and founder of Utopia Animal Rescue Ranch. He also calls himself a "professional friend-of-presidents," specifically Bill Clinton and George W. Bush. "I call myself the new Billy Graham," he said.

Friedman uses himself and his friends as characters in his mystery novels, which recount the adventures of a musician-turned-gumshoe (fond of cigars and Jameson's whiskey), who lives on Vandam Street in lower Manhattan and discusses his cases with his cat. "The cat said nothing" is a frequent rejoinder in his mystery books, of which there are fifteen and counting, translated into some seventeen different languages. He has also published a non-fiction book, *Kinky Friedman's Guide to Texas Etiquette, or How to Get to Heaven or Hell Without Going Through Dallas-Fort Worth*; and a recent non-mystery novel, *Kill Two Birds and Get Stoned*, about three people trying to destroy a Starbuck's.

Friedman is the son of the late S. Thomas Friedman, a former UT psychology professor, and the late Minnie Samet Friedman, a speech therapist, who founded Echo Hill Ranch, "a child-centered, non-competitive ranch camp for boys and girls six to fourteen," more than fifty years ago. It was there that Friedman cut his entertainer's teeth, performing on skit nights and "bunk song nights." He wrote his first song, "Ol' Ben Lucas," at eleven. While in the Peace Corps after college, Friedman continued writing songs, including the satirical "Ballad of Charles Whitman," about the tower sniper at UT. Friedman's stint with the Jewboys—a country band with a social message—took him across the country throughout the '70s, culminating in a tour with Bob Dylan's Rolling Thunder Review. Afterward, Friedman went solo; and in the mid-'80s he put down his guitar and took up his pen, publishing his first novel, *Greenwich Killing Time*.

When he's not traveling to promote his books, Friedman—famous for his love of cats, chess, and Cuban cigars—lives in the Hill Country on the family ranch, where he spends his time writing and helping save neglected and abandoned animals for his rescue ranch, which he founded in Utopia, Texas, but which has since moved to Medina.

For his work with animals—which began in his heart in Chinatown, New York, when he rescued Cuddles, a kitten abandoned in a shoebox—he enlisted the support of many famous and not-so-famous friends, who contributed money, time, land, and love. An excerpt from the eulogy he wrote for Cuddles, who died in 1993, expressed Kinky's more sentimental side: ". . . They say when you die and go to heaven all the dogs and cats you've ever had in your life come running to meet you."

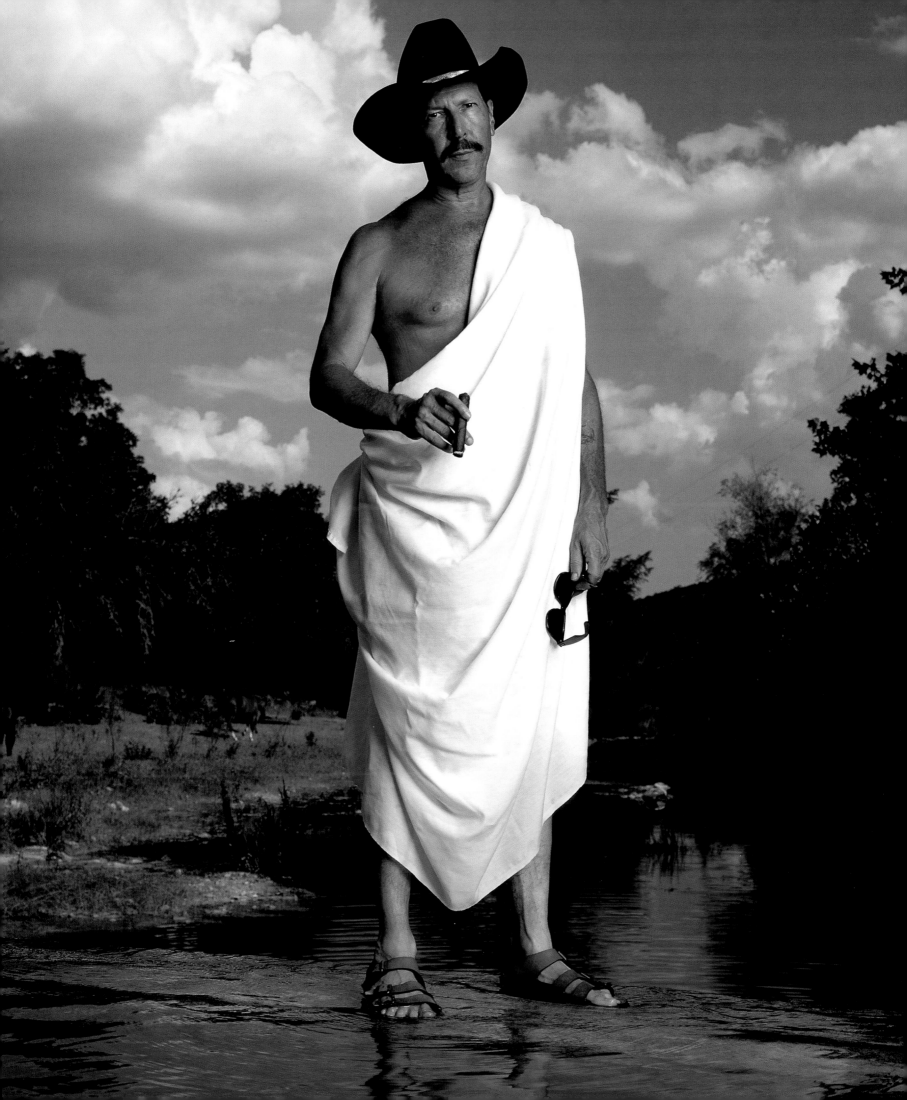

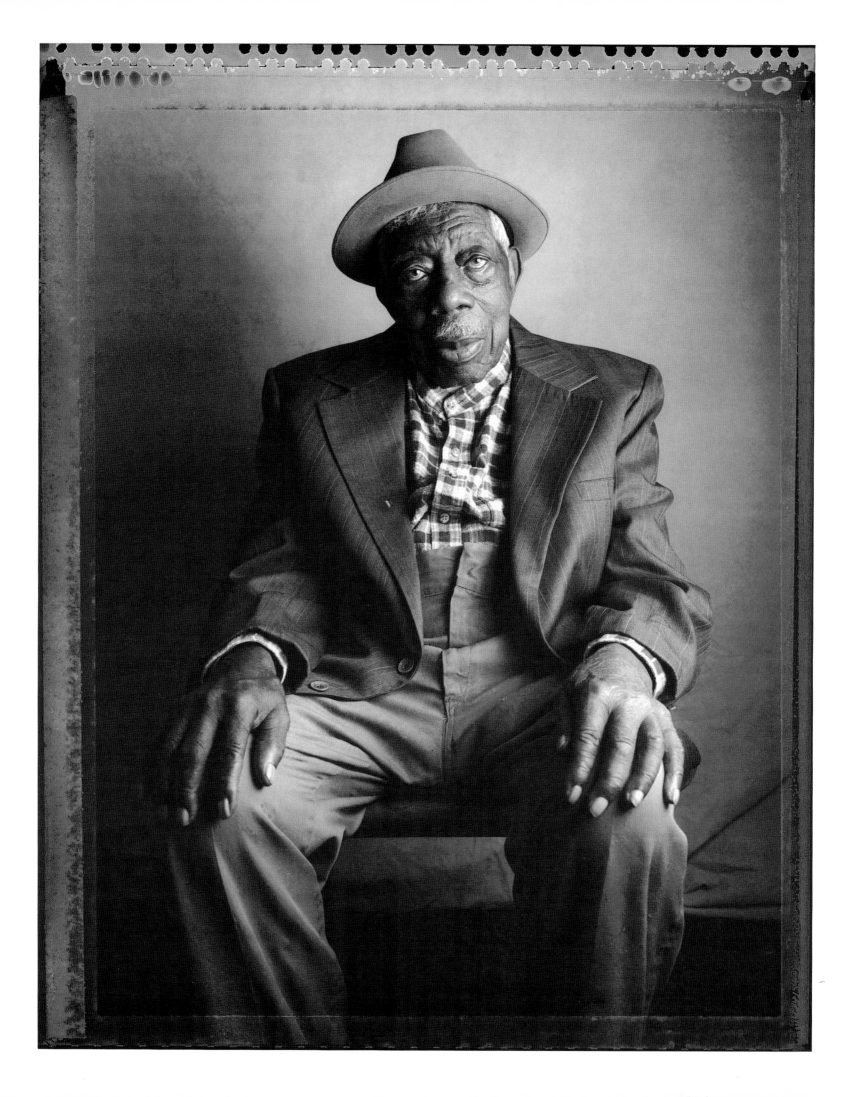

George Dawson

To the day he died, George Dawson (1898–2001) couldn't abide the taste of peppermint. He associated it with a tragic day a long time ago. When he was just a boy, Dawson accompanied his father into town—Marshall, Texas—to sell ribbon syrup and pay off some debts. His father bought him a peppermint for his day's work mashing sugar cane. While they were in the general store, they heard a commotion outside and watched in horror from the doorway as a gang of white men surrounded a teenage black boy—a friend of Dawson's family—and hung him from a tree. The youth had been accused of raping a white girl.

"After we got home, I found the peppermint was still in my pocket," Dawson said in his book *Life Is So Good*. "I scraped off the lint and the dirt. I gave it to one of my little sisters. My taste for it had disappeared. Ninety years later, I still don't like peppermint."

Six months later, when the girl gave birth to a white baby, no one said a thing.

Yet Dawson, who learned to read and write at the age of ninety-eight, managed to maintain a happy outlook; and at 102, he became an author. *Life Is So Good*, written in collaboration with Richard Glaubman, an elementary schoolteacher from Port Townsend, Washington, is Dawson's life story, and it embodies the philosophy his father taught him—that life is a gift and each moment is precious.

"Life is so good," Dawson's father told him as a young boy. "I do believe it's getting better."

George Dawson, the grandson of slaves, grew up poor on a small farm in Marshall, the oldest of five children. He started working full-time for his father when he was just four, hauling water from the well, working the cotton fields, hand-combing the cotton, and feeding the family's few chickens and lone mule. They lived in a three-room cabin with an outhouse and a small barn. School was not an option.

"We had almost nothing," said Dawson, who lived in Dallas until his death at 103. "But we had each other, and nobody told us we were poor. I never felt lonely. Ever since I remember, even on the cold mornings when the fire had burned down, I would wake up under a blanket, always with some brothers and sisters next to me. We were warm and cozy."

Dawson went on to experience monumental world changes—wars, political upheaval, a succession of presidents, and the advent of automobiles, television, airplanes, spaceships, and computers. He worked for over seven decades, laboring on farms, driving spikes for railroads, breaking horses, building levees on the Mississippi River, and working at a sawmill. At the age of ninety-eight, he decided to learn to read and write, and enrolled in a literacy program at the Lincoln Instructional Center in Dallas, where he excelled. But he was already a very wise man.

"Yeah, I've seen it all in these hundred years, the good and the bad," said Dawson, who fathered seven children. "My memory works fine. I can tell you everything you want to know."

Larry McMurtry

Larry McMurtry died on the operating table in 1991. After having a heart attack, he underwent quadruple bypass surgery, and doctors brought his body back to life. But McMurtry, who fell into a debilitating depression a few months later, believes his personality suffered a permanent rupture; and though he began functioning—and writing—again, he has never been quite the same. In the mid-'90s, after living in big cities most of his life, he returned to his hometown of Archer City, Texas, population 1,800, and focused on his first love: book collecting.

McMurtry is the author of more than twenty novels, including *The Last Picture Show*, *Terms of Endearment*, and the Pulitzer Prize-winning *Lonesome Dove*. He is one of America's best-known writers of Western fiction, yet he has never liked horses. But he's a rancher nonetheless—of books. He has transformed Archer City into the home of the largest collection of used and antique books in the country. His enormous bookstore, Booked Up, is housed in four buildings—one of them the former Ford dealership—scattered around Archer City's town square. It is the largest business in the once nearly bookless town—inspiration for *The Last Picture Show*—that sits at the intersection of Highways 25 and 79 in the rolling plains of North Texas.

"I think of my bookshop as a book ranch—a large one," said McMurtry, who was born in Wichita Falls and grew up in nearby Archer City with his grandparents, ranchers and first-generation pioneers. "Instead of herding cattle, I herd books."

Booked Up has a small staff, mostly concentrated in the main building; the other three buildings are often left unstaffed and open to customers, who are expected to use the honor system and lug their prospective purchases to the cashier across the way. The store has no catalog, database, or master stock list. You can't use a search engine to find what you're seeking. Booked Up is set up for browsing, and book enthusiasts have to catch on to McMurtry's quixotic system: a store flyer notes that the books are arranged "Erratically/Impressionistically/Whimsically/Open to Interpretation." Works of fiction are located in two buildings, split by the year 1925; history books are spread across three stores; and art catalogs are housed separately from art and photography books.

McMurtry, who opened the original Booked Up in Washington, D.C., in 1971—and who owns another store in Tucson, Arizona—prefers customers to make the trek to Archer City themselves. His dream is to create another Hay-on-Wye, the small Welsh village that has become a mecca for book lovers around the globe. And with the death of urban bookstores in America—due to astronomical real estate prices and redevelopment—his future as a bookseller seems bright.

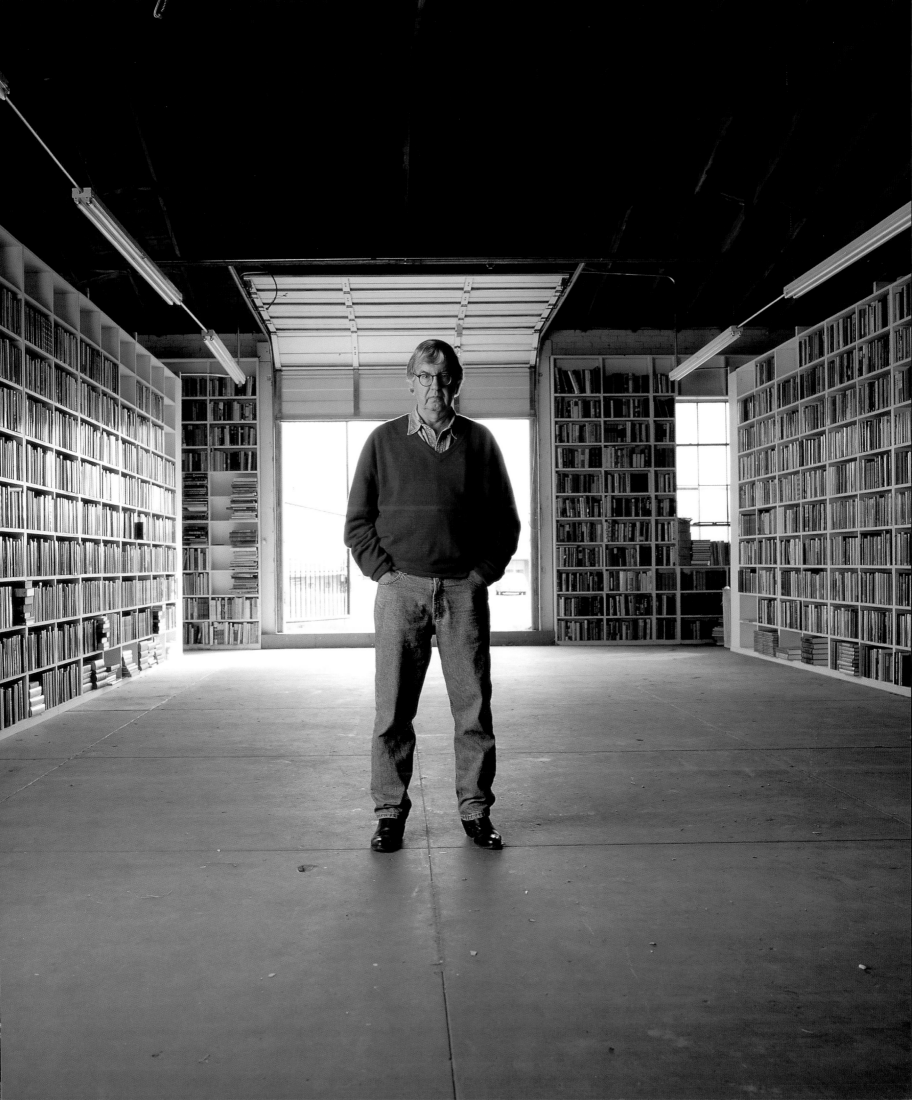

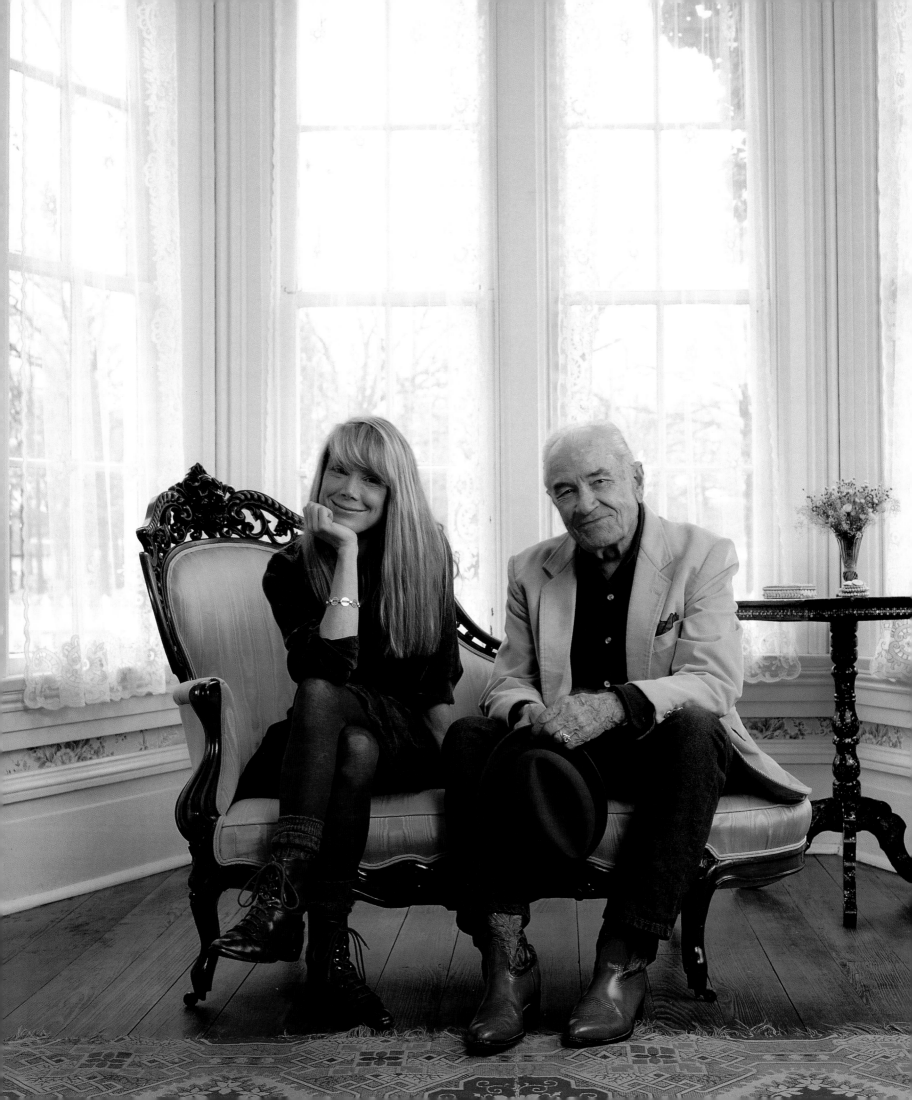

Sissy *and* Ed Spacek

When Sissy Spacek read the script for *Carrie* (1976), she understood the part: she vividly remembered a poor girl at her school in Quitman, Texas, who lived in a shack and was ostracized by the popular kids. For the audition, Spacek—whose proper name is Mary Elizabeth—donned an old blue sailor dress her mother had forced her to wear to a seventh-grade party, and she matted her long strawberry-blond hair with Vaseline. She spoke to no one and disappeared inside herself, focusing solely on the character of the high school outcast who possesses psychokinetic powers. Director Brian De Palma, who wanted another actress for the part, had an instant change of heart.

Spacek doesn't live in Texas anymore, but she will always claim it as her home, and she makes a point to visit her hometown of 2,030, midway between Dallas and the Louisiana border, whenever she can. Her father, Ed, a widower since 1981, lived there until his death in 2001, but there are other relatives; and she has kinfolk in Central Texas, too.

"My husband laughs and says whenever I get anywhere near Texas, my accent thickens, and I begin to feel very safe," she said.

In 1980, Spacek won an Academy Award for her portrayal of Loretta Lynn in the film *Coal Miner's Daughter*. She has been an Oscar nominee for her work in several other films, including *Carrie,* and most recently, *In the Bedroom* (2001), in which she gives a wrenching performance as a tightly wound wife and mother struck by tragedy.

Spacek has made a career of playing ordinary people thrust into extraordinary circumstances. She grew up happy and normal, the daughter of the county agricultural agent, cruising the Dairy Queen, participating in 4-H, vying for Dogwood Queen (she came in second), taking guitar lessons, and being voted homecoming queen. She left home at seventeen—after her older brother, Robbie, died of leukemia—and tried her luck in New York, where her cousin, actor Rip Torn, lived with his wife, actress Geraldine Page. Spacek was seduced by the lives they led, and although her original goal was to be a singer, she wound up pursuing acting and landed parts, first in *Prime Cut,* then *Badlands,* and *Carrie.* Her other big films have included *Raggedy Man, The River, Marie, Crimes of the Heart,* and *'Night Mother.* She has done a string of television movies in recent years.

Spacek, who was recently inducted into the Texas Hall of Fame—the honors having been conferred by cousin Rip Torn—is a recluse by Hollywood standards. Married to the film director Jack Fisk, she lives with him and their two daughters, Schuyler and Madison, on a 210-acre horse ranch in Albemarle County, Virginia, preferring a rural oasis where she's known mainly as "Schuyler and Madison's mom."

Harry *and* Jay Knowles

A U S T I N , 1 9 9 7

When Harry Knowles earned a trip to the regional spelling bee in Stephenville, Texas, and the competitors had been whittled down to just Harry and another high school freshman, Harry misspelled the word "harmonica," blowing his chances for state.

"I don't know what happened to my brain," said Knowles, who later missed only one question on the ACT college entrance exam. "The word was too easy. But it's my fondest mistake, a moment that reveals a simple flaw that can be endearing."

Knowles, a college dropout who created aint-it-cool-news.com in 1996 at the age of twenty-four, after an accident confined him to bed for six months, feels the same way about his famous film-fan website. AICN is full of misspellings, grammatical errors, Knowles's refreshing politically incorrect opinions, and tall tales about secret advance screenings and Hollywood film junkets. "I type faster than I think," said Knowles, whose book *Ain't It Cool* was published by Warner Books in 2002. "It's all breathless enthusiasm, train of consciousness. After I see a film, I can't wait to get it out of me. I believe perfection intimidates, and faults endear you to people."

After seeing the long-awaited *Spiderman,* Knowles wrote a record 3,400-word review; and his AICN website—with a server that can accommodate three million hits—was so deluged that it shut down. "I generate more text than any reporter in history," said Knowles, one of the most powerful figures in Hollywood. "Other writers don't have the stamina—or typing skills!"

To this day, Knowles remembers his Seymour High School typing teacher, Ms. Conners, "a big, bouffant-beehive, blond, typing witch" who came up behind him one day and snipped off his "rat tail" that he kept tucked discreetly under his collar. But he learned to type. He even went so far as to join the typing club—and every other club from drama to Spanish—to stay away from home. After his parents divorced, he and his little sister moved with their alcoholic mother to a ranch in northwest Texas, and their home life was beyond gruesome. When he finished high school, he fled to Austin.

"I'm very old-fashioned," said Knowles, who still shares the cluttered, 900-square-foot house in north Austin with his father, Jay, his personal assistant. "I don't think it's necessary to leave your family to become your own person. Fame is an empty cup."

At any given time in his office, Knowles—whose writing stretches can last as long as fourteen hours—might be simultaneously screening a film, doing an interview on speakerphone, and typing a review.

"I'm a multi-hyphenate," he said. "I'm very much about AICN."

Since he grabs only three to four hours of sleep some days, he crashes for occasional eighteen-hour blackouts. When the laundry builds up, Jay heads to the laundromat and conducts "laundry orgies," marshalling nine washers and three commercial-sized dryers. Father and son organize their whole existence around the movies.

"I call myself a film advocate," said Knowles, who grew up helping his hippie parents in the film-memorabilia trade. "'Film critic' is a term of bitterness. To a film critic, movies are guilty until proven innocent. I think a film's great until proven otherwise. I haven't walked out of a movie in nine years."

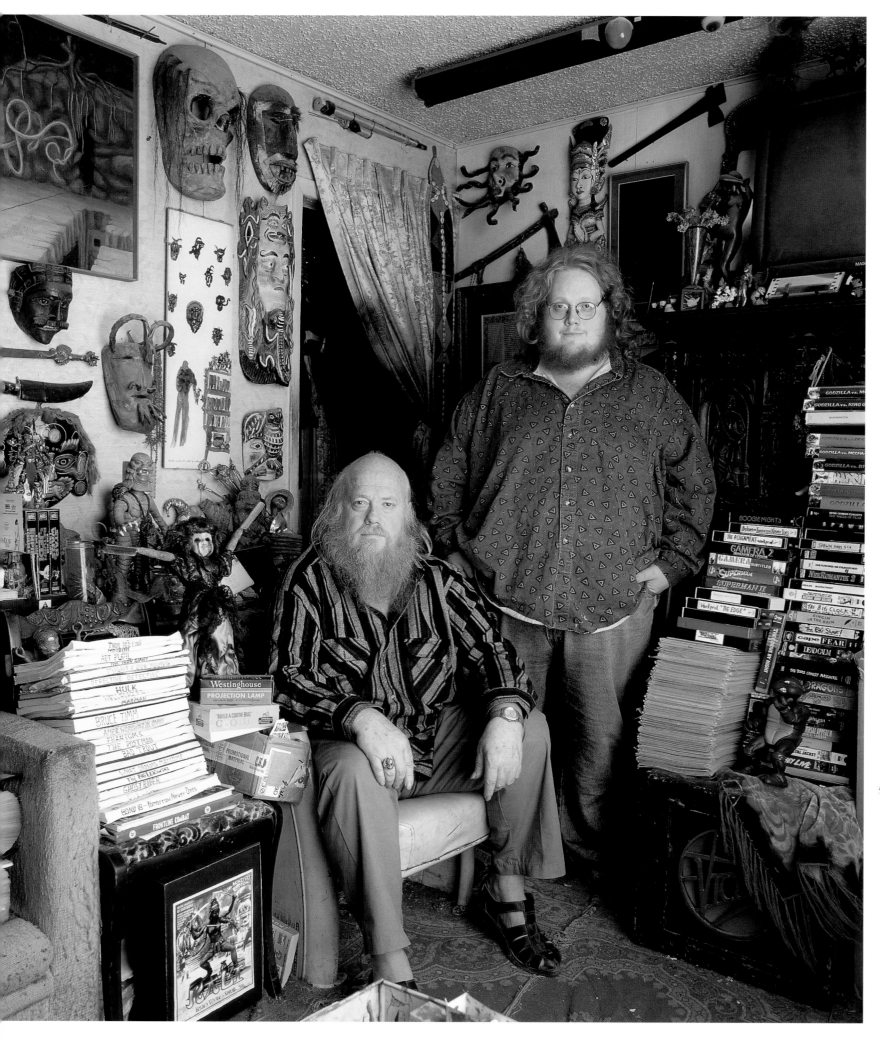

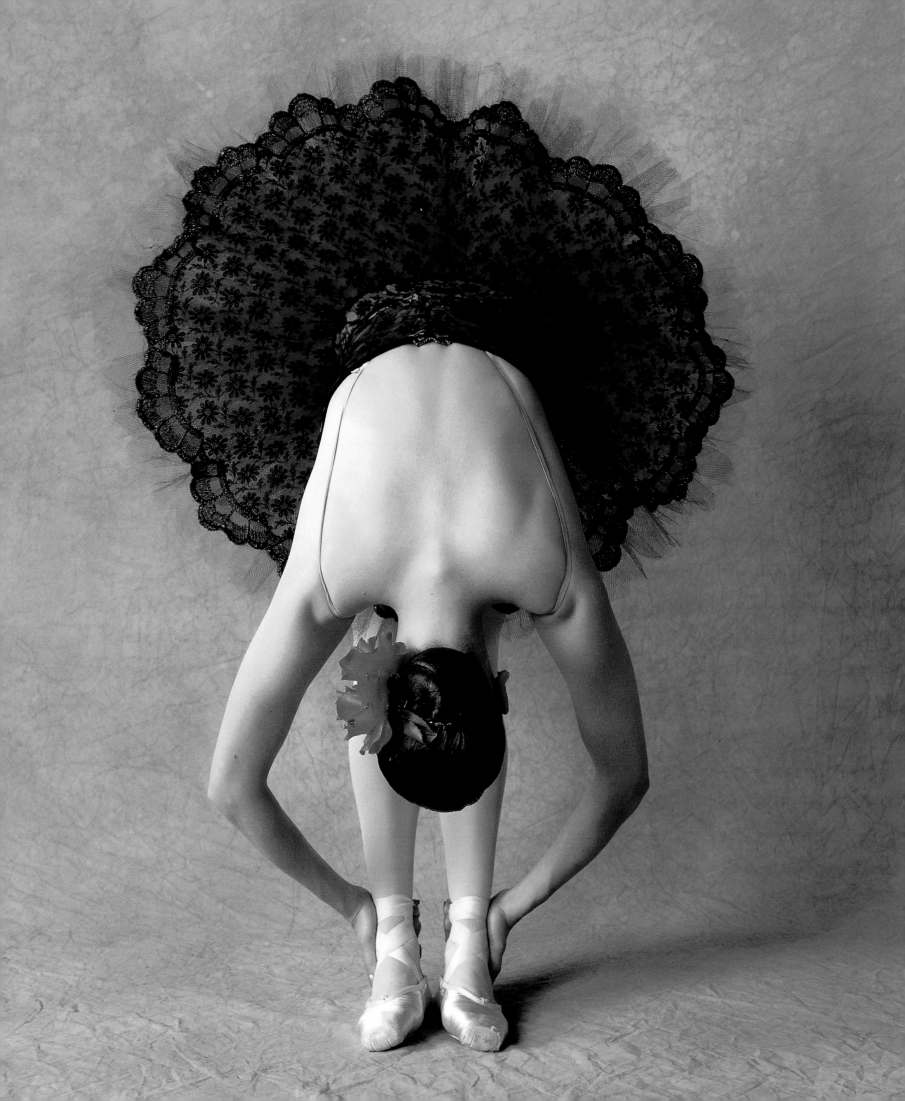

Susan Stowe

AUSTIN, 1989

Susan Stowe, a dancer with Ballet Austin, posed for a photograph for a *National Geographic* cover story on Austin, Texas, that ran in June 1990. Stowe, a dancer for Ballet Austin for just one year—the '88–'89 season—wore a costume from the ballet *Don Quixote*. Then twenty-eight, she said her experience with the company was intense and memorable.

"We worked incredibly hard," said Stowe, chairman of the dance department at Point Park College, a conservatory of performing arts in Pittsburgh, Pennsylvania. "We were a small company, and almost every dancer was in every piece. We did a lot of performances and a lot of community outreach. We took classes in the morning and then had up to six hours of rehearsal, Monday through Saturday. It was physically exhausting, but it was emotionally and artistically fulfilling."

Stowe, who grew up in Milwaukee, says the only reason she left Ballet Austin was because the directors of the company, Eugene Slavin and Alexandra Nadal, left; and though the dancers were told they could stay while the company searched for a new director, Stowe auditioned in Pittsburgh, where her long-distance fiancé—now her husband, David Nash—lived. She won a spot with the Pittsburgh Ballet Theatre and danced there for six years. In 1995, she retired from dancing to teach at Point Park College. Four years later, she was named artistic director of the college's summer dance program, a position she still holds; and in the summer of 2002, she was also named department chair.

"I love Texas, I love the people of Texas, I loved the company, and I loved my fellow dancers," she said. "I would have stayed ten years had the directors not left. But being a dancer, your opportunities are limited by your physical being. You have a window of opportunity in which to dance and you have to do as much as you can in those few years. You can't do it forever. I had to make my choice."

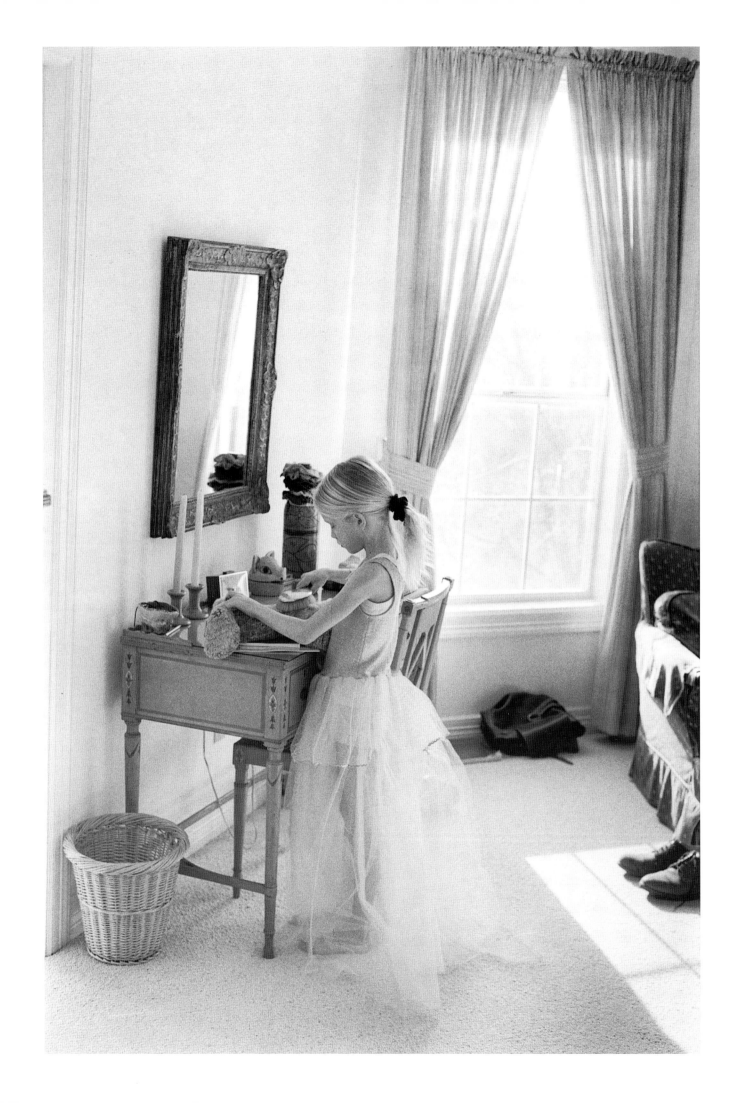

Owen O'Brien

AUSTIN, 1996

Owen O'Brien was eight years old when this photograph was taken in 1996 at the vanity in her mother's bedroom, a favorite spot for make-believe. Brushes, combs, make-up, perfume, jewelry, and other trinkets and accessories absorbed Owen's attentions for hours of an afternoon. The vanity came from Owen's great-grandmother, Mary Cordes, who kept the piece—and its matching dressers and single bed—at her summer cabin on Lake Pulaski in Minnesota.

In 2002, Owen talked about the photograph:

"When I was eight was when I first started asking myself, 'How did I get here?' and 'What is my purpose in life?'

"I was so simple and innocent, and as I grow older I don't want to lose that. I have gone through a lot of phases: first I wanted to be an artist because I saw a sunset and wanted to recreate it; then I wanted to be a potter because I loved squishy clay; then a monkey trainer because I love animals; then a clothes designer because I love to make my own outfits and costumes. Now I see the future's coming up so fast and I realize how tough the real world is and that it would be hard to survive with those careers . . . so now I'm thinking about becoming a writer—to reach out and connect with people.

"In most ways I've stayed the same, though I *have* matured. Since 9-11, I've become aware of how fragile and afflicted the world is. But I'm still just a kid."

Owen is a student at Westlake High School in Austin, Texas, where she plays on the tennis team. When she's not with her friends, she spends her time reading, babysitting, and exploring the greenbelt in her neighborhood with her dogs, Jordan, a chocolate Laborador retriever, and Buffett, a bichon frise.

Morgan Fambro, *Prairie Flower*

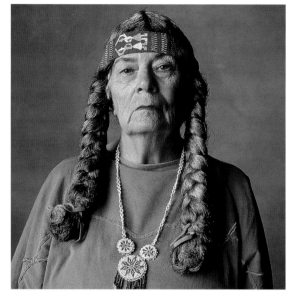

Sam Gillespie, *Old Indian Woman*

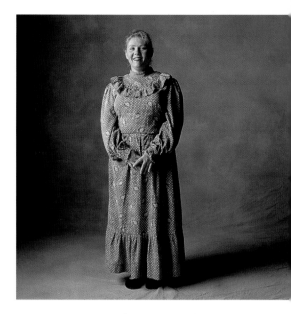

Letha Key, *Young Settler*

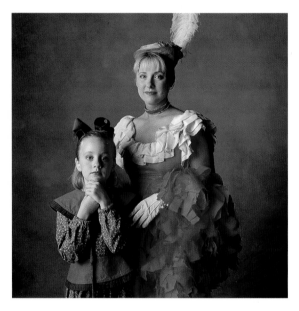

Abby and Sara Head, *Townspeople*

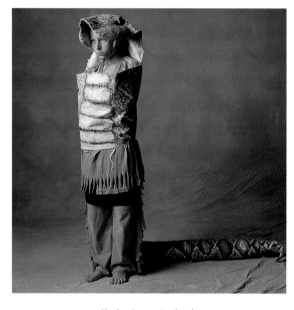

Keelan Lowe, *Rattlesnake*

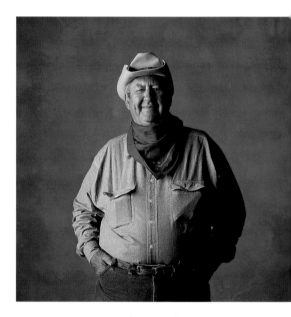

Harold Law, *Cowboy Singer*

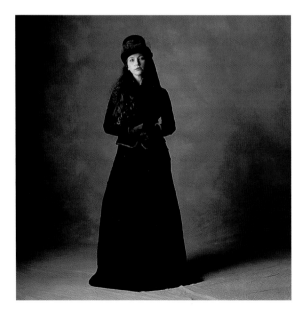

Jana Caldwell, *Sidesaddle Rider and the Widow Larn*

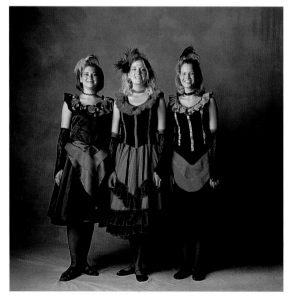

Josi Hudson, Sage Parsons and Belynda Smith, *Saloon Girls*

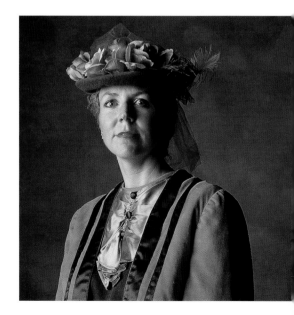

Tamberley Thomas, *Lottie Deno*

The *Fandangle*

Robert Echols has been performing in the *Fort Griffin Fandangle*, Texas's oldest outdoor musical, off and on since he was a babe in arms.

"I was in the first production in 1938," said Echols, president of the Albany Chamber of Commerce, and a performer in twenty-seven *Fandangle* productions. "That's the year I was born. My mother carried me across the stage in my striped knickers. Through the years, I've been a featured singer, Hurricane Bill, Sam Hall, the town drunk, and a cowboy. I've never had a desire to be a cowboy, but six nights a year, I can be one."

Fandangle, held in Albany, Texas, for more than six decades and staged outdoors in a "prairie amphitheater," recounts in period splendor the settling of the West Texas frontier. Some 400 actors—proud citizens of the small town, from infants to great-grandparents—recreate the era when buffalo hunters, cowboys, Fort Griffin soldiers, and prairie settlers displaced the Indians of the Clear Fork of the Brazos River, and newcomers staked their claims on the untamed land. Covered wagons and buggies, cowboys on horseback, a replica of the first Texas Central Railroad train, gushing oil derricks, and a thundering herd of real Texas Longhorns take to the grassy stage. Between acts, tractors or horses transfer life-size sets of frontier towns and Indian encampments.

The audience sits up especially straight in the middle of the play when the herd of Longhorns rushes to the fore, not ten feet from the front row. Each steer weighs some 2,000 pounds and sports an intimidating rack of horns spanning six feet. Although cowboys on horseback surround the imposing animals, the Longhorns facing the audience could bolt at any time. There are goose bumps all around until the final stanza of the Longhorn song, "Cowboy's Prayer," begins, and the veteran steer—the old Longhorn that has acted in the play the longest—recognizes his cue, occasionally a tad early, then turns and head's back up the hill.

The *Fort Griffin Fandangle*—so named for Fort Griffin, an 1850s-era government outpost that preceded the nearby town of Albany—was created by Albany native, playwright Robert Nail. In the 1930s, Nail, a Princeton graduate, returned to Albany after producing a number of off-Broadway plays in New York and helped stage the senior class play *Dr. Shackelford's Paradise*. The production was such a hit that the town prevailed upon him to do it again. But Nail was interested only if he could take the production outdoors and add the authenticity of cowboys, Indians, horses, and covered wagons. The townspeople agreed and everyone joined in: the men cut trees and built a huge stage screen made of cedar posts and chicken wire covered in mesquite; the women set up their sewing machines in the schoolhouse and stitched period costumes; volunteers with artistic flair constructed the props; and the stage was set up on the high school football field. Nail, who wanted to come up with an original title for the production, coined *Fandangle* from the word *fandango*, meaning "Mexican dance." *Fandangle*, in his mind, encompassed a great deal more.

It is a unique spectacle: past and present merge as the descendants of the original settlers, along with the descendants of the original horses and Longhorns, act out their historic tale on pastureland once traversed by Butterfield's Overland Mail Company.

"As it says in the script," said Echols, '*Fandangle* is not history as it comes from the pages of books, but history as it comes from the heads of oldtimers.'"

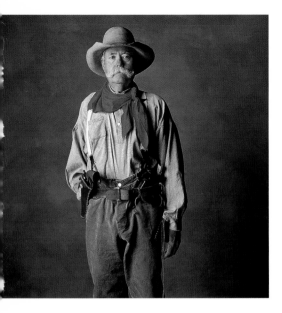

Lester Galbreath, *Soldier*

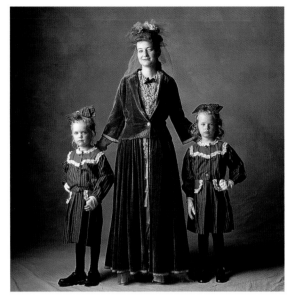

Peyton, Laurie and Cheyenne McCullar, *Godey's Ladies*

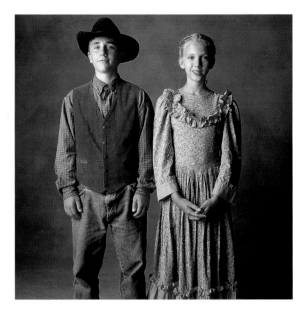

David Waller and Emily Hahn, *Young Settlers*

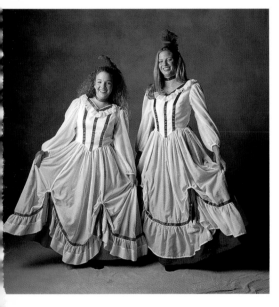

Misty Wolf and Melissa Bartee, *Officers' Ball Waltzers*

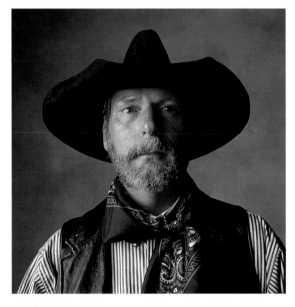

Mike Parsons, *Rattlesnake Charmer*

Hunter Owen, *Prairie Dog*

Kolby Lowe, *Owl*

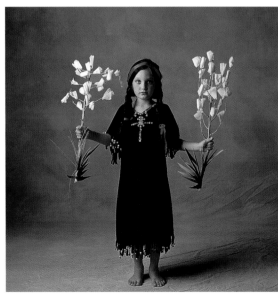

Autumn Owen, *Yucca*

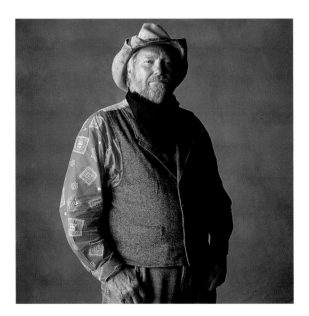

Robert Echols, *Hurricane Bill*

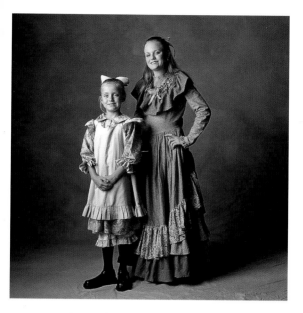

Lexa and Lauren Willen, *Young Settlers*

Grant Head, *Little Cowboy*

Pati and Madison Jones, *Settlers, mother and daughter*

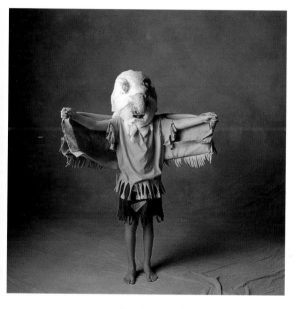

Hailey Owen, *Eagle*

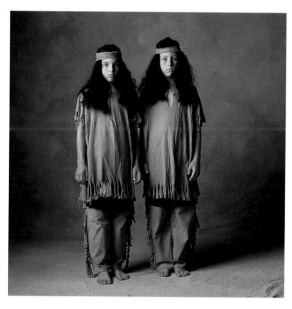

Kolby and Keelan Lowe, *Indian boys*

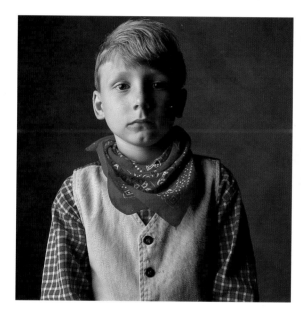

J. T. Thomas, *Young Cowboy*

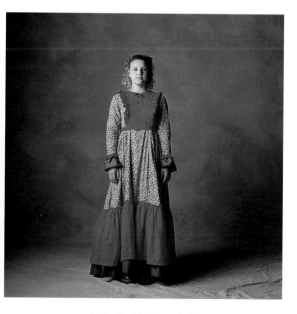

Kayla Braddy, *Young Settler*

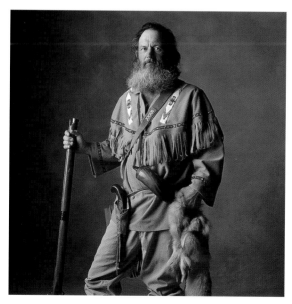

Paul Hensley, *Jesse Stem*

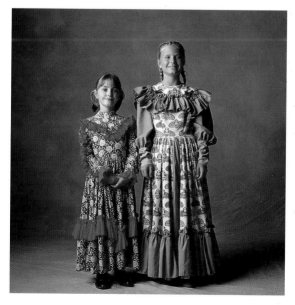

Virginia Waller and Katie Waller, *Young Settlers*

Ran Horn

VAN HORN, 1998

Ran Horn of Van Horn hasn't lopped off his ear, but otherwise the artist is living up to his image as the "Van Gogh of Van Horn." Randell Horn owns Van Gogh in Van Horn, an art gallery and used bookstore where he sells his own Van Gogh imitations and offers art lessons—for a mere $5.

"I want to redo all of Vincent's paintings and maybe come up with an original idea," said Horn, who paints all day, eschewing both telephone and computer, "then, if there is a beyond, have a good laugh with Mr. Van Gogh."

Horn—a former Baptist preacher, prison guard, and mail carrier—was born in "flat, dry, dusty Odessa," where his father worked in the rich Permian Basin oil fields while his mother raised him and his seven sisters. He left Texas and worked as a preacher in frigid Duluth, Minnesota, for several years before moving back. He chose Van Horn, where he could be "Ran Horn of Van Horn" and support his family as an artist—more or less.

"I will mow lawns and sweep parking lots to make sure bills are paid," he said. "I'm trying to be like Vincent, Leo Tolstoy, and Jesus, who identified with the poor. Ephesians 4:28 sums it up quite nicely: '[We] must work doing something useful with our own hands, that we may have something to share with those in need.'"

Horn is pictured just off Main Street in Van Horn with his Chihuahua, Lilly, named after Lillian Gish, the silent film star.

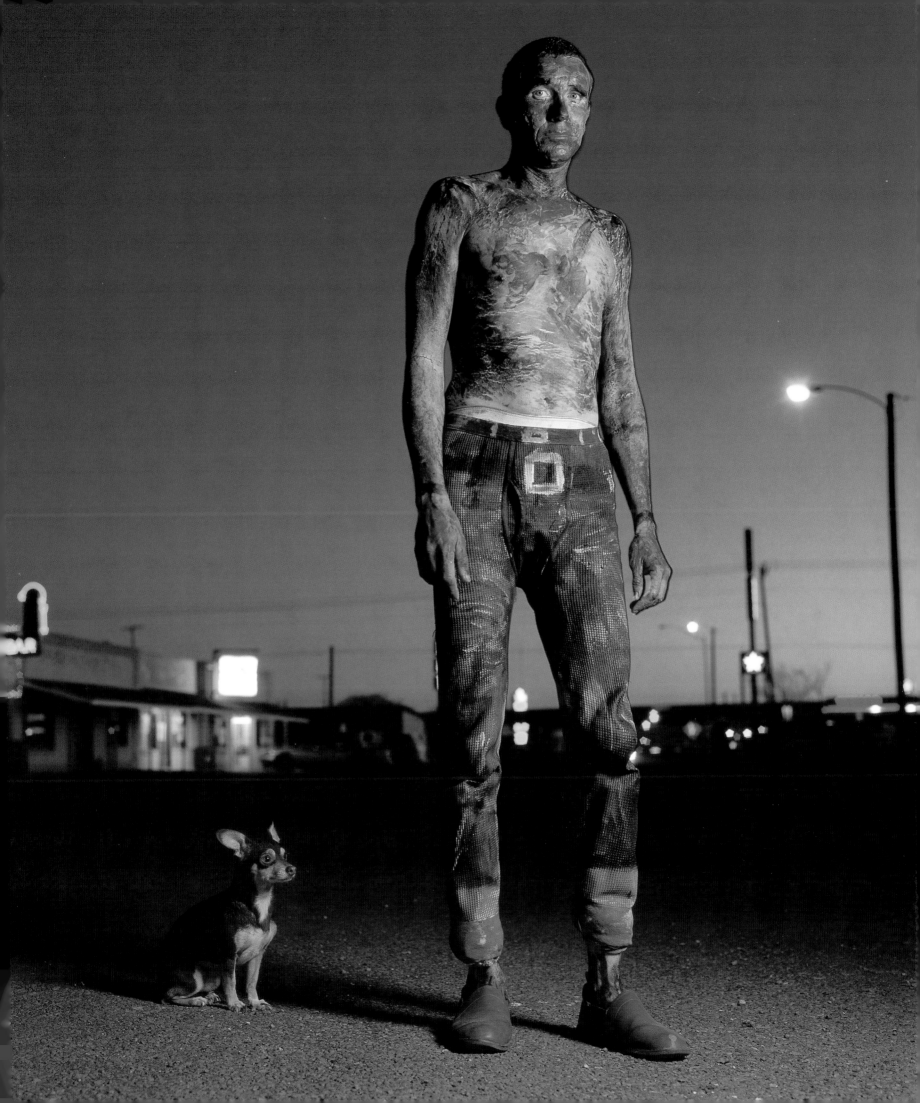

Jesse Trevino

S A N A N T O N I O , 1 9 9 2

Jesse Trevino came home from Vietnam a changed man. After only three months in the war-torn jungles, he was injured in a booby trap explosion when his platoon was caught in an ambush in the Mekong Delta. His right hand—his painting hand—was so badly wounded that he was sent home to the States. Trevino spent a grueling two years at Brooke Army Medical Center at Fort Sam Houston, where doctors amputated the hand and fitted his arm with a steel hook.

The artist, a native of Mexico who grew up in San Antonio, was a promising young talent from the city's poor West Side barrio. He left high school with a scholarship to the Art Student's League in New York, where he studied under the respected portraitist William Draper. But in late 1966, his apprenticeship was interrupted by the draft.

When he returned to San Antonio, Trevino had to recreate himself. He began taking art classes at San Antonio College, training himself to use his left hand. He concentrated on painting the life around him—his family, neighbors, and their surroundings, capturing the vitality of everyday life with uncanny, near-photographic clarity. He developed an international reputation as a fine artist; and his work is displayed in the permanent collection of the Smithsonian Institution's Museum of American Art.

Trevino had long held the dream of giving something back to the people of San Antonio. He realized that dream in the late '90s with the creation of a nine-story, $1.5 million tile mural—*The Spirit of Healing*—on the wall of the Santa Rosa Children's Hospital. The ninety-three-feet-high-by-forty-three-feet-wide engineering and artistic marvel took three years and 150,000 pieces of tile to complete. The tile mural process, which Trevino calls "painting with tile," is a unique method in which an image is first drawn on tile and then painstakingly hand-cut with a glass cutter.

The Spirit of Healing is the largest public art piece of its kind in North America. It depicts a stone angel hovering protectively over a small boy, based on Trevino's own son, Jesse Alexander, holding a brilliant dove in his hand. The angel, true to Trevino's theme of hope in the face of adversity—and reminiscent of the artist himself—has a broken wing.

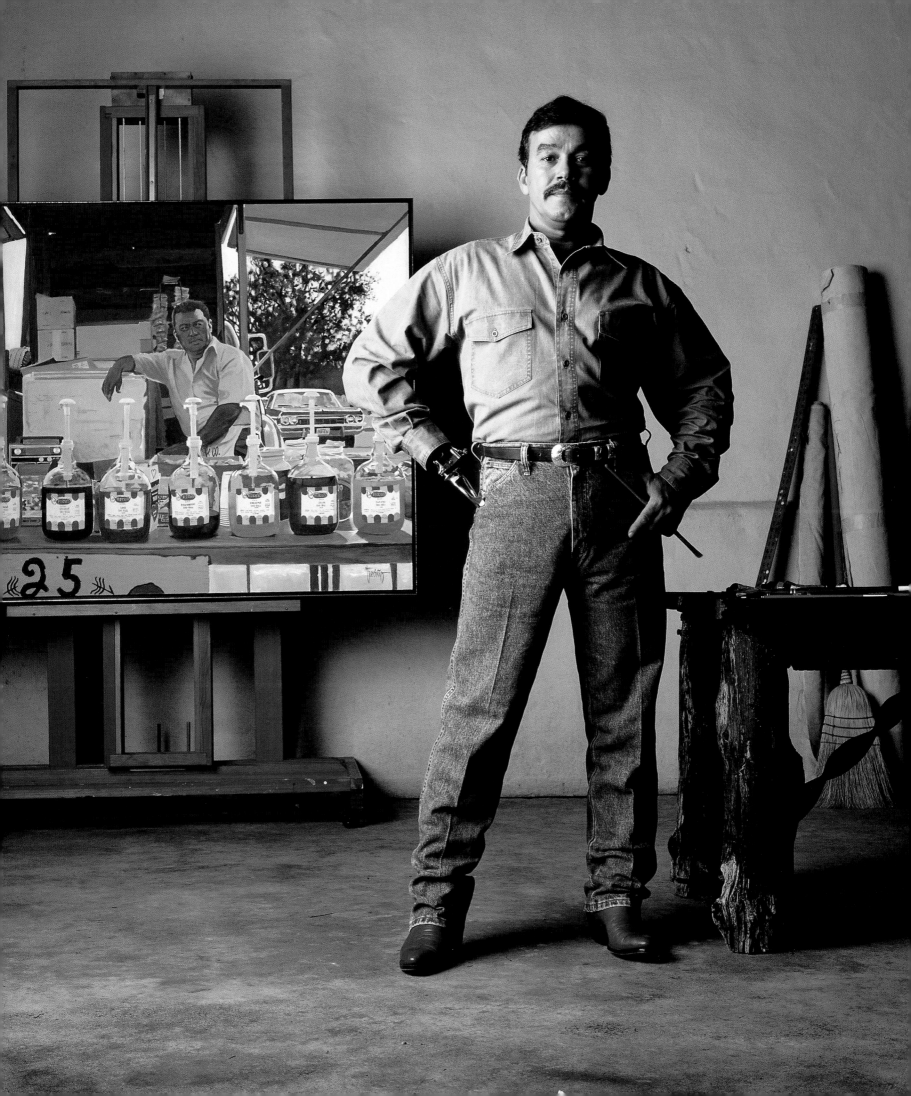

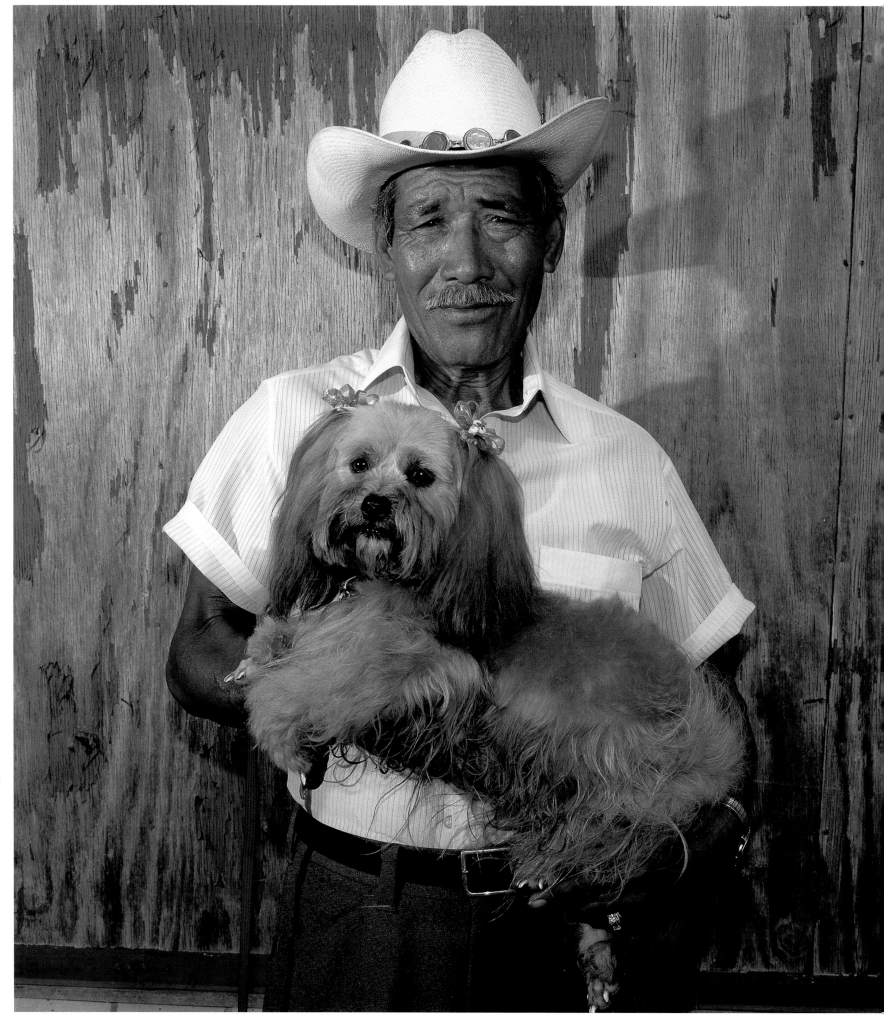

Juan Vasquez *and* Leticia

MANOR, 1989

Juan Vasquez (1926–1992) showed off Lone Star Leticia, a Lhasa Apso dyed the colors of the Texas flag, at a street fair in Manor, Texas, in 1989. Vasquez, a native of McAllen, was a mason who worked on most of the buildings in downtown Austin, and some in Dallas and San Antonio. When he was young, he worked on the Alaskan railroads. He kept chickens and sheep in his yard in Manor; and in his garden he grew squash, corn, hot peppers, okra, tomatoes, and watermelons.

"He would harvest them and share them with whoever came to visit," said his daughter Ernestine, one of twelve children. "He'd give them a bagful. He taught us to share like he did. My dad was a very hard worker. He made sure we had food on the table and a roof over our heads. He was strict with us and made sure we always did the right thing."

Leticia—named after Ernestine's daughter Nadia, who was nicknamed 'Ticia—belonged to Juan Vasquez's daughter-in-law Diana Gerling, who bought the dog as a puppy from the local flea market on Highway 290 in Manor. Gerling, owner of Details Mobile Pet Stylist, borrowed hair dye from her hairdresser and styled "'Ticia" for the photo.

"I was promoting my home grooming business," said Gerling, who married Vasquez's second son, Juan Vasquez, Jr., after meeting him in a Manor bar, where she played pool with both father and son.

James "Wimpy" Mason

W A X A H A C H I E , 1 9 8 8

The late James "Wimpy" Mason rode his white horse in Waxahachie's town parades.

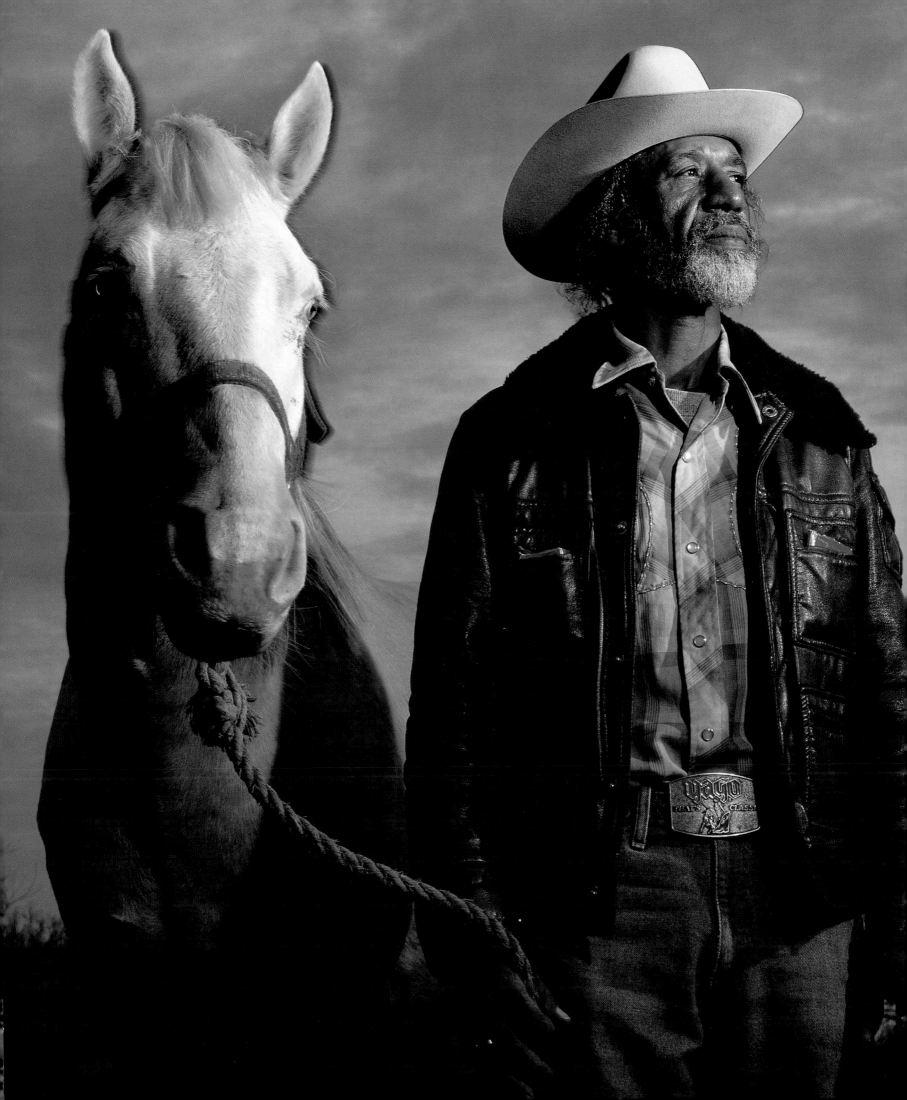

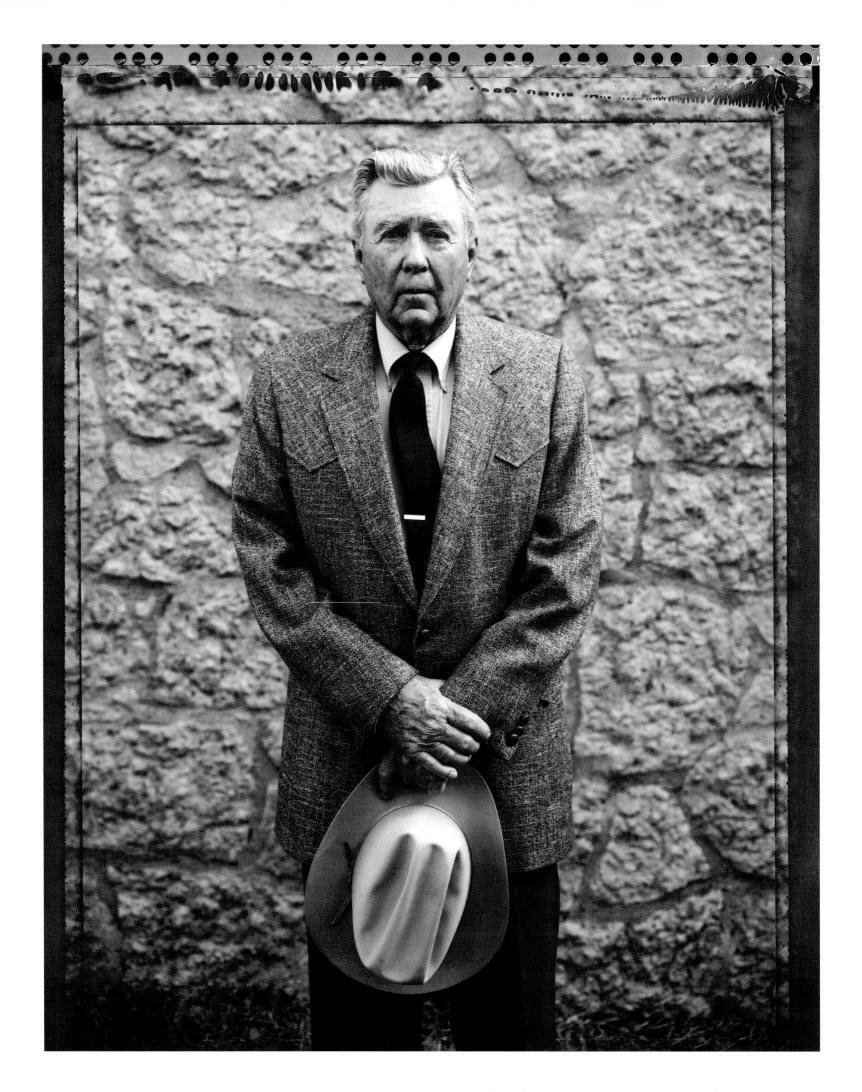

John A. Matthews

A L B A N Y, 2 0 0 2

John A. Matthews has ranching deep in his bones, and even when he's not working, his favorite pastime is not going into town for amusement, but loading his .22 and calling his dogs for a walk around the pastures.

"My grandparents came out here in the 1850s," he said. "This place—West Texas—sort of vaccinates you. It's a way of life; it gets into your blood."

Matthews was born in Dallas in 1919, but raised on a ranch outside Albany—the same ranch, YL, to which he returned in 1988 after the death of his mother. In the preceding years, he bought, managed, and sold other ranches in Texas, Montana, Colorado, and Australia.

"Working with animals, being in the country, watching things grow, improving your herd . . . I love ranching for the satisfaction of doing it," said Matthews, a former air force pilot who was assigned, for a time, to a photographic mapping squadron in Africa during World War II. "I have seen a lot of places, but I haven't seen another place where I'd want to move."

Matthews—a graduate of Cornell University in animal husbandry—grew up milking cows, mending fences, riding horses, rounding up, branding cattle, and "doctoring screw-worms." He spent his afternoons after school fooling around his ranch with his dogs, much as he does now.

"I'm still doing the same things," said Matthews, who also owns a ranch twenty-five miles away on the Clear Fork River. "We just don't have to doctor screwworms."

He explains that screwworms—carnivorous fly larvae from eggs laid in open wounds of cattle and other warm-blooded animals, including humans—were eradicated from the area forty-odd years ago when the government, in conjunction with the livestock industry, developed and released sterile male screwworm flies in a controlled agricultural program. Since the female screwworm fly mates only once, the flies were eventually wiped out, and ranchers were free of an overwhelming burden.

Most of Matthews's family is equally committed to the ranching life. His second wife, Sharon, "fools with horses," in his words—breeding and training purebred and half-Arabians. Matthews's three sons are ranchers like their father. Only his daughter broke the family mold: she's a contemporary artist in Austin, Texas, and Santa Fe, New Mexico.

Bob Holloway

DECATUR, 1998

Bob Holloway (1926–2000), the son of a Keller, Texas, dairy farmer, continued the tradition—the old-fashioned way—on his own 340-acre ranch eleven miles north of Decatur. For thirty-seven years he milked as many as 150 cows a day. He used machines for the milking, but he didn't go so far as to get a computer to keep track of things. And he brought in bulls for breeding—nature's way—instead of using the far more prevalent method of artificial insemination.

Holloway eventually sold the dairy operation so he could kick back. When he wasn't traveling around border country or out West, he read history (he held a history/government degree from Southwestern University), wrote poetry, traded cattle, and rode horses.

"I kinda hole up here like a cowboy in a dugout," said the six-foot-three Holloway, who also served as a Wise County judge in the mid-'80s.

Holloway, whose daughter Rosalinda describes him as a "larger-than-life character who gave my life character," penned a new message for his answering machine every couple of weeks; some favorite verses follow:

It's a spur for the hoss
And a whip for the fool
It's time to get mounted
So saddle yo' mule
The old sun ball's a pokin'
Up high in the sky
So leave me a message
Ki-yippy ki-yi!

I'm off across the prairie
Or down around the bend
I've gone to check the cattle
To see that they're all in
I've gone to check the ranch out
That's what it's all about
We hope we get some rain tonight
To make some grass come out.
Leave me a message!

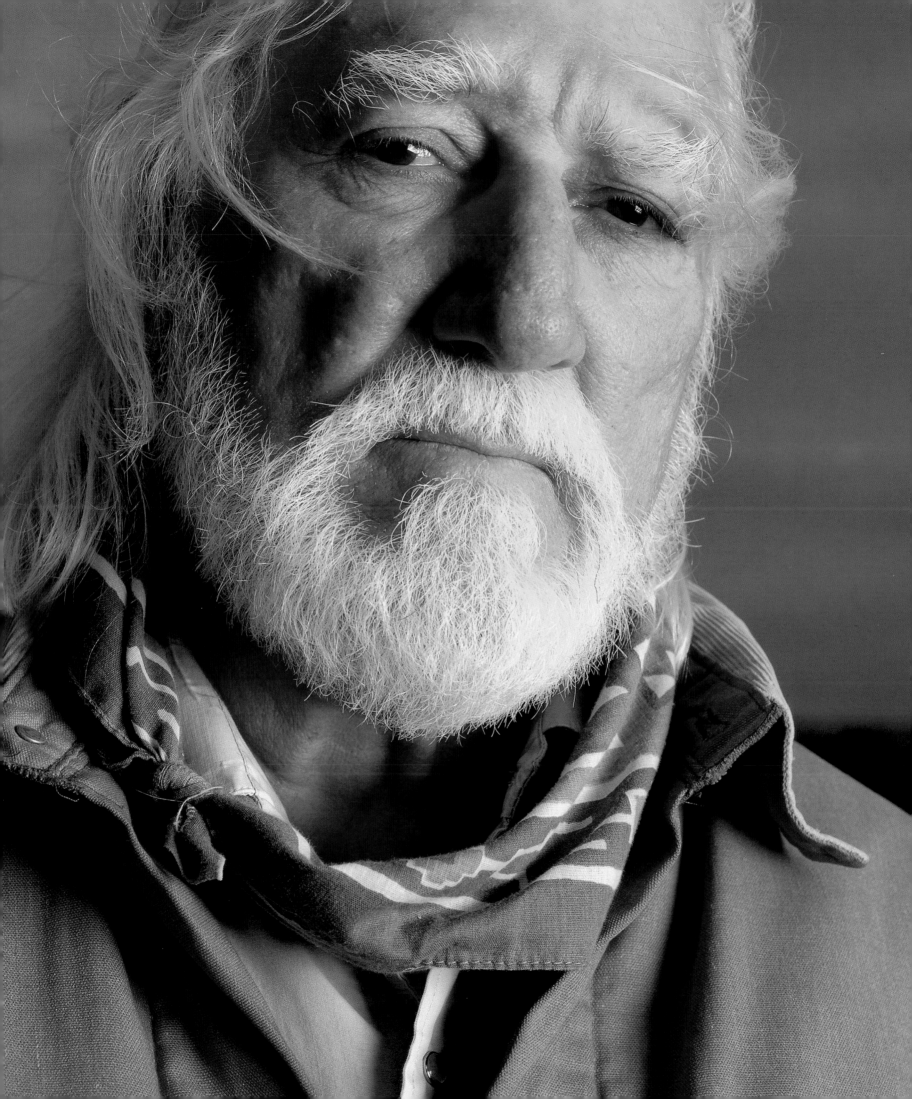

Bill Cauble

A L B A N Y , 2 0 0 2

Bill Cauble—cowboy, chef, artist—was born in Albany, Texas, in 1938. He grew up on the Cook Ranch, where his father worked for the oil company Roeser & Pendleton on Cook Field, one of the largest oil fields in Texas at the time.

The family raised their own milk cows, hogs, and chickens, and Cauble and his three younger brothers learned to take care of themselves at an early age. "With four boys, my mother taught me early how to cook," said Cauble, who is co-author (with fellow cowboy Clifford Teinert) of *Barbecue, Biscuits and Beans*, a cookbook featuring authentic chuck wagon cooking. "We washed dishes, made our beds, and cleaned our rooms every day before we left for school. But like all boys, we ran wild in the country."

Cauble attended Albany schools, then headed out to far West Texas and New Mexico, where he worked the oil fields. After the oil field stint, Cauble spent several years pursuing a career as an artist, producing some 1,700 large-canvas landscapes of oil wells and drilling rigs, many commissioned by large oil companies. He worked in oil-rich areas like Dallas, Midland, Odessa, and Breckenridge, Texas, as well as Tulsa and Oklahoma City, Oklahoma; and his paintings graced the walls of the oil companies' corporate offices. He also spent some time mastering the art of bronze sculpture.

"I work at something until I master it, then I pick something else," said Cauble. "I'm always looking for something to do."

Cauble met his wife while working in Tennessee as a partner in some drilling rigs. But when the bottom fell out of the oil business in the mid '80s, he returned home to Albany, where he hired on with Watt Matthews at Lambshead Ranch. He's been there ever since and has become a premier chuckwagon cook and preservationist of authentic chuck wagons, equipment, and methods. His catering company, Western Wagons, cooks for gatherings across Texas and at the National Cowboy and Western Heritage Museum in Oklahoma City.

"When people ask me where I'm from, I say 'West Texas,'" said Cauble, a fifth-generation Texan who serves as president of the *Fort Griffin Fandangle*, the state's longest-running outdoor musical. "It's my part of the country. It's a hard land, but it's home."

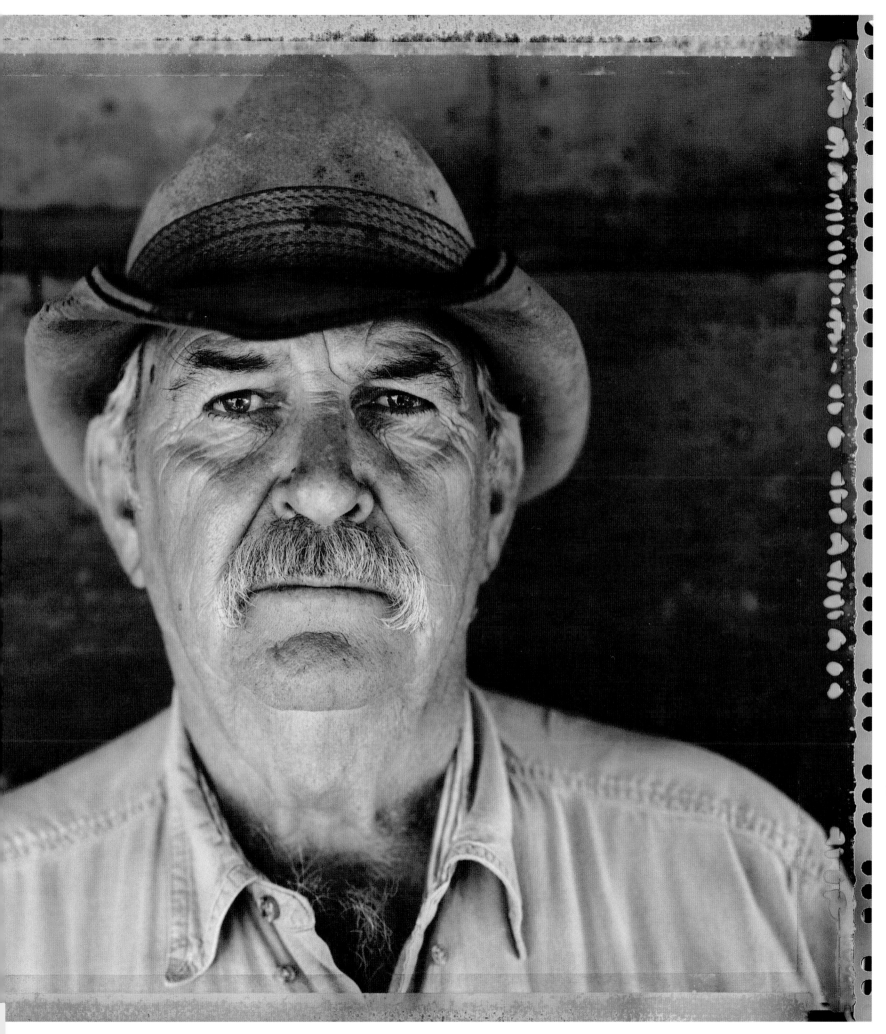

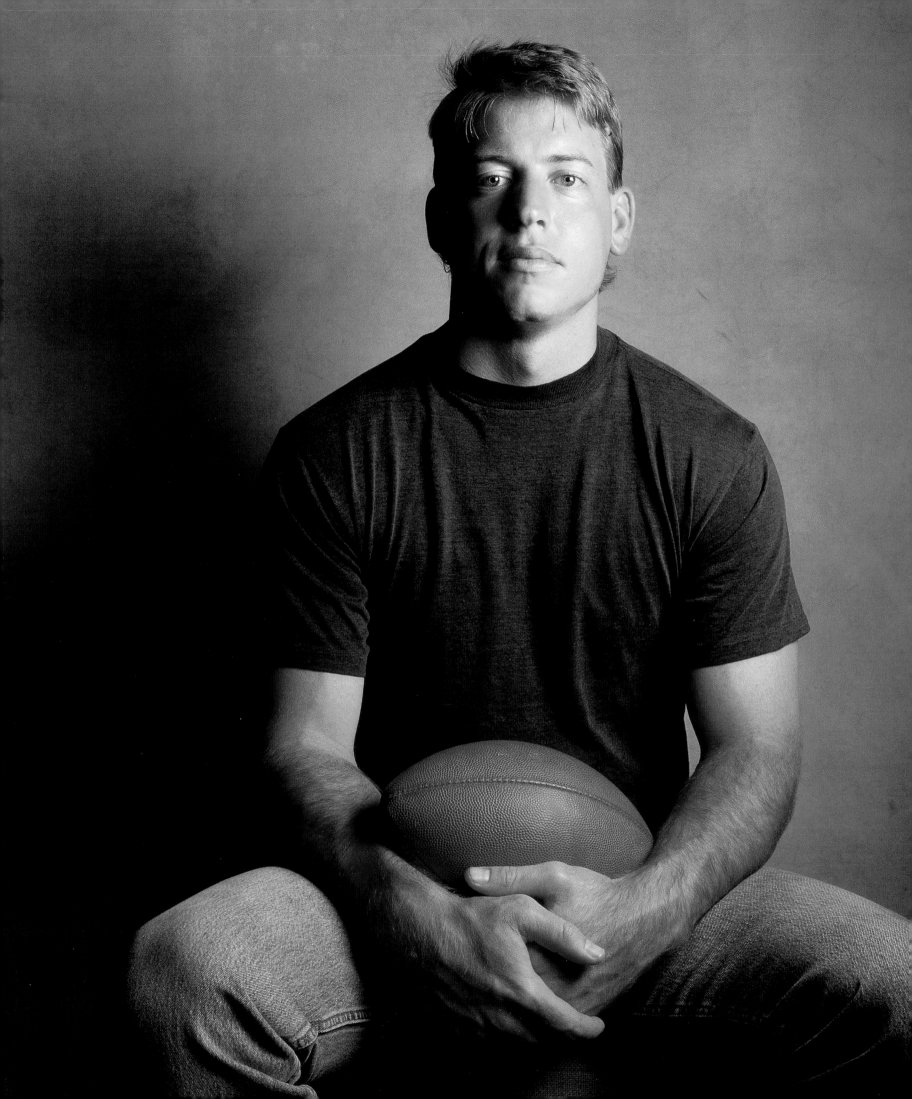

Troy Aikman

DALLAS, 1993

Troy Aikman possessed a distinct talent in football: his ability to throw accurate, crisp passes and the savvy to target secondary receivers beneath defensive coverage. The six-foot-four, 220-pound quarterback has earned three Super Bowl rings and completed 2,898 career passes.

Born Troy Kenneth Aikman in West Covina, California, in 1966, Aikman grew up in the suburban sprawl of Cerritos, California, but later moved to a 172-acre ranch near Henryetta, Oklahoma. After he adjusted to culture shock, he grew fond of Oklahoma—and country music—and went on to earn all-state honors at Henryetta High. He began his college football career at the University of Oklahoma—somewhat unhappily—but transferred to UCLA, where he was better able to play his game, a pro-style offense, designed by coach Terry Donahue. In 1989, Aikman was the Dallas Cowboys' first draft pick; the six-year, $11 million deal was considered excessive by some. But the new quarterback was ultimately able to reverse the team's losing streak, leading the Cowboys to two consecutive Super Bowl championships in 1992 and '93 and becoming a stellar replacement for the legendary Roger Staubach. He was selected MVP in Super Bowl XXVII. The Cowboys were victorious again in Super Bowl XXX in 1995.

Aikman has said he got his determination from his father, a hard-driving pipeline construction worker and rancher.

"Part of the reason that I play the way that I play, and don't fear getting hit ... stems from back when I was younger and seeing how hard [my father] worked and how tough he was ... ," said Aikman, who has suffered many injuries during his career, including eleven concussions, two of them in college. ". . . I always wanted to prove that I was as tough as he was."

But Aikman has another side. The man who was once the highest-paid player in professional football history has a reputation for being shy and reluctant to sell himself. When asked his reaction to being chosen as one of *People* magazine's Fifty Most Beautiful People, he quipped: "Well, they must not know very many people."

He has concentrated on using his image to help others. He established a permanently endowed scholarship at UCLA, where he majored in sociology. His Texas-based Troy Aikman Foundation constructs interactive playrooms in children's hospitals; and through his Aikman's End Zones, he funded a 2,500-square-foot interactive playroom and education center for children called The Zone at Children's Hospital of Dallas. He has also written a children's book, *Things Change*, with proceeds going to the foundation.

Aikman, who retired from football in the spring of 2000, works as a broadcaster for FOX Sports. He lives in Plano, Texas, with his wife and children.

Earl Campbell

BLANCO, 1993

Earl Campbell, one of the most powerful running backs in the history of college football, grew up among roses in Tyler, Texas. After his father died, Campbell's mother raised Earl and his six brothers and four sisters on her own by growing and selling the flowers—initially for a mere seventy-five cents a dozen. Campbell worked in the family business until he was eighteen, and then set out to play football for the University of Texas at Austin.

"I always wanted to be an athlete," said Campbell, winner of the Heisman trophy in 1977. "I never wanted to see another rose again."

After playing with the Longhorns, Campbell moved on to the NFL to play for seven years with the Houston Oilers, for whom he was the number one draft pick, then played for another year-and-a-half with the New Orleans Saints. His reputation for being virtually unstoppable on the field—with both phenomenal speed and strength—was unsurpassed; his powerful thighs were legendary. By the end of his professional football career, he had amassed a total of 9,407 yards rushing, 806 yards receiving, seventy-four touchdowns, and 10, 213 total yards. He ranks tenth in the NFL in all-time rushing yards. Campbell, who appeared on the cover of *Sports Illustrated* six times, was inducted into the Professional Football Hall of Fame in 1991. But the "Tyler Rose," whose two young sons play football, says his most significant accomplishment is not as an athlete.

"I wanted to be the first one in my family to get a college education," said Campbell, who returned to the University of Texas after his rookie year with the Oilers to get a bachelor's degree in speech communications. "I'd vote *that* bigger than the Heisman and the Hall of Fame."

Since then, several of his siblings have followed suit.

Campbell, a successful businessman in Austin, has run Earl Campbell Meat Products, Inc., which sells Earl Campbell's smoked sausage, barbecue sauce, and other food products, since1988. He also briefly owned a restaurant, Earl Campbell's on 6th.

"Everything Texans do is big," said Campbell, who tipped the scales at 230 pounds in his football prime, and who still actively supports University of Texas athletics.

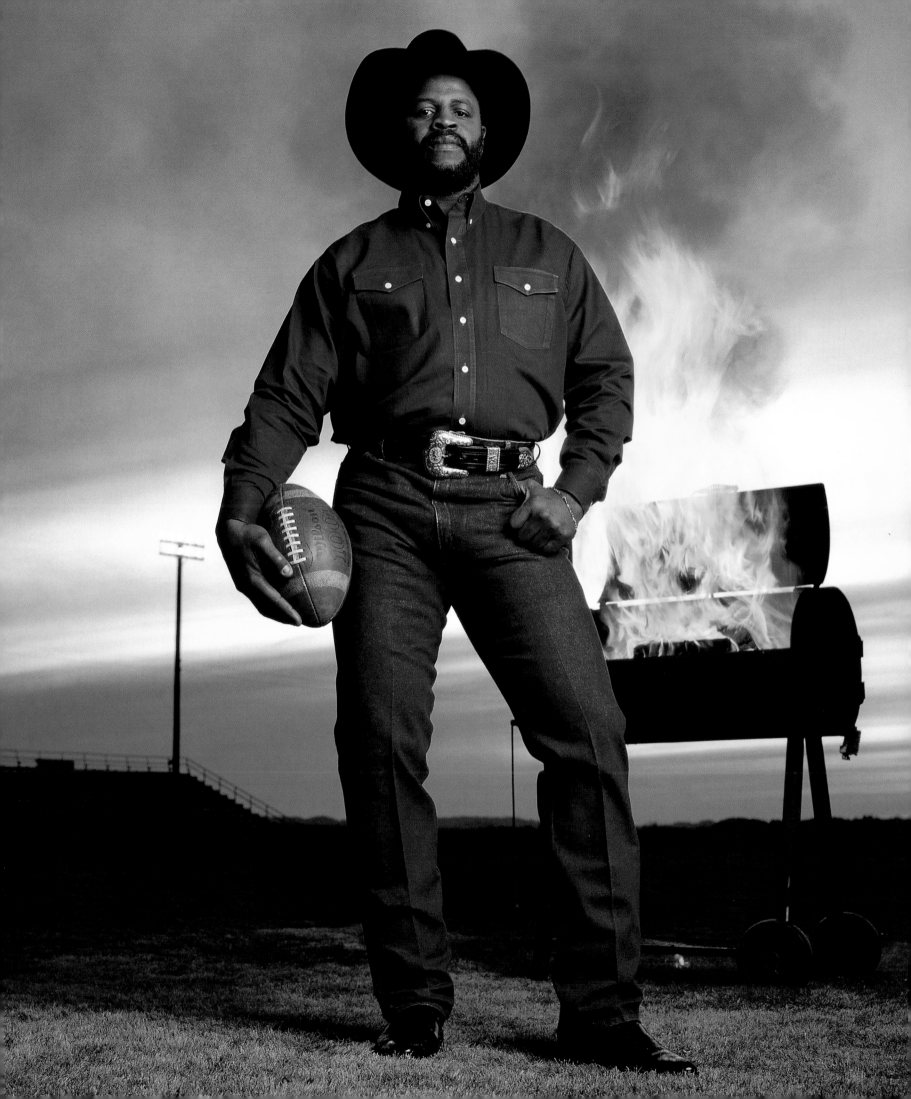

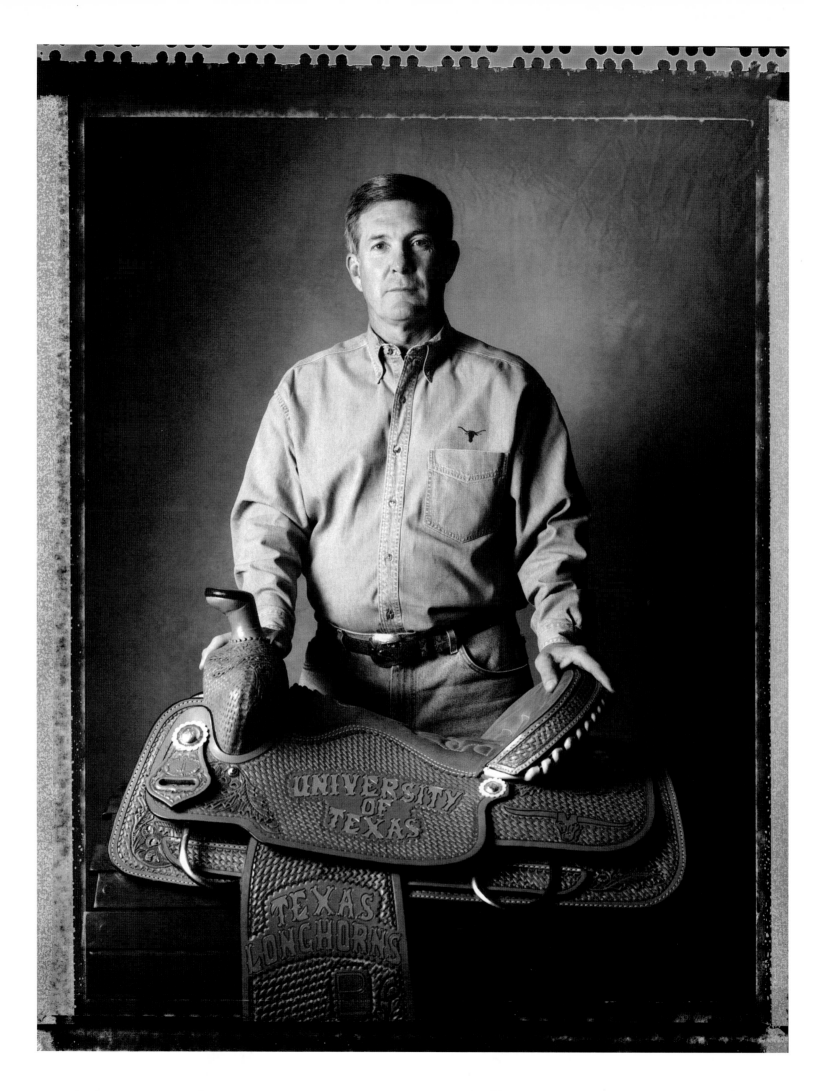

Mack Brown

A U S T I N , 2 0 0 0

Mack Brown laid the groundwork for his career on a road trip with his grandfather. At the age of five, Brown rode a yellow school bus through the rolling countryside of middle Tennessee with his granddad, Eddie "Jelly" Watson, and the football team of Cookeville Central High. They were heading to an out-of-town game, where Watson, one of the most successful high school football coaches in the state, would try to rack up another win. The stage was set: though he didn't know it yet, young Brown was preparing for a life in football.

The head coach of the University of Texas went on to play high school baseball, basketball, and football; but he turned down an offer by Paul "Bear" Bryant to play college ball at Alabama. He chose Vanderbilt instead, but transferred to Florida State, where he earned two letters. Afterward he pursued the coaching track with head coaching jobs at Appalachian State, Tulane, and the University of North Carolina.

Brown came to the troubled Longhorns in December 1997. Texas was looking for the man who could bring home the national title, and the search committee was unanimous in its choice. Brown moved to Austin after a successful run at North Carolina, and, with his gift for recruiting, set about rebuilding the UT program into a national power. In the first four seasons, the team boasted a 38–13 record; and Brown's Longhorn squads featured a Heisman Trophy winner, fourteen All-Americans, eighteen first-team All-Big 12 Selections, two Big 12 Offensive Players of the Year, a Big 12 Defensive Player of the Year, and five Big 12 Freshmen of the Year honorees. Brown helped establish Texas as one of the nation's premier offensive teams and turned the once-struggling defense into a formidable force—one that many consider the best in the country.

But Brown's passion for football—and his mission to win the national title—doesn't affect his commitment to education and to developing his players as men of intellect and character.

"Our goal is to win championships with nice kids who are graduating," he said. "We may be in the entertainment business on the weekends, but we are in the education business during the week."

Brown, a native of Cookeville, Tennessee, likes to say he's been "dipped and vaccinated" in all things Texan. His spacious office overlooking the south end zone of the Darrell K. Royal–UT Memorial Stadium, is a shrine to Texas and the Longhorns. Besides steer-hide decor and assorted memorabilia, he keeps a Native American "dream catcher," a gift from Willie Nelson, to inspire him to dream of championships. The players' lounge is a young jock's dream: plush leather sofas, pool tables, private phone booths, half a dozen custom-made saddles, and two big-screen televisions with video game machines attached. And the locker room looks like something befitting the Cowboys. Every player's locker is outfitted with a personal action photograph and the names of any all-conference Texas player who sported the same jersey number. Brown, whom his predecessor Darrell Royal has called "a marketer, a coach, a politician, and a CEO" rolled into one, sees that the football complex, which he transformed, stays immaculate and bespeaks Texas pride. Even the elevators are fodder for the Longhorn image: visitors are serenaded with "Texas Fight" on the way up and "Eyes of Texas" on the way down.

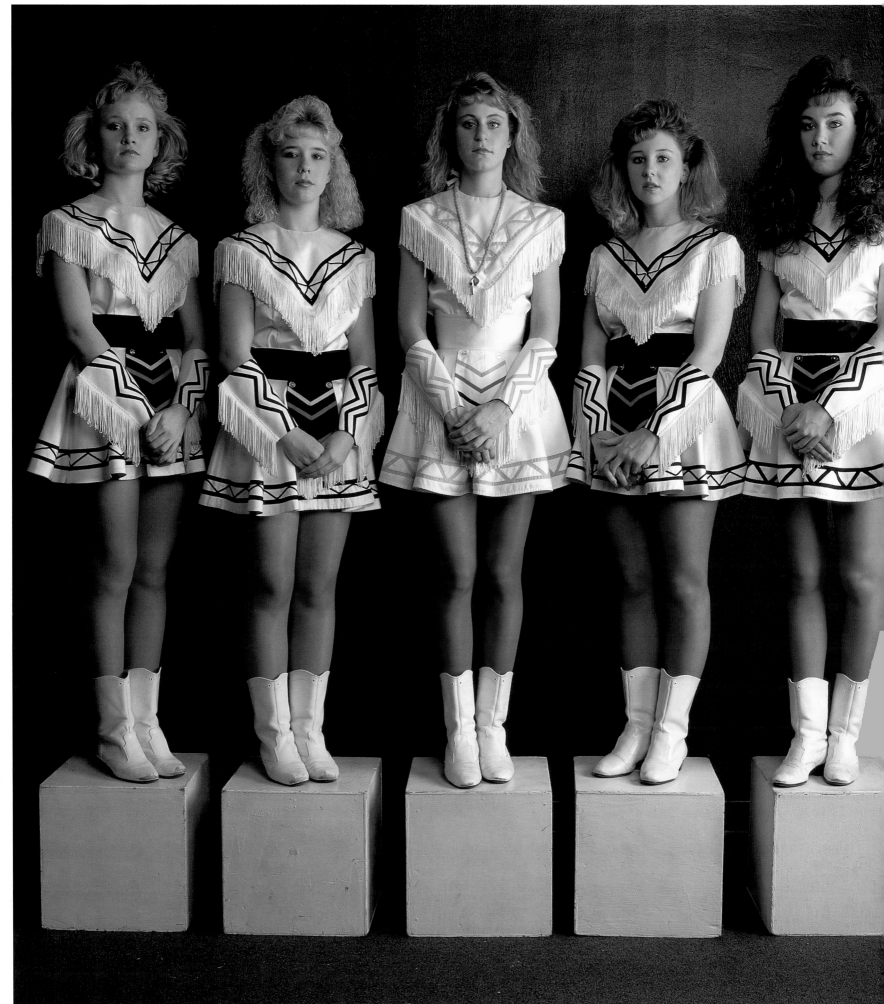

Cherokee Charmers

WAXAHACHIE, 1988

The officers of the Waxahachie High School Cherokee Charmers, the school's performing dance squad, posed for a 1989 issue of *Life* magazine. From left to right: Susan Duke, Hope Hays, Shelley Fromm (captain), Heather McCutchen, and Michelle Rhodes. The Cherokee Charmers—still in existence, though the crew in the photograph has moved on—perform at football games, pep rallies, and other special events.

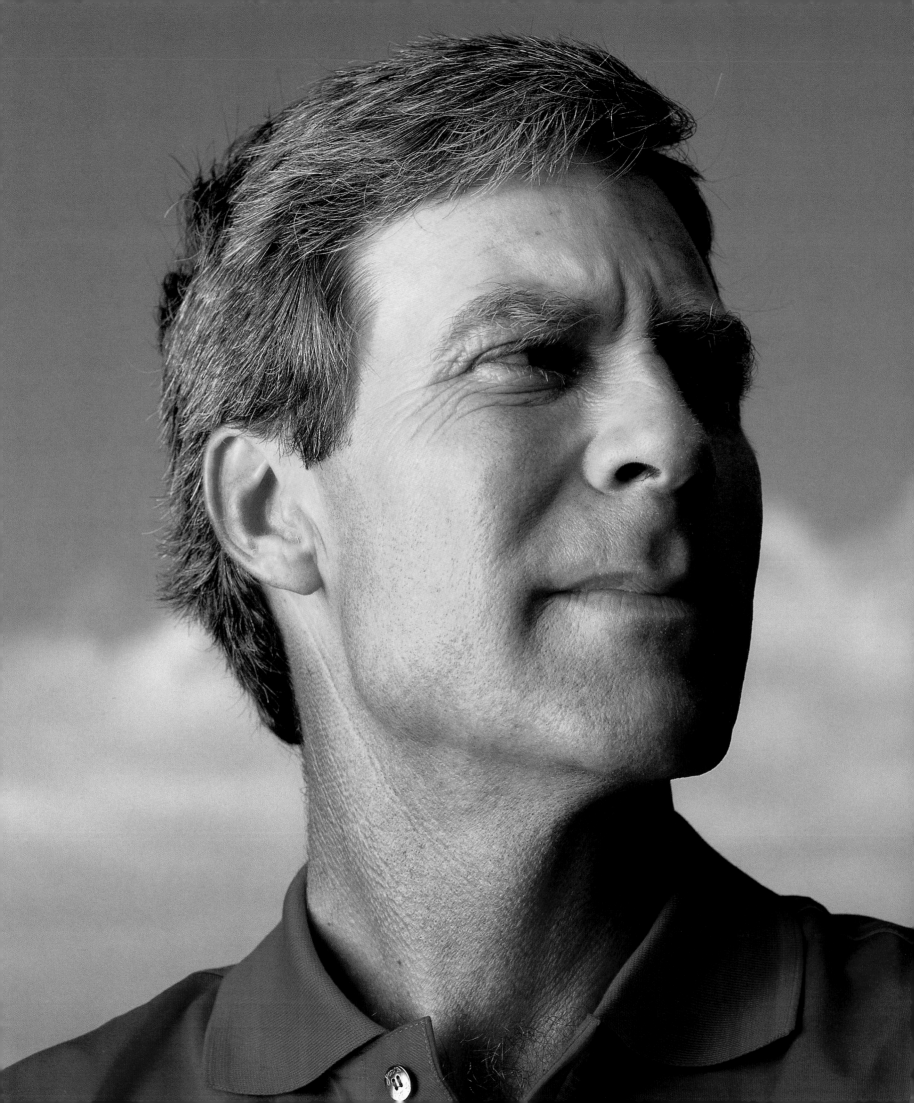

Ben Crenshaw

A U S T I N , 1 9 9 5

When Ben Crenshaw was just eight years old, he paid a visit to golf pro Harvey Penick at the Austin Country Club. Penick cut off a seven-iron for him, showed him a good grip, and took him out to the course. Looking at a green seventy-five yards away, Penick told young Crenshaw to tee up a ball and hit it onto the green. Crenshaw did as he was told. Once on the green, Penick told him to putt it in. Crenshaw turned to him and said, "If you wanted it in the hole, why didn't you tell me the first time?"

This anecdote, from *Harvey Penick's Little Red Book,* sums up Ben Crenshaw, who considers Penick his greatest influence in terms of improving his game. Though he never took formal lessons from the famed golf teacher, "Gentle Ben" Crenshaw always went to him with problems. Penick, for his part, considered Crenshaw's swing—natural, long and smooth, using mostly the shoulders—one of his all-time favorites.

Ben Daniel Crenshaw was born in Austin on January 11, 1952, to Pearl Johnson Crenshaw, an elementary schoolteacher, and Charles Edward Crenshaw IV, an attorney who worked as assistant to State Attorney General Price Daniel. He learned golf early from his father.

Not long after his first session with Penick, Crenshaw won his first tournament, in fourth grade—the Cassis Elementary Open—with a score of 96. He went on to rack up the stats: he shot a 74 for eighteen holes at the age of ten; qualified three years later for the state junior tournament, with a score of 69; won the state junior championship at fifteen, and again in 1968; won the first of three consecutive Austin City Championships, also in '68; and won his first national title, the Jaycees Junior Championship, again in '68.

In high school, Crenshaw was an accomplished athlete: he played quarterback in football, point guard in basketball, catcher in baseball, and participated in the broad jump. But golf occupied him most intensely; he played up to thirty-six holes a day for ten months a year. He won a golf scholarship to the University of Texas in 1970, and in '71 he was named to the All-American College Golf Team. He turned professional in 1973.

After a decade of frustration, Crenshaw won his first major championship title in 1984 when he took the Masters. His second victory, at Augusta in 1995, secured his place in golf history. In 1999, he was captain of the American team that won the Ryder Cup.

Crenshaw is now on the senior tour, and he has a golf course architecture business that builds championship courses across the United States.

His honors include the Bob Jones Award, the highest honor of the United States Golf Association, and induction into the World Golf Hall of Fame.

"There is a long line of outstanding golfers from our state . . . Texans have always been risk takers" said Crenshaw, a noted golf historian, who grew up playing alongside Tom Kite. "Wherever I travel around the world to play golf, I'm always proud to talk about Texas being my home."

Harvey Penick *and* Bud Shrake

AUSTIN, 1993

Writer Bud Shrake had known Harvey Penick for years when Penick summoned him one fall day in 1991 to Austin Country Club. Shrake joined the eighty-six-year-old head golf professional emeritus in his golf cart under the trees. The two discussed Shrake's brother Bruce, who had been on Penick's team when Penick was golf coach at the University of Texas—a position he held for thirty-three years.

"I thought he wanted to talk about my brother," said Shrake, a former *Sports Illustrated* writer and the author of seventeen books and numerous screenplays. But Penick—who started caddying at the Austin club when he was eight years old and held the head pro position for fifty years—dispensed with small talk.

"He reached into his attaché case and pulled out a five-by-seven, red scribble-text notebook," said Shrake. "He said he'd never shown it to anyone except his son, Tinsley."

With the writer's help, the notebook became the famed *Harvey Penick's Little Red Book*, a sixty-year compilation of Penick's considerable golf wisdom, plainly told, along with plenty of practical life philosophy. Shrake collaborated with Penick on the writing of the book and arranged a publishing deal with Simon & Schuster. The *Little Red Book* has become the best-selling sports book of all time, and four similar Penick/Shrake golf books have followed. Penick's simple advice—"Take dead aim"—is legendary among golfers.

"I revered Harvey Penick," said Shrake, who begged off a movie commitment to take on the project. "At the time, I felt, 'I've been chosen by some divine force to do this.'"

The book is as much about life as it is about golf. Penick relates in the book that when a New Yorker showed up at Austin Country Club one day for his help, the man said, "If you're such a great teacher, teach me how to get out of sand traps."

"Not so fast," Penick told him. "I can teach you how to get out of sand traps. But I'm not going to do it until I teach you how to avoid getting into them in the first place."

Considered by many to be the greatest golf teacher in American history, Penick taught people, not methods. He says he never used the words "never" and "don't" with his students, who included such golf greats as Ben Crenshaw and Tom Kite.

"I try to put everything in positive, constructive terms," he said.

When one of his less-talented pupils hit a fine shot, Penick got as excited as he did with a professional.

"I would get goose pimples on my arms and a prickly feeling on my neck from the joy of being able to help," he said.

"Harvey came closer than anyone I know to living life by the golden rule," said Shrake, whose latest novel, *The Border Land*, deals with the history of Austin. "People love his soul as well as his teachings."

Penick died at the age of ninety in 1995.

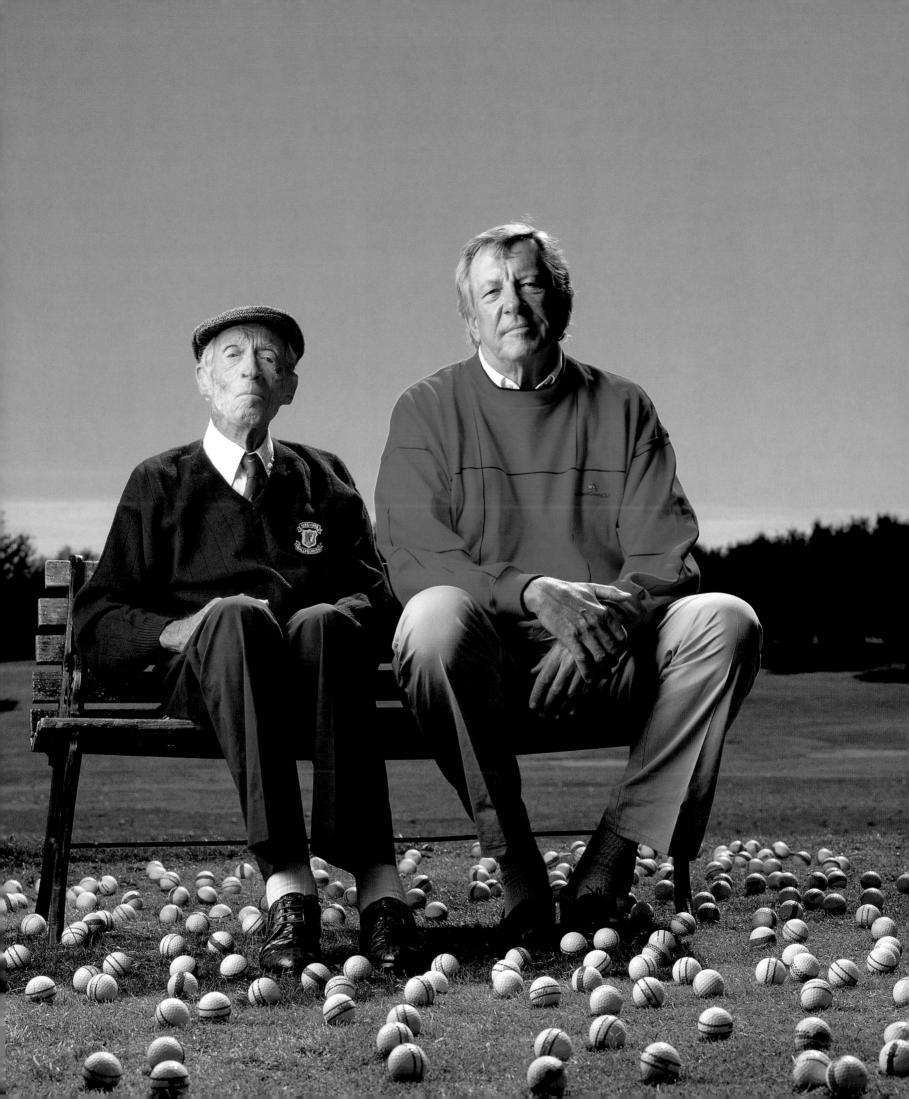

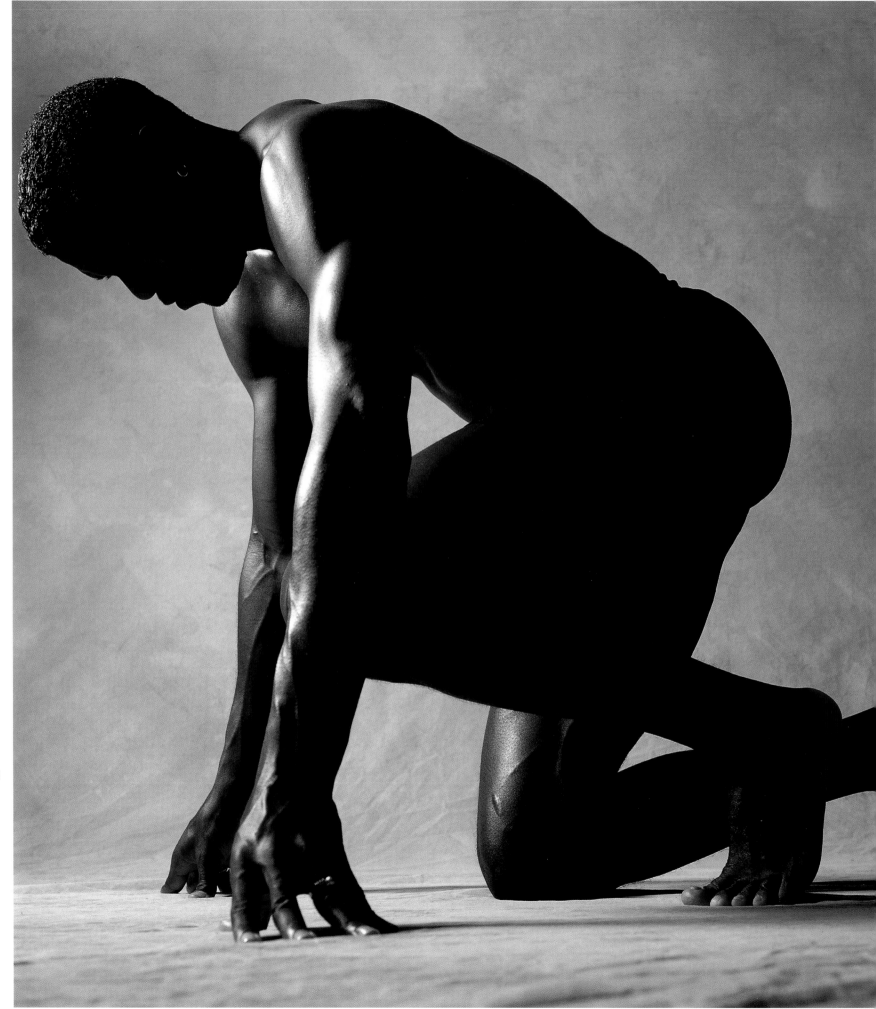

Carl Lewis

Carl Lewis was born, literally, to run. On July 1, 1961, Frederick Carlton Lewis came into the world in Birmingham, Alabama, the newest member of a family of swift athletes. Though small as a boy, he experienced a teenage growth spurt so dramatic that he had to use crutches for several months until his body adjusted. By the time he graduated, he was the top-ranked high school track athlete in the country and earned an athletic scholarship to the University of Houston.

Lewis, an outspoken critic of steroid use by athletes, went on to win nine Olympic gold medals, and eight gold medals in the World Track and Field Championships, and to break world records in four events. He won one of those Olympic golds in 1988 in Seoul, South Korea—in the one hundred-meter dash—after Ben Johnson tested positive for steroids and was stripped of the honor.

Lewis trained hard all his life, but the talent was in his genes. His father, Bill Lewis, was a former track athlete and football star at Tuskegee Institute in Alabama, and his mother, Evelyn Lawler Lewis, represented the United States as a hurdler in the 1951 Pan-American Games and was an Olympian in the eighty-meter hurdles in Finland in 1952. Lewis's siblings were also athletes: his oldest brother, Mack, was a high school sprinter; his brother Cleve played professional soccer; and his younger sister, Carol, was once the top-ranked woman long jumper in the country, as well as an accomplished high jumper, hurdler, and sprinter.

When Lewis was a boy, the family moved to Willingsboro, New Jersey, where his parents became high school teachers and founded the Willingsboro Track Club. Lewis started running with the club when he was eight, but he was smaller than his siblings and regularly lost to his little sister in track events. When he was nine, he won the long jump competition at a children's track meet and received his medal from Jesse Owens, a man whose career he would ultimately shadow.

"You're really talented," Owens told him. "You're a little guy, but you beat all the big guys."

Years later, at the 1984 Olympics, Lewis won the gold medal in the same four events—the one hundred-meter dash, the long jump, the two hundred-meter run, and the four hundred-meter relay—in which Owens had prevailed in Berlin in 1936. When his father died in 1987, Lewis buried his one hundred-meter gold medal from the 1984 Olympics with him.

Lewis, who was inducted into the United States Olympic Hall of Fame in 1985, continued to live in Houston after college for nearly two decades. He briefly owned a restaurant there and launched a line of sports clothing. He recently moved to Los Angeles to pursue his other passion, acting.

Tim Duncan

SAN ANTONIO, 1999

Tim Duncan is an imposing human being: he stands seven feet tall and weighs 260 pounds. Yet the Saint Croix, Virgin Islands, native—who in 1999 led the San Antonio Spurs to their first NBA title, and was named MVP in the finals—admits to being afraid of heights and sharks.

Unlike many professional basketball players, Duncan—a competitive swimmer before he started playing organized basketball in ninth grade—is a college graduate, having attended the prestigious Wake Forest University. It is not surprising that he received his degree in psychology, considering he's known for his impassive "game face" and for being, in one sportswriter's words, "the coolest player on the planet."

Duncan has remained loyal to Texas and the Spurs, even in the face of an extraordinary offer from the Orlando Magic after his spectacular '99 season. He likes his Texas life and feels especially comfortable with the Spurs, playing power forward next to David Robinson's center. The two were dubbed the most effective "Twin Towers" in NBA history.

Besides that, San Antonio depends on him. In 2001, he won the NBA Home Team Community Service Award. Duncan gives away twenty-five Spurs tickets to each home game, donates computers to local schools, and reads to schoolchildren to honor his mother, who died of breast cancer when he was fourteen. He also hosts Bowling for Dollar$ Charity Bowl-a-Thon, with the proceeds benefiting various cancer-related charities.

Duncan, known for wearing his practice shorts backwards, was named regular-season MVP by the NBA for the 2001-2002 season.

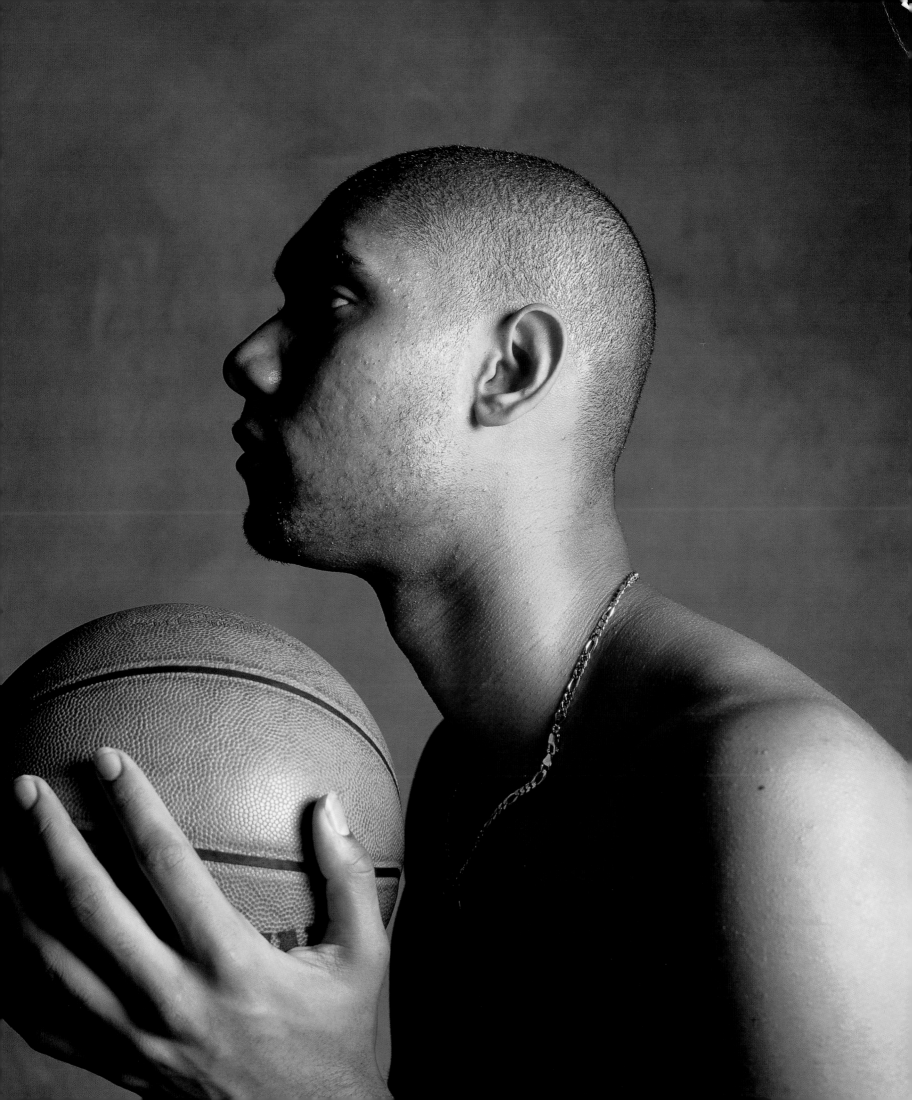

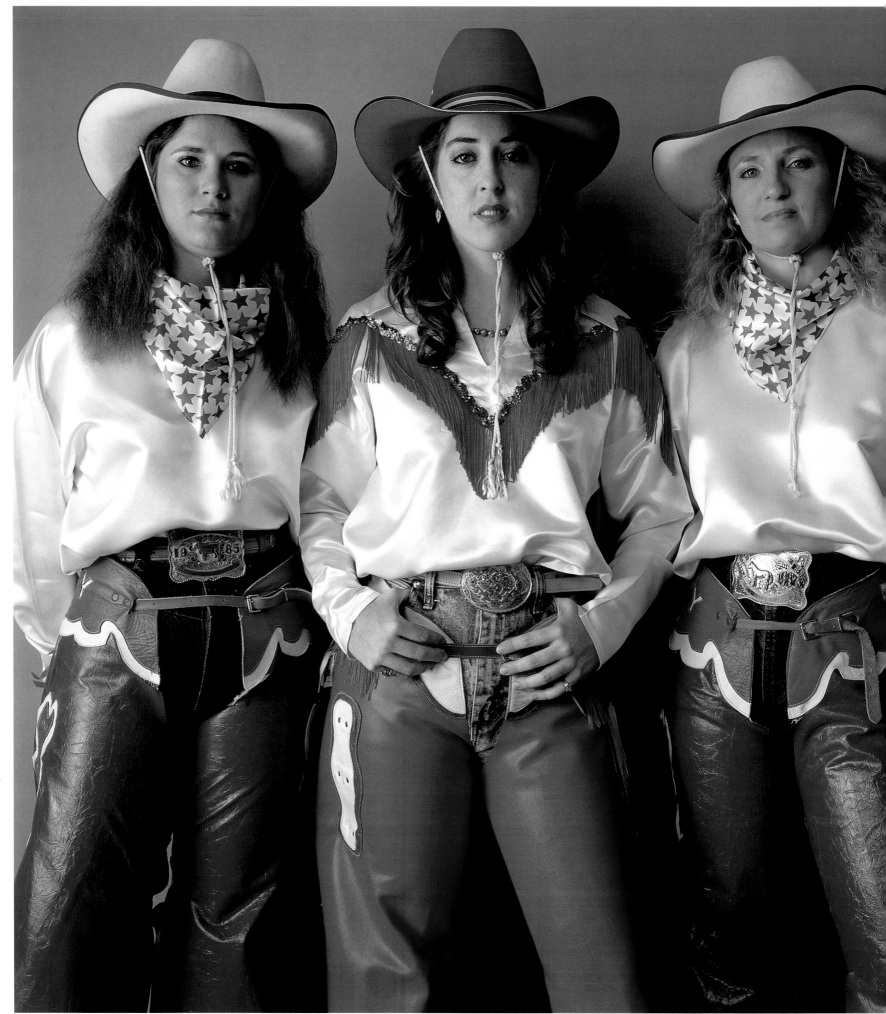

Urban Cowgirls

Robyn Bankston, Debbie Kutch, and Karen Roemer (left to right) appeared in the June 1990 issue of *National Geographic*, which featured Austin on the cover. The three young ladies rode in the opening ceremonies of the 1989 Austin-Travis County Livestock Show and Rodeo, now known as the Star of Texas Fair and Rodeo.

Scott Johnston

Aussie Scott Johnston came to this country with $700 in his pocket and a dream—to be the best cowboy in the world. He succeeded: at twenty-seven, he won $180,280—more than anyone entering the 2000 rodeo championships. A champion bronc rider, Johnston, who grew up in Australia's rugged Outback, had the right stuff when he got here. But he had to prove himself, so he joined the rodeo circuit and promptly won Saddle Bronc Rookie of the Year, following that up in '97 with the National Finals Rodeo (NFR) average title. In 2000, he was the second-biggest money earner on the circuit, with $200,726, an astounding feat for a cowboy who had broken his back in an airplane crash in 1998.

Those who have seen him ride say Johnston's posture on a horse is so natural and fluid that it is difficult to distinguish between man and horse. In competition, a bronc rider must start with his feet above the horse's shoulders, at the "breaks"—"to give the horse the advantage," says Johnston—and he must stay on, melding with the horse's movements, for eight seconds. In addition, the horse must be judged a worthy adversary—a savage bucker with a will of his own. Johnston attributes his utter confidence and ease on horses to an instinctual bond with animals. His early life as the son of a cattle rancher in the Never Never, the locals' moniker for the Outback, bred titanium nerves and a spiritual sense of invincibility. He lived half an hour from the nearest human and five hours from a decent sized town.

Johnston met his wife, Jane—who worked as a nurse—at a gas station in Brewarrina, New South Wales, where he was working, and they went "pig chasing" on their first date. Johnston explains that pig chasing is akin to hunting, except no guns are used; men take dogs "out in the middle of nowhere," where they hold the wild pigs at bay until the men can wrestle them to the ground and capture them alive. They don't "cut 'em up and dress 'em" until later, so the meat is as fresh as possible when it's eaten or shipped to market in Germany.

Johnston, who gave up bull riding in Australia after getting injured, has only had one serious mishap as a bronc rider. Early in 2002, he fell off a horse, and it jumped on his leg, tearing some knee ligaments. He had to stay off the rodeo circuit for three and a half months, and though he did a little physical therapy and a lot of walking, he mainly practiced mind over matter.

"I just prayed a lot," he said.

Johnston lives with his wife and four children on a 280-acre ranch near Gustine, Texas, three hours southwest of Dallas. In his mind, it's the best of both worlds.

"It's a little quieter than most places, but it's still only a few hours from two major airports—Austin and Dallas," said Johnston, who's gone 200 days a year rodeoing. "The weather doesn't get too cold for too long, and everyone's good to us. We have a lot of friends."

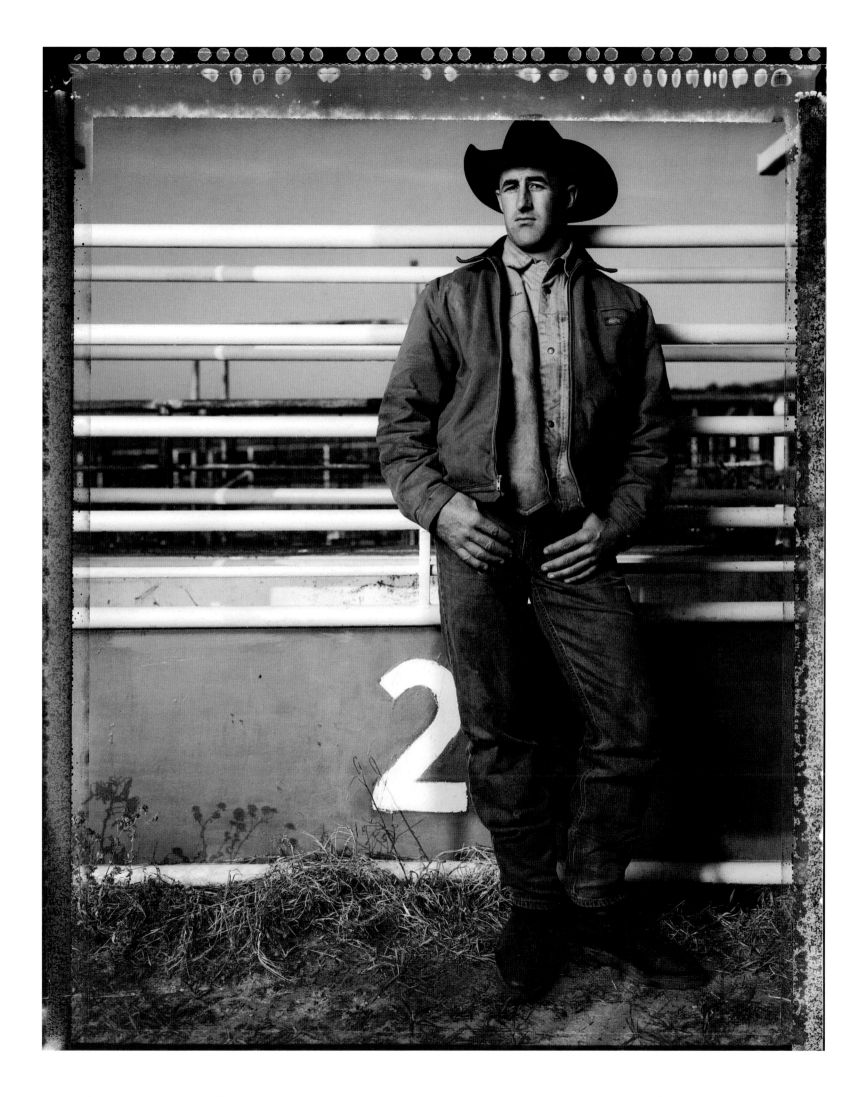

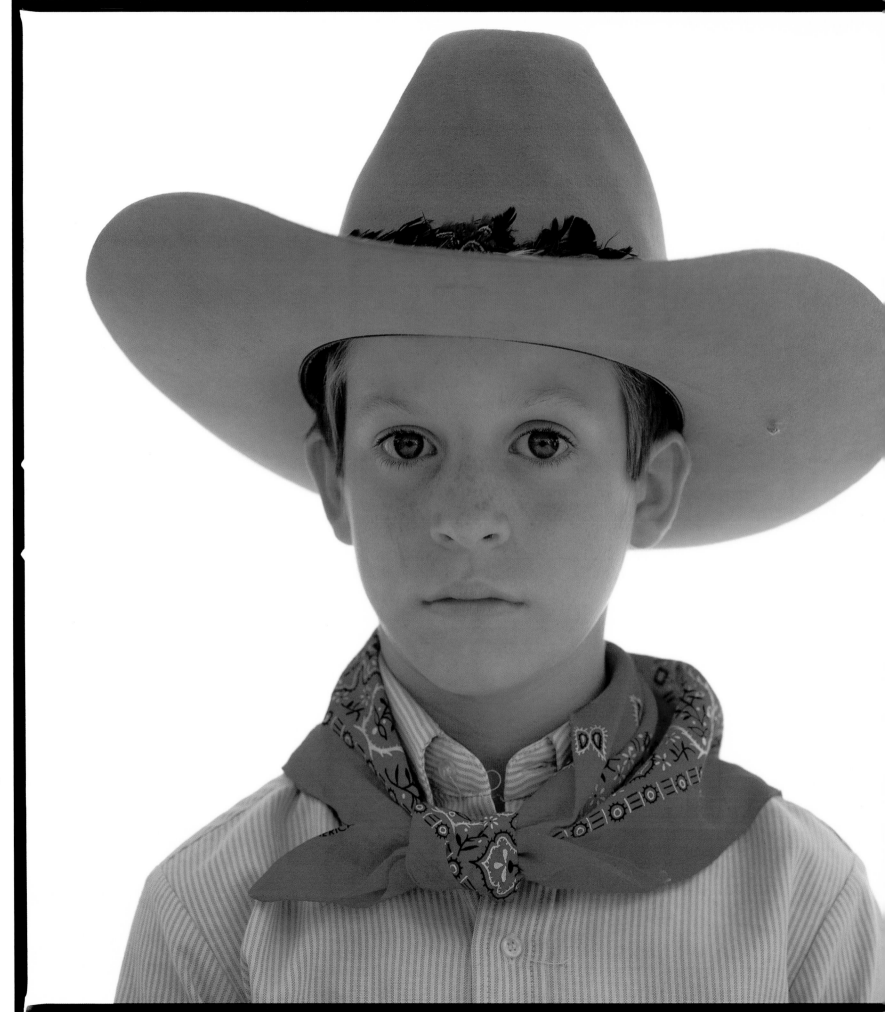

Brent Cunningham

A U S T I N, 1 9 8 9

Brent Cunningham was nine years old and a fourth-grader at Plum Creek Elementary School in Lockhart, Texas, when this photograph was taken at the 1989 Austin–Travis County Livestock Show and Rodeo. He had competed with his heifer in the Red Brangus division and walked away with a second-place ribbon.

"It's pretty much what we did when we were growing up, showing heifers and stuff," said Cunningham in 2002. "It was a 4-H kind of thing. We'd feed 'em, raise 'em, and train 'em to walk around with halters. We'd show our heifers in Austin, Houston, Fort Worth, and here in Caldwell County."

Cunningham grew up on his family's 400-acre ranch in Lockhart, where he took on adult responsibilities at an early age.

"When your parents are divorced, and you grow up on a ranch, you have to become a jack-of-all-trades," said Cunningham, now owner of Cadillac Boat Docks, a boat dock building and repair business. "My stepfather was off working all the time, so I was the man of the house. I had to grow up a lot faster than other kids."

By the time he was a teenager, Cunningham had started working outside the ranch as well.

"At age fifteen he had his own welding business, and I was his secretary," said Cunningham's mother, Pat Lock. "He even skipped school to do jobs and I had to drive him."

Cunningham went to work full time straight out of Lockhart High School, continuing his welding and wrought iron fence work, then expanding into the boat dock business. Since he had spent a great deal of time at his grandparents' house on Lake Travis—and even more time building and repairing things at the ranch—the work was familiar. Now he hopes to expand again, into the home remodeling and resale business.

"When I was a kid, I was always building things," said Cunningham at twenty-three. "I've always done my own thing and paid my own way. I guess you could almost say I'm a loner."

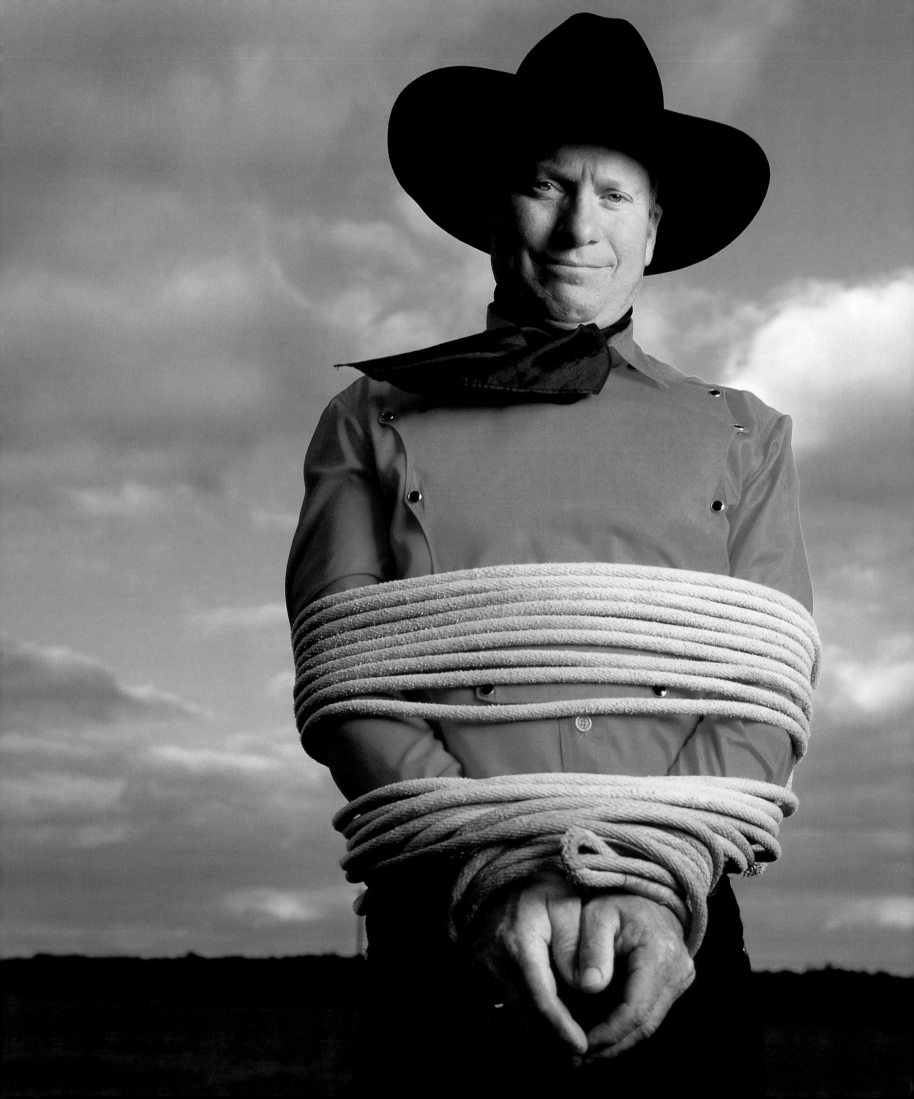

Kevin Fitzpatrick

"Cowboy Kevin" Fitzpatrick can do just about anything with a rope. Besides lassoing horses, bulls, people, and anything else that moves, he can transform a rope into a beautiful, soaring butterfly. Appropriately, the trick is called the "Butterfly." His "Ocean Wave" is just that—a dramatic, rolling rope wave, crashing onto shore. His "Rollovers" and "Flataround" are equally sublime. When he attended the Guinness Book of World Records Show in Germany, he tied the reigning European champion with his "Texas Skip," completing seventy-nine in-and-out loop jumps in fifty-six seconds before stepping on his rope on the eightieth jump.

"I'm a cowboy," said Fitzpatrick, the son of a farrier and rodeo rider, who often stands or does handstands on his horse while performing. "That's all I do, is rope and ride."

Fitzpatrick, raised in Phoenix, Arizona, moved to Bandera, Texas, just after high school. He followed his father, Bud, who had moved back to his native state after working for years in California.

"My dad was a rodeo rider in the '30s and '40s," said Fitzpatrick, who worked with his father shoeing racehorses when the elder Fitzpatrick slowed down. "He used to gallop racehorses and ride bucking horses and bulls. He competed in the world finals of bull riding at Madison Square Garden in 1943. Roy Rogers was there."

Fitzpatrick hired on at a series of dude ranches. Then he got his own horse, a two-year-old quarter horse named Wetback—"Wet," for short. With visions of Roy Rogers and Gene Autry in his head, he spent his free time with Wet, learning how to ride and rope.

Eventually, Fitzpatrick became so skilled at roping—and so in demand as a performer—that he quit his regular job in pursuit of his art. He and Wet, who's getting on in years, and a younger horse, a paint named Chief, make a living traveling around to rodeos, conventions, livestock shows, schools, and birthday parties. He and his horses also appear in occasional advertisements, and have traveled as far afield as Geneva, Berlin, London, and Toronto doing promotional work for the Texas Department of Tourism. In 2001, Fitzpatrick performed at the Texas State Society's "Black Tie and Boots" party for George W. Bush's inauguration.

"I have the most complete life of anybody," said Fitzpatrick, who lives on a ranch in the Hill Country with his wife, three children, half-dozen cows, three horses, one dog, one cat, and one fish. "I get the best of every world, and I make people happy."

George Strait

More than two decades ago, George Strait was on the verge of abandoning his dream of a music career and signing on, instead, with a company that designed cattle pens. But his wife, Norma, intervened. She encouraged him to turn down the job and give music another try. After a few false starts, Strait got his break in 1981, when he recorded a hit single, "Unwound," which led, finally, to a record deal with MCA.

Strait sings country music the way it's supposed to be sung—with conviction, vulnerability, and poignant artistry. His clear, powerful voice delves into pain and heartache with such compelling vocal phrasing and resonant lyricism that mainstream pop radio stations have changed their tune: in 2001, Strait was just behind Mariah Carey as one of radio's most-played artists during the previous five years, and his influence has increased radio play of other more traditional, less pop-influenced country music.

Strait, born May 18, 1952, in Poteet, Texas—the "Strawberry Capital of the World"—is considered the class act of country music. Handsome, courteous, and refined, he has earned a reputation as a gentleman and country artist of the highest order. The singer, whose inspirations include country legends Bob Wills and Merle Haggard, has amassed more Country Music Association nominations than any singer in history. He has been Male Vocalist of the Year and Entertainer of the Year, and he has collected a staggering forty-seven number-one singles. He has sold some 57 million records and has twenty-five platinum records to his credit—more than any other country artist in history. His four-disc retrospective, *Strait Out of the Box*, is the best-selling boxed set in country music history. His final concert at the Houston Astrodome in the spring of 2002 drew a record crowd of 68,266.

Strait grew up not far from Poteet on his family's 2,000-acre cattle ranch southwest of Pearsall, Texas, near the Frio River; the ranch has been in the family for a century. He studied agriculture briefly at Southwest Texas State University, and then eloped with his high school sweetheart, Norma Voss, to whom he is still married. Shortly thereafter, he joined the army, planning to resume his education—and the ranching life—when he returned. It was while he was stationed in Hawaii that he began his music career. He bought a cheap guitar and a Hank Williams songbook and auditioned for lead singer in an army-sponsored band. Rambling Country, which was formed by Strait's base commander to entertain the troops, immediately began to garner attention.

When he returned to Texas, Strait—a genuine cowboy who learned to ride horses and rope cows before he handled a guitar—re-enrolled at Southwest Texas State on the G.I. Bill, eventually earning his agriculture degree. He also joined a band, Ace in the Hole, which developed a passionate local following. To supplement his music income, he worked as a ranch manager. It was on that ranch, near San Marcos, where he first heard his song "Unwound" playing on the radio.

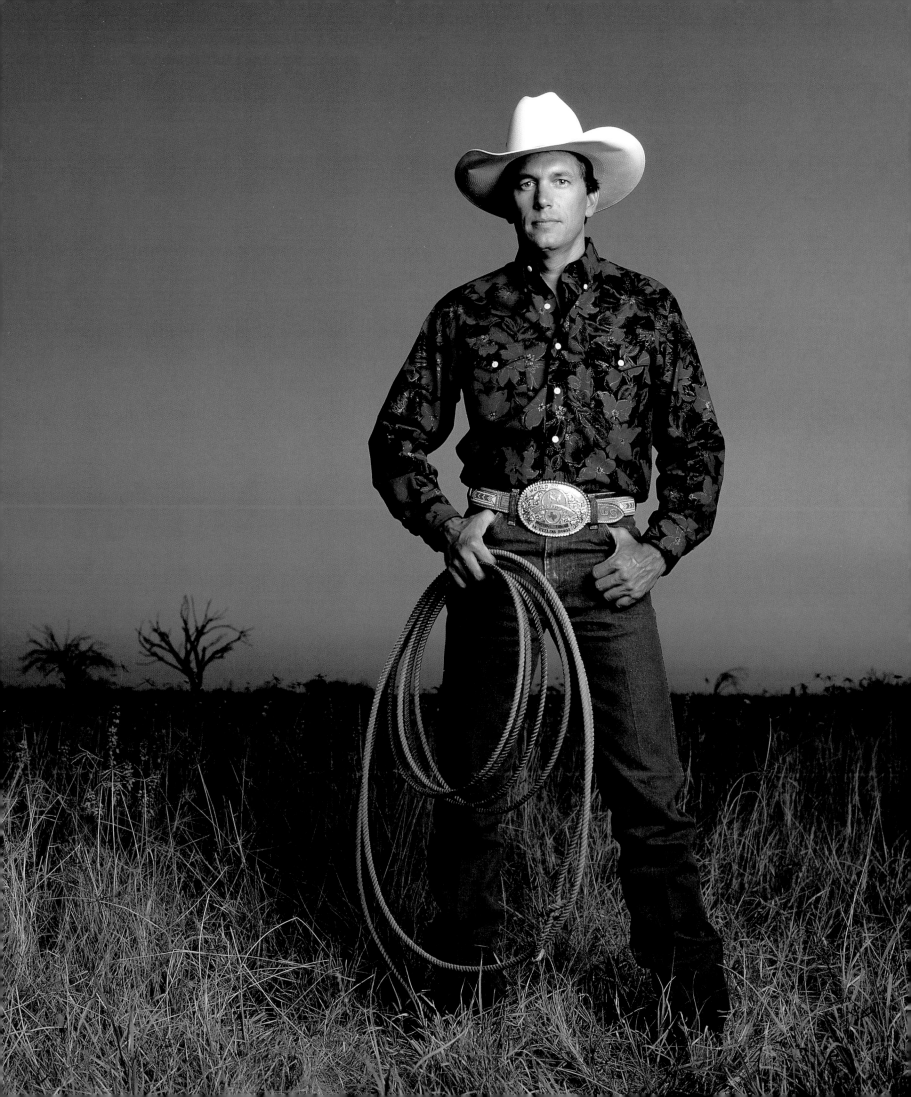

South Park Mexican

HOUSTON, 2000

Carlos Coy, a.k.a. South Park Mexican, went from street thug to rap entrepreneur by turning his life around. At both ends of the spectrum, he climbed to the top. Coy grew up tough in the barrios on Houston's south side. Although he came from a solid family, he took to the streets like those around him and became a premier drug dealer. By everyone's account, his drugs were the finest.

But after witnessing the violence and tragedy around him, and almost dying himself, he gave up the dealer life and transformed the experience into art—specifically "gangsta music." His hardcore rap songs—"… Used to fool with crack, now I'm through with that. I just opened up the SPM School of Rap …" (from "Power Moves")—speak to the dangers of the drug life; and his example as a performer, musical engineer and entre-preneur, and founder of the wildly successful Dope House Records resonates deeply within the Latino community.

SPM, who considers himself a "street philosopher," has sold more than 650,000 albums independently since 1995, and Dope House Records has emerged as the dominant independent label in the Mexican-American rap world.

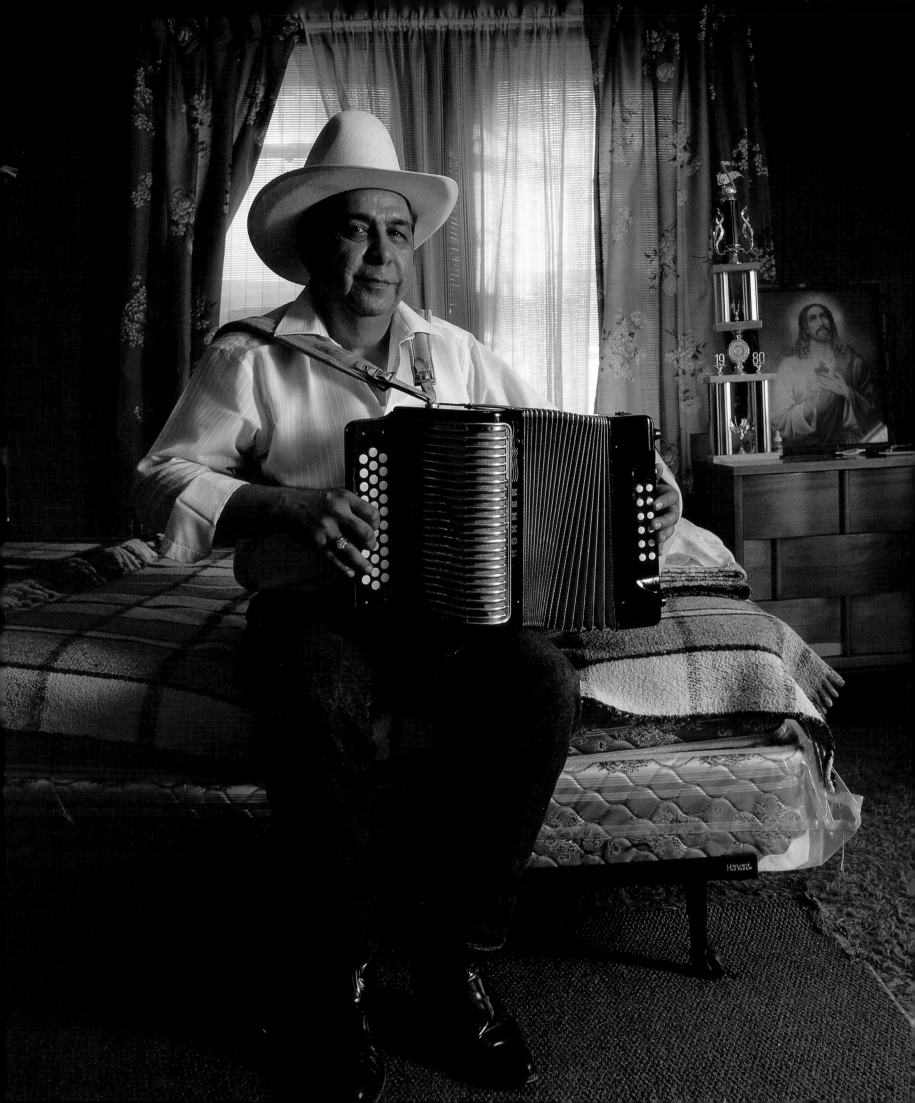

Johnny Degollado

Johnny Degollado wasn't like the other ragtag boys in his East Austin neighborhood. When they asked him to go fishing, he joined them, but he didn't take a fishing pole. Instead, he shouldered his accordion and practiced on the bank of the creek while his friends fished. Known as the "Montopolis Kid," after the neighborhood where he grew up and where he still lives—just two blocks from his childhood home—Degollado is the king of conjunto Tejano music in Central Texas. He is the only musician in these parts who has played conjunto music continuously for fifty years. Conjunto music, a Tex-Mex creation, is traditionally played by a four-member band with an accordian and a bajo sexto—a low-voiced, twelve-string guitar—as the core of the sound. The word *conjunto* means, loosely, "grouped together." Fittingly, Degollado's band, Johnny Degollado y Su Conjunto, has never reshuffled or broken up.

"I'm really happy with the way everything has turned out," said Degollado, who has made over 300 recordings—on eight-track tapes, records, cassettes, and CDs—and who has written 200 songs. "For fifty years, I have entertained the people of Central Texas. What I want is for kids to do what I did and keep conjunto music going."

Degollado was an early disciple of the revered but unrecorded master accordionist Camilo Cantu. When Degollado was eight years old, his parents started taking him along to dances at La Polkita, a dance hall on the outskirts of Austin, where Cantu, known as "El Azote de Austin"—The Trailblazer of Austin—held forth.

"I was watching him all the time, and I loved the way he played," said Degollado, whose father, a carpenter, bought him his first accordion for forty dollars when he was ten years old. "Cantu taught me all he knew. He didn't want conjunto music to die without passing it on. Everyone used to say: 'Camilo Cantu passed the torch on to Johnny Degollado.'"

Degollado's band has five members instead of the traditional four: Vicente Alonzo, who has been with him since adolescence, on bajo sexto; drummer Lupe Murillo; bass player J. J. Varrera; and saxophonist Jesse Botello. The saxophone was Degollado's idea, and it creates a unique "Austin-style" Tejano sound.

Degollado is married to his third wife, Antonia, who was also his first girlfriend. He is the father of eight children. He has slowed down some in recent years and performs mainly on weekends. During the week, he eats breakfast at Joe's Bakery, a Tejano musician hangout on East Seventh Street, then heads to work in the accordion repair shop behind his modest home. For the past dozen years, he has organized a popular conjunto music festival, bringing in the best Tejano musicians from the region.

He still has his first accordion, a beautiful 1930s-era Hohner that he has restored to its former grandeur; it occupies a place of honor in a glass case in his tiny office. But once in a while, on special occasions, Degollado dusts it off and takes it onstage.

Charlie Robison

B A N D E R A , 2 0 0 1

Charlie Robison's mother, Martha Ben, tended bar at various watering holes around his hometown of Bandera. She managed the Purple Cow Saloon, and at the Mayan Dude Ranch, she poured drinks and played a "pistol-packin' mama" in the bar's Wild West show. Robison was accustomed to honky-tonks and juke joints at a tender age, and music was in his blood.

"It was in the early '70s, at the height of the outlaw movement, when Willie had returned [from Nashville]," said Robison of the "cross-pollination" of rednecks and hippies that characterized the music scene then. "When I wasn't working on the ranch with my grandfather and father, I was sitting behind the bar listening to music at a grungy Texas honky-tonk."

Robison, originally a drummer by default, was only fifteen when he took to the stage himself. He first played in a band with his brother Bruce on bass, and a friend on guitar. He got what was left—drums. The trio cut their musical teeth playing rodeos and school dances in their quaint Hill Country hometown, population 940, which was settled by Polish immigrants in the nineteenth century.

Later, Robison switched to guitar and singing and became so focused on music that college got in the way. He dropped out of Southwest Texas State, sacrificing football and baseball scholarships, and headed to Austin. He spent a few years establishing his music career—in bands like the Chaparrals, Two Hoots and a Holler, and the Millionaire Playboys—until the '90s, when he went solo and eventually returned to Bandera and the land that inspires him.

"I always felt I was born a century too late," said Robison, who raises cattle and quarter horses on his family spread and lives in a 1920s-era ranch house with his wife, Emily, the banjo player for the Dixie Chicks. "Texas is the only place you can lie to yourself that time has stood still . . . where you can play cowboys and Indians the rest of your life."

Robison's songs—gritty, robust—reflect the man himself, a native Texan whose family has ranched in Bandera for six generations. Family, Texas history, and real life are the stuff of his music, and in Robison's case, you *can* go home again:

> If you're ever out west son, and you're feelin' like slowin' down
> I'll see you around, 'round my hometown
> I'll see you around, 'round my hometown.

("My Hometown," *Life of the Party* CD)

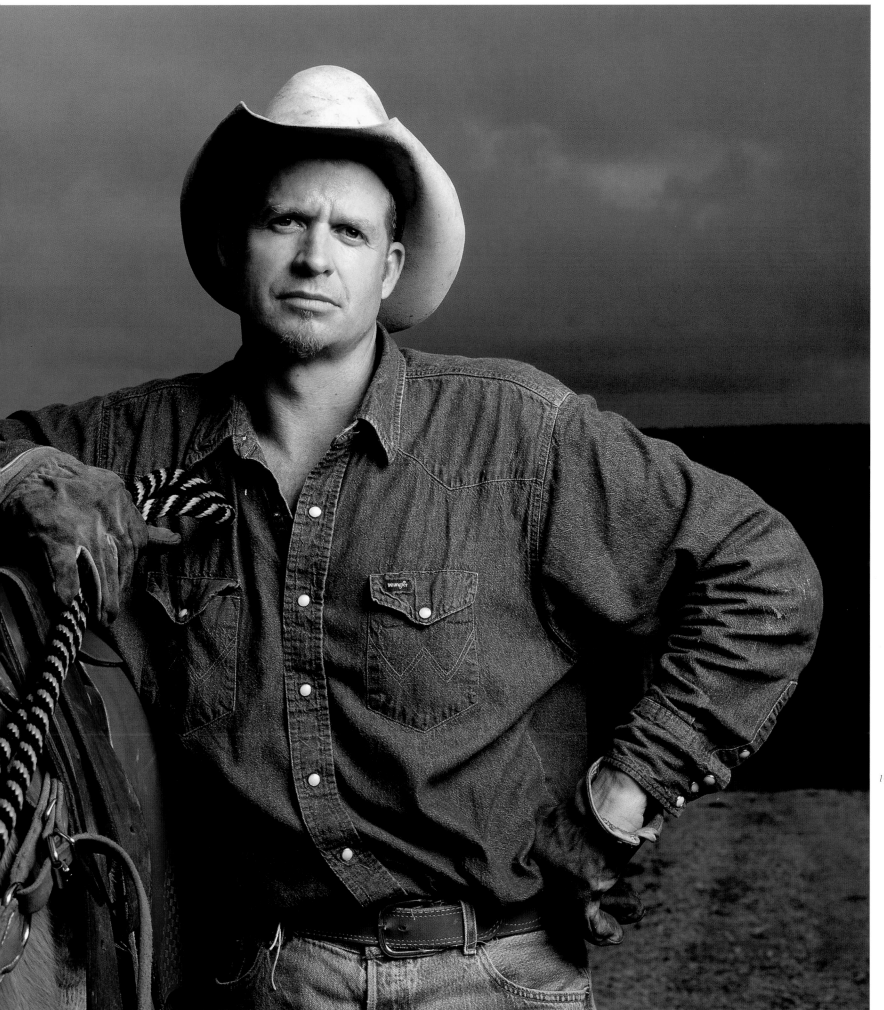

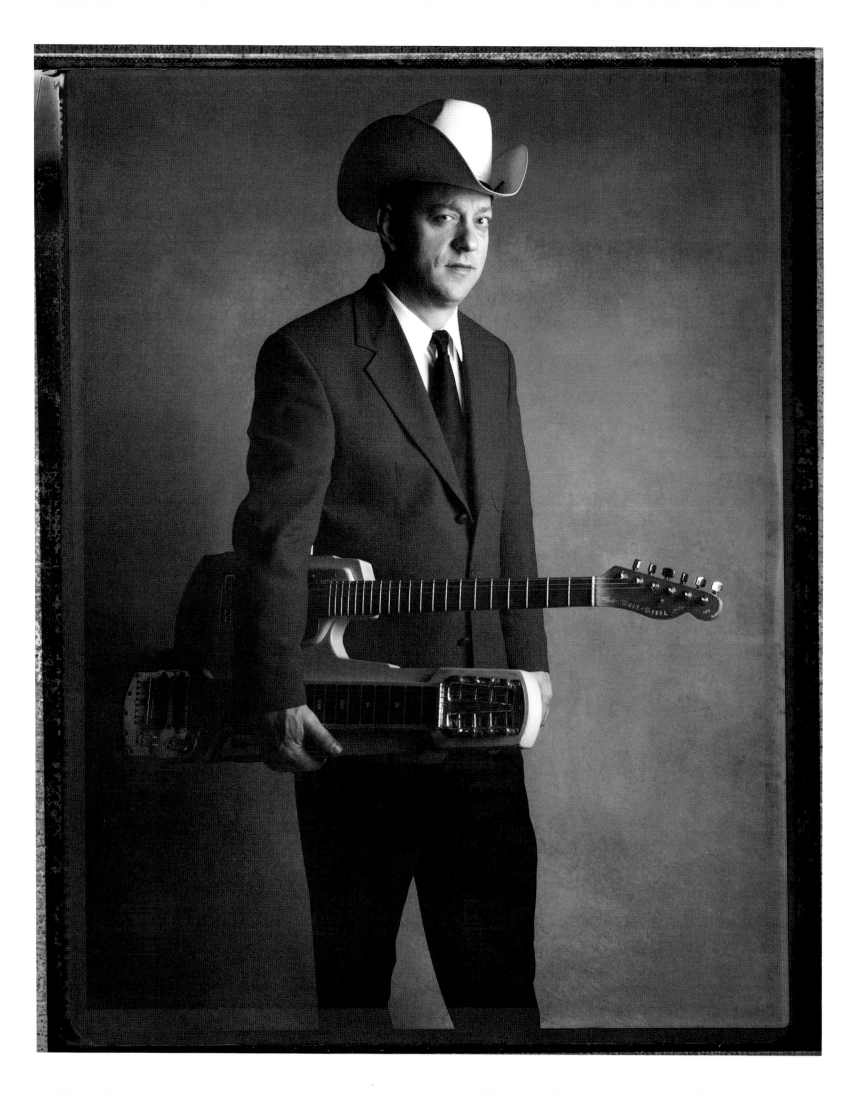

Junior Brown

Anyone who has seen Junior Brown perform can tell you he's a radical dude. He takes the stage wearing a crisp suit and tie, cowboy hat and boots, and wielding a strange-looking stringed instrument that looks like something out of a low-tech alien flick. He's accompanied by his band and his wife—"the lovely Miss Tanya Rae"—who, in her equally crisp skirt-and-jacket suit, looks like an IBMer. Then Brown, playing this "guit-steel" thing like Ernest Tubb in overdrive, opens his mouth with a reverberating country baritone that penetrates to the pit of your gut. His droll lyrics, meanwhile—on the order of "I got to get up every mornin' just to say goodnight to you," about a late-night girlfriend—complete the tongue-in-cheek picture, which is as compelling as it is incongruous.

Junior Brown—who grew up in the woods around Kirksville, Indiana; Chesapeake Bay and Annapolis, Maryland; and the piñon-studded hills of Santa Fe, New Mexico—wasn't happy with just a regular guitar; it didn't meet his musical needs. So he invented his own instrument.

"I was playing both the steel and guitar, switching back and forth a lot while I sang, and it was kind of awkward," said Brown. "But then I had this dream where they kind of melted together. When I woke up, I thought 'You know, that thing would work!'"

Brown took his dream to guitar-maker Michael Stevens, and the guit-steel—a single guitar body with both the steel guitar and six-string necks—was born.

There is no one like Junior Brown, and though most modern country radio stations still won't play his songs, he has forged his own unique path, all the way from small clubs like Austin's famed Continental Club and the Grand Ole Opry to some of the hippest venues in Manhattan and Europe. He's been nominated for three Grammys, and his latest album, *Mixed Bag*, has prompted reviewers to label him one of the greatest guitar players alive.

"A lot of people tell me they don't like country music," said Brown, who played the piano before he could talk, "but they like what *I'm* doing."

What he's doing is a peculiar but driving blend of country and rock 'n' roll that has prompted major magazines like *Musician* to dub him a "genius." *Life* magazine honored him as the only contemporary musician included in their All-Time Country Band. And his song "My Wife Thinks You're Dead" won Video of the Year at the 1996 Country Music Association Awards.

Brown considers his music "traditional honky-tonk, with some ideas thrown in."

"Texas has always been the place to welcome my music with open arms," said Brown, who has worked in Austin for more than three decades. "I've always been able to find an audience in Texas. That, in itself, has spiritual meaning."

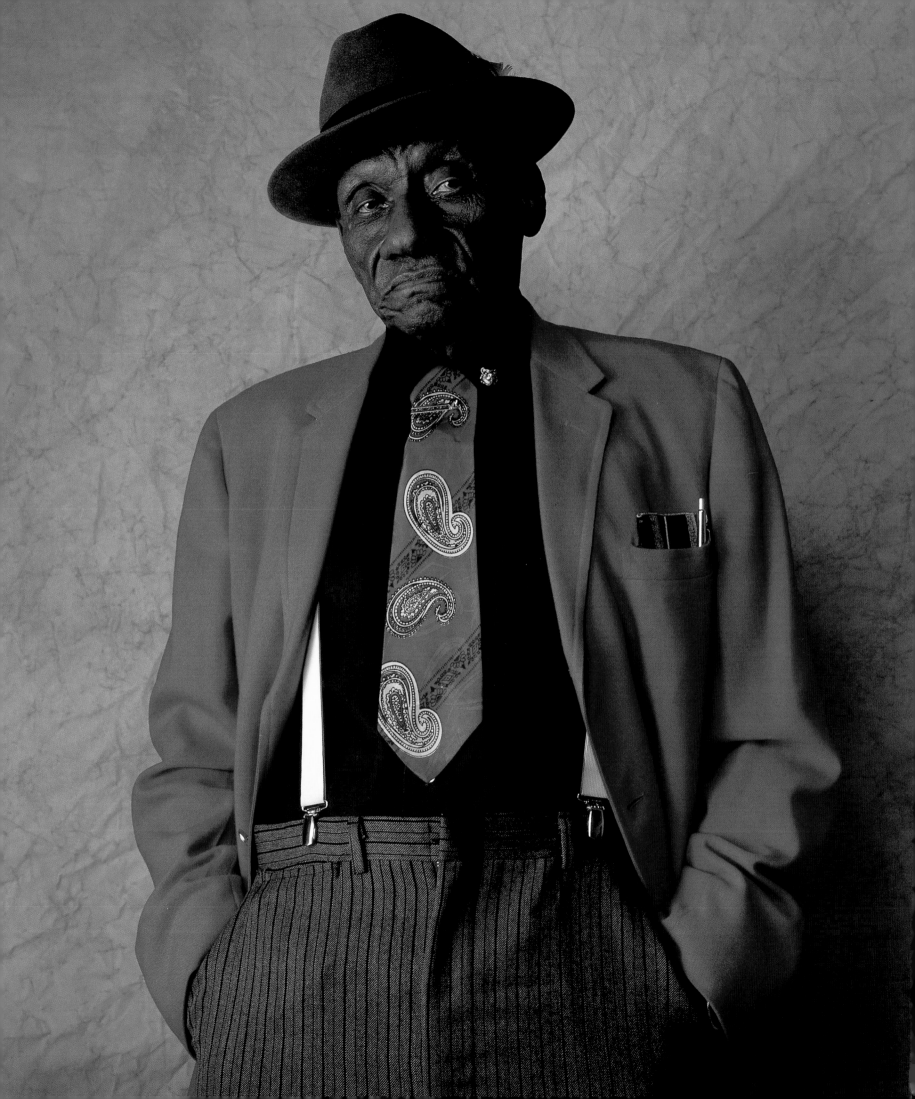

Roosevelt Thomas Williams

His fans knew him as the Grey Ghost; the nickname came from his penchant for suddenly materializing at a gig, then vanishing just as quickly. Roosevelt Thomas Williams (1903-1996), considered the last of the original barrelhouse blues pianists, spent years performing at clubs located along the Texas & Pacific Railroad line between Dallas and El Paso. Wearing overalls over his stage clothes, he would hop a freight train, jump out at the appointed town, stash his overalls in the bushes, and steal to the gig under cover of darkness. When he finished playing, he would slip back to the depot, slide back into his overalls, then hop a train to the next town.

"I'm just like a ghost," he told his bewildered fans, who never saw him arrive or leave. "I come up out of the ground and then I go back in it."

Williams, who was named after Teddy Roosevelt, was born December 7, 1903, in Bastrop, Texas, and raised in Taylor. During a music career that spanned over seventy-five years, he supported himself by laboring in cotton fields and cotton gins, bootlegging, gambling, working as a chauffeur, and driving an Austin school bus. Though he had brushes with fame when he was younger, it wasn't until Tary Owens—who had earlier recorded a collection of Williams's songs—tracked him down at eighty-three that the Ghost came back into the limelight. Williams spent the next several years traveling in style to prestigious gigs around the country. The mayor of Austin declared December 7, 1987, "Grey Ghost Day," and the following year he was voted into the Texas Music Hall of Fame.

But Williams is perhaps most famous for his regular happy-hour stint at Austin's Continental Club. When he was in his late eighties and early nineties, a whole new generation of fans flocked to the club to hear the first-generation Texas bluesman play and sing soulful tunes of a bygone era.

He spent the last year of his life in a nursing home, where he still enjoyed some of his old vices: eating barbecue, smoking cigars, and drinking a daily beer or whiskey before settling down to play the piano.

"I don't ever give up," Williams once said.

ZZ Top

Most people know them only by their collective name, but ZZ Top consists of three very distinct individuals: bassist Dusty Hill (left), guitarist Billy F. Gibbons (right), and drummer Frank Beard (seated), pictured here at the Old Humble Barbershop in Humble, Texas. The band keeps its business headquarters in Austin, although all three principals live in Houston.

ZZ Top became a household name after their World-Wide Texas Tour in 1976. The band's Texas-shaped stage, adorned with a real live buffalo, Longhorn steer, buzzards, and rattlesnakes, made a vivid—and permanent—impression on those who attended the concerts. Since then, the band has continued its tradition of "Takin' Texas to the People," with mythic concerts across the United States and in international venues as far afield as Japan, Russia, Latvia, and South Africa. The band's trademark hillbilly beards, sunglasses, Harleys, hot rods, key chains, and droll, synchronized stage antics—not to mention the shapely dancing girls on stage—cemented its quirky, Delta blues-based image. And ZZ Top's famous songs "Legs," "Sharp-Dressed Man," and "Gimme All Your Lovin'" imprinted the band's persona on at least two generations.

The members of "that little ol' band from Texas," as it is affectionately called, have been honored as "Official Texas Heroes" by the Texas House of Representatives; and the band was nominated by *Saturday Night Live* as a write-in candidate for president. ZZ Top even performed at President George W. Bush's inaugural celebration in a show billed as the "Best Little Ball in D.C."

The band's other claim to fame: it has offered its services to NASA as the lounge band for the first passenger flight to the moon. Incidentally, neither Gibbons nor Hill has had a close encounter with scissors since 1979.

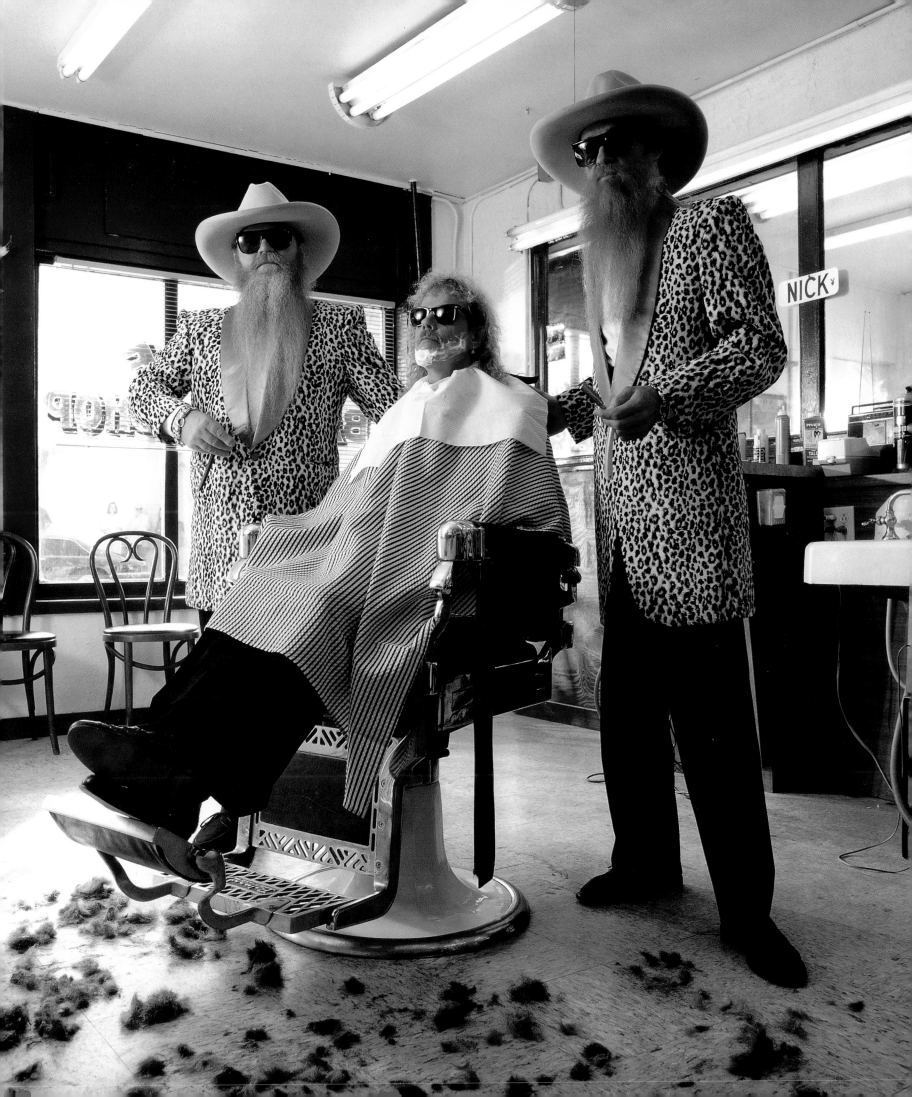

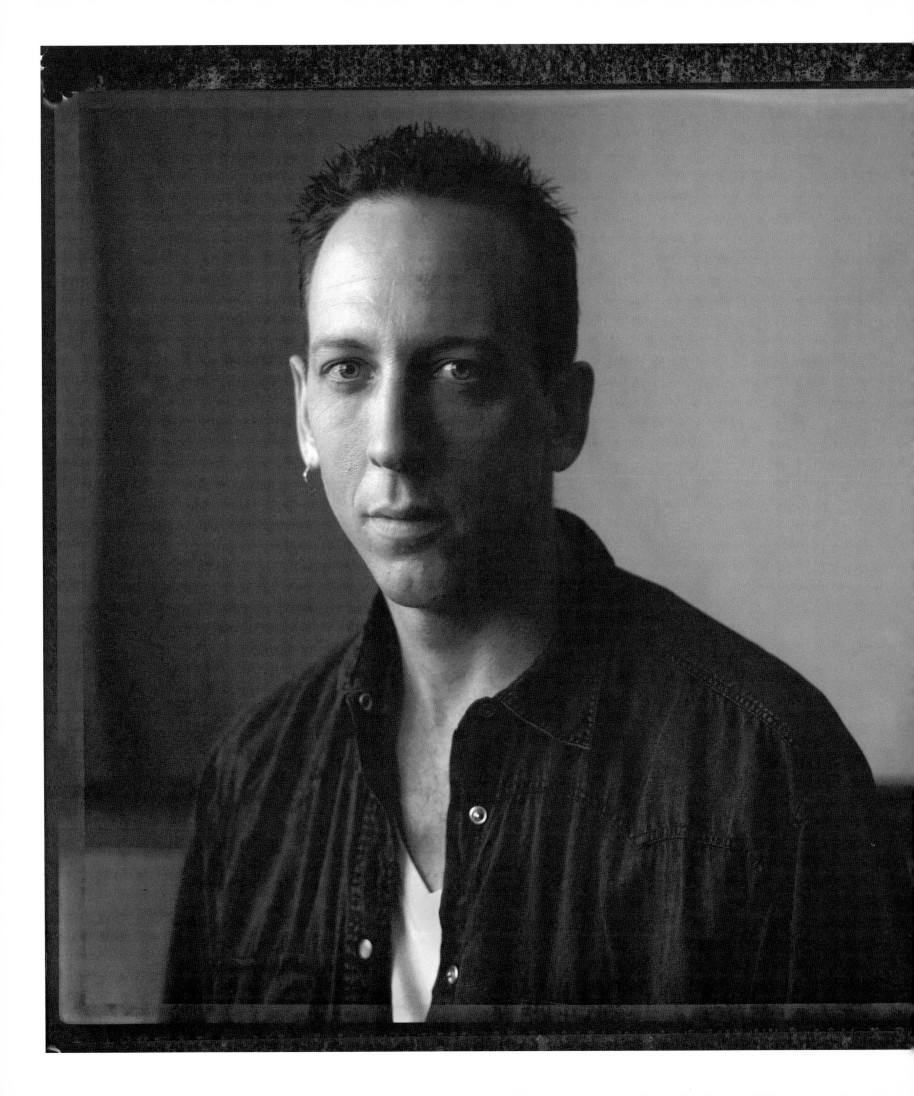

Darden Smith

AUSTIN, 1996

When nine-year-old Darden Smith stepped on a scorpion, his mother sliced a homegrown tomato in half and slapped it on the wound. Later, when she was bitten on the finger by a copperhead, she used the same remedy, coring a tomato and jamming her finger into the spongy hole, until she could drive herself—two kids in tow—to the hospital. Smith grew up in the country outside Brenham, and though he lives in Austin now, he works at maintaining the same kind of simplicity in his life. He keeps a tomato-heavy garden—and chickens—behind his house, landscapes his own yard, and works in a studio he built behind the garden.

"I've tried to move away from Texas several times, but never could," said Smith, whose grandfather was a fiddler and square-dance caller. "I think it's because of the landscape. The geography here grounds me. I've never been comfortable on a horse, but I'm a Westerner."

The singer-songwriter, who opened his first checking account in third grade to save money from his fresh-egg business, started playing guitar at nine and wrote his first song at ten. But it wasn't until later that he hit his true creative stride.

"In eighth grade, my family moved from Brenham to a suburb of Houston," Smith said. "We went from a family farm to a condominium across from a golf course. It was such culture shock! I started writing songs aggressively then."

Earning cash through a self-styled landscaping-and-odd-job business, Smith wormed his way into his older brother Dugan's band by being indispensable.

"They needed a mike and an amp, so I went out and bought the equipment," he said. "I told them that if they wanted to borrow it, I came with the deal."

Smith ended up taking over the band, and his brother, now a financial expert, moved on.

"Artistically, the trick is to keep going," said Smith, who at forty released his eighth record, *Sunflower*, an intimate, melodic work that celebrates renewal and reconciliation. "There's never a shortage of things to write about; there's just a shortage of focus."

But Smith, a practicing Buddhist, is making progress. Daily meditation helps him stay on track.

"When you're on a spiritual journey, your family, your work, takes care of itself. My spiritual path is about self-examination, and in order to do that, you have to be in the moment. Deep down, though," he said, laughing, "I'm still a Lutheran."

113

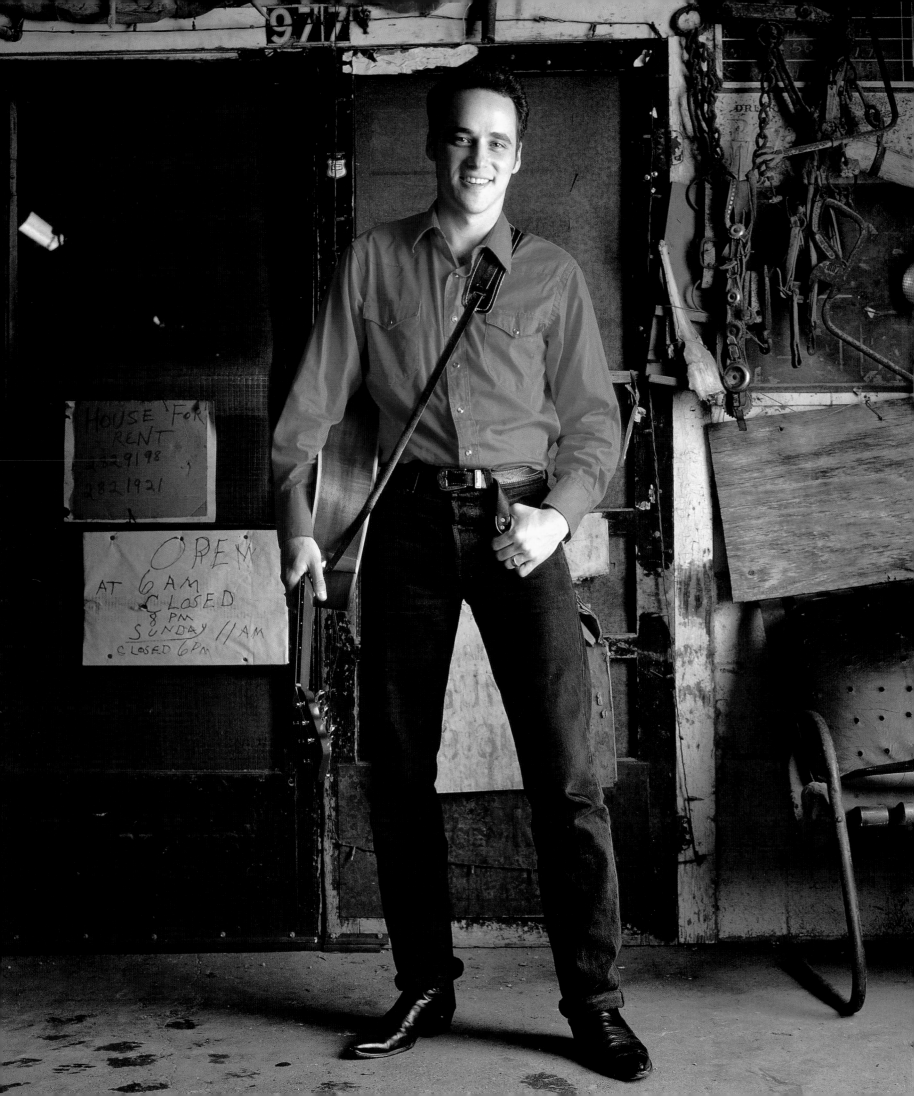

Monte Warden

K Y L E , 1 9 9 3

Career day at school never went very well for Monte Warden. When he arrived with his guitar, saying he planned to be a songwriter, his teachers were not amused. In fact, at O. Henry Junior High, one teacher called Warden and his friend Walter Slaughter—who dreamed of becoming a fighter pilot—before the class, citing them as examples of students with "unrealistic" career goals.

"You know what Walter was doing recently?" asked Warden, who has made a living singing and writing songs since he was eighteen—and who, with second wife Brandi, owns Moon Kiss Music, a successful publishing company. "He was dropping bombs on Afghanistan. I ran into him a few years ago and he said, 'Monte, do you realize we are the only people we grew up with who are actually doing what we said we would do?'"

Warden, a seventh-generation Texan, grew up on the corner of Enfield and Exposition in the heart of Austin. He walked to Cassis Elementary and O. Henry Junior High and rode his bike to Austin High. But school was not his focus.

"All I could think about were girls and my guitar," said Warden, who started playing guitar at ten and wrote his first songs at eleven. "When I got bitten by the music bug, it consumed me."

His father, pragmatic but supportive, took him to the record store, where Warden fixated on a picture of Buddy Holly on his *A Rock and Roll Collection* album.

"I was skinny, wore glasses, and had curly hair," said Warden. "I didn't think anybody could relate to me. When I saw Buddy Holly, he looked like me! My dad bought me that record, and it changed my life."

Warden started performing with the band Whoa, Trigger! when he was fifteen, then with the Wagoneers, and later on his own. He credits Texas dance halls and "the Texas attitude" with his early success.

"There are dance halls in Texas, and only in Texas; these are family places where everyone brings their kids," said Warden, who played his exuberant version of country-rock music at the Broken Spoke and Gruene Hall. "I never had to beg for a gig just because I was young. It didn't matter if I was fifteen or fifty, as long as I kept them dancing. In Texas, everyone's heart is as big as the sky. If you don't feel you can do anything you put your mind to—looking out at that big Texas sky—then you're a fool."

Warden, the father of two boys, is still thinking about career day. He's hoping, for his part, to make things right—for some kids. He's teaching an after-school songwriting class at his younger son Sam's elementary school. His students should pay attention: one of his songs, "I Wish I Was Wrong," recorded by Travis Tritt, has gone double platinum.

115

Willie Nelson

Willie Nelson is a man who has paid his dues. He has risen from a guitar-playing country boy with a dream—who got his start playing local honky-tonks—to a renowned songwriter and, ultimately, one of the most beloved entertainers of our time. Along the way, Nelson sold vacuum cleaners, encyclopedias, and Bibles, worked as a disc jockey, labored for years in songwriting obscurity in Nashville—and wrestled with the IRS over millions of dollars in back taxes. Though it was his accounting firm that steered him wrong, it was Willie who took the rap.

In addition, Nelson, the father of six children, has weathered three divorces (he's on his fourth marriage).

Through it all, Nelson has managed to stay true to his dream and give back more to the world than he has ever gotten. Almost every year since 1972, he has hosted a now-famous Fourth of July picnic for his fans. One of his greatest contributions, besides his music, is Farm Aid, a series of concerts he helped organize that has raised millions of dollars to help the plight of independent farmers. The simple country life is deeply personal to Willie Nelson; he was born south of Fort Worth, in the farming community of Abbott, Texas, in 1933, and he grew up there on his paternal grandparents' place on the edge of town. In his book, *The Facts of Life and Other Dirty Jokes*, Nelson writes:

> We still have a home in Abbott. We bought the house Dr. Simms
> used to live in. He's the doctor who delivered sister Bobbie and me.
> The house is about a quarter of a mile from where I was born. I go
> there when I can, and run and bike the same places again and again.
> They say you can't go back. Maybe they can't, but I can. Thank you,
> Abbott, for never changing.

Not forsaking his love for the country, Nelson now makes his home in Spicewood, near Dripping Springs outside Austin, where he owns a ranch, complete with an old Western movie set he calls Luck, Texas, which was the location for the movie *Red Headed Stranger*.

Nelson, author of such timeless American ballads as "Crazy," "Blue Eyes Cryin' in the Rain," and "On the Road Again," was inducted into the Country Music Hall of Fame in 1993.

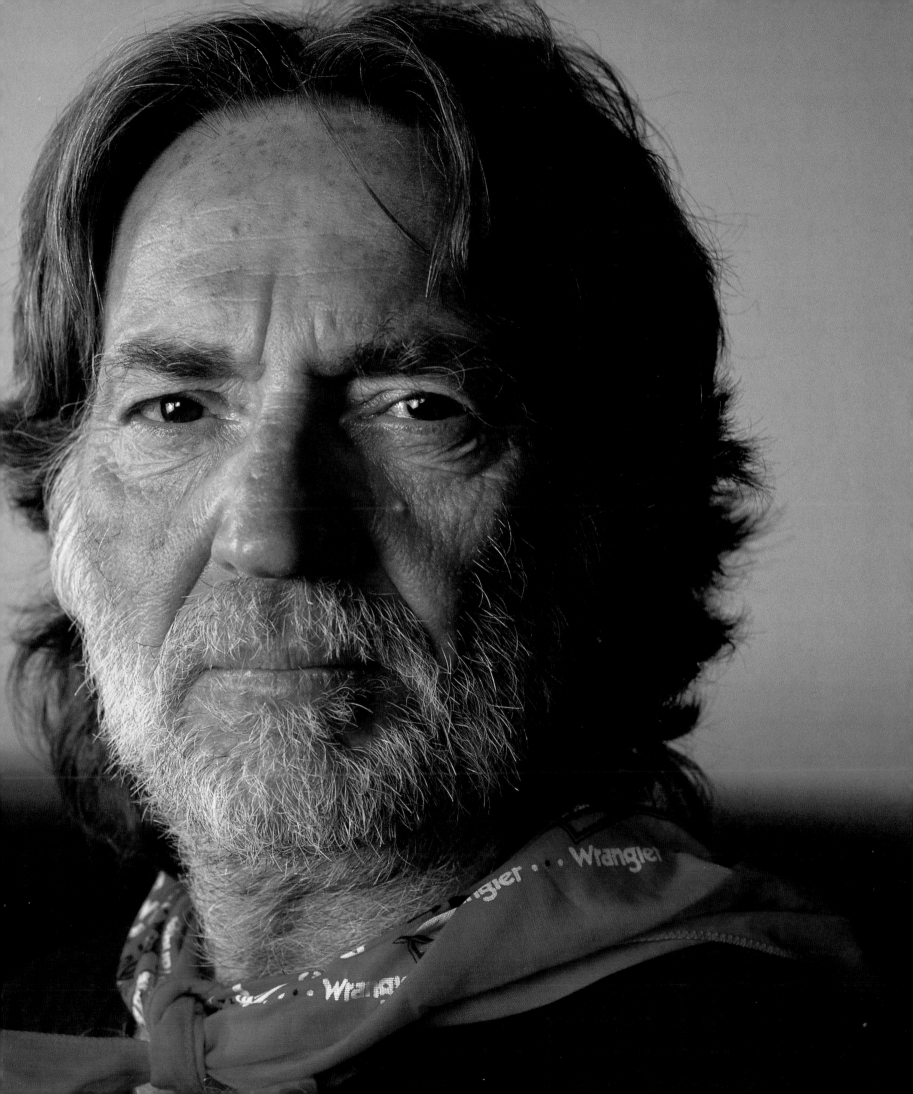

Jaci Velasquez

HOUSTON, 2000

Jaci Velasquez's parents claim that her talent emerged even before she could walk or talk: when she was in her crib, and she heard the music that her parents were playing in the other room, she waved her tiny fingers in perfect time to the music. When she was two, she would sing along with the choir, belting out "Our God Reigns" in a powerful voice back in the church nursery. Velasquez said that it was her devoutly Christian parents who shaped her more than any musical influence.

"I want it to be crystal clear to people," said Velasquez, a native of Houston who is of Mexican and Spanish ancestry, "that I am who Christ has made me to be, and I'm attempting to follow in his footsteps."

Velasquez, the young, inspirational singer whose album sales have topped the three million mark, grew up in a musically gifted family. Her father, David Velasquez, was lead singer of the Four Galileans, who won the award for Most Promising New Gospel Talent at the second annual Dove Awards. Jaci won her first major contest at eleven, over a field of 3,000 competitors, and by the time she was thirteen, she had already performed at the White House. She, too, has distinguished herself at the Dove Awards, winning four so far, including Female Vocalist of the Year. Her first million-selling recording, *Heavenly Place*, became the fastest-selling solo debut in the history of contemporary Christian music; and she has written a book by the same title containing inspirational thoughts. In addition, she's had sixteen number-one radio hits, and she has released two albums in Spanish. But Velasquez is equally proud of her work as a spokesperson for the popular national campaign True Love Waits, which espouses sexual abstinence until marriage.

Kelly Willis

T A Y L O R , 1 9 9 3

Kelly Willis was new to Austin when she was "discovered" by singer Nanci Griffith. Willis was singing at Austin's Continental Club in 1990 when Griffith wandered in and caught the end of her set. Griffith was so impressed by the plaintive, sensual, country voice of the pretty, young singer that she headed for the phone and dialed MCA producer Tony Brown. A few months later, a record deal was struck, and Willis was on her way with her debut album, *Well Traveled Love*.

She's had lots of ups and downs since then—including a disappointing experience with the highly commercial Nashville music scene and a parting of the ways with MCA—but at thirty-two she got back on track with the CD *What I Deserve*, released on the independent label Rykodisc to glowing reviews. In the last couple of years she's followed that up with *Easy*, her latest CD, which she co-produced.

Willis is not a Texan by birth. She was born in Lawton, Oklahoma, the youngest of three children, and grew up in North Carolina and Virginia. Her particular twang is resonant of these formative years. She got her start in high school. One day at a beach arcade, she slipped into a coin-operated recording booth and sang Elvis Presley's "Teddy Bear." She took the demo and parlayed it into a spot in her boyfriend's rockabilly band. Kelly and the Fireballs became a moderate success around the D.C. area in the late '80s before they moved on to Austin.

Willis's reputation has been enhanced by some forays into big-time celebrity. She appeared in the film *Bob Roberts*, directed by and starring Tim Robbins. She was selected as one of *People* magazine's Fifty Most Beautiful People. Her songs were featured in the films *Thelma and Louise* and *Boys*. She posed for some glossy magazine photo spreads—*Vogue* among them. And she performed at a mansion gala honoring President Clinton at $1,000 a plate.

But the singer, who's known among the local media as "the voice of Austin," seems determined now to concentrate on the basics: writing good songs, performing with musicians she admires, and maintaining artistic control of her career. If blockbuster success eludes the shy, ethereal artist, so be it.

"Since I was raised an army brat . . . Texas was the first connection I had to any place," said Willis, who lives with husband Bruce Robison, a respected singer-songwriter, and their son, Deral. "I feel lucky to be connected to the landscape of Texas—the earth—the dirt and rocks. It makes me feel whole, complete, and peaceful."

Destiny's Child

HOUSTON, 2000

The Houston-based R&B vocal group, in an earlier incarnation, left to right: Farrah Franklin, Beyoncè Knowles, Kelly Rowland, and Michelle Williams, photographed for the May 2000 issue of *Texas Monthly*. Franklin and Williams replaced original members LaTavia Roberson and LeToya Luckett, who quit the band after a dispute with their manager. The original members—who also included lead singer Knowles and Rowland—began singing together when they were children. They had their first number-one single with "No, No, No" when their average age was sweet sixteen; the song went multi-platinum and put the group on the musical map.

Though she didn't invent the term, Knowles catapulted the rap term "bootylicious" into the pop lexicon when the group's "Bootylicious" single from the group's number-one *Survivor* album—along with the video of the song, featuring a cameo of Stevie Nicks—was released. "It's about having confidence and feeling good about your mojo and whatever you have," said Knowles, who came up with the title after listening to a Nicks CD on an airplane. The term is also used to describe an especially attractive member of the opposite sex, or a particularly delicious food item, according to one slang dictionary; or, simply, "yumehh," according to another.

But Destiny's Child also has a serious, philanthropic side. The group has established a charity, The Survivor Foundation, which has donated a good deal of money to AIDS Foundation Houston (AFH); and the singers have become public advocates of HIV/AIDS education and social services. In addition, the group donated 300 of their signature dolls to AFH's Camp Hope, a camp for children living with HIV/AIDS.

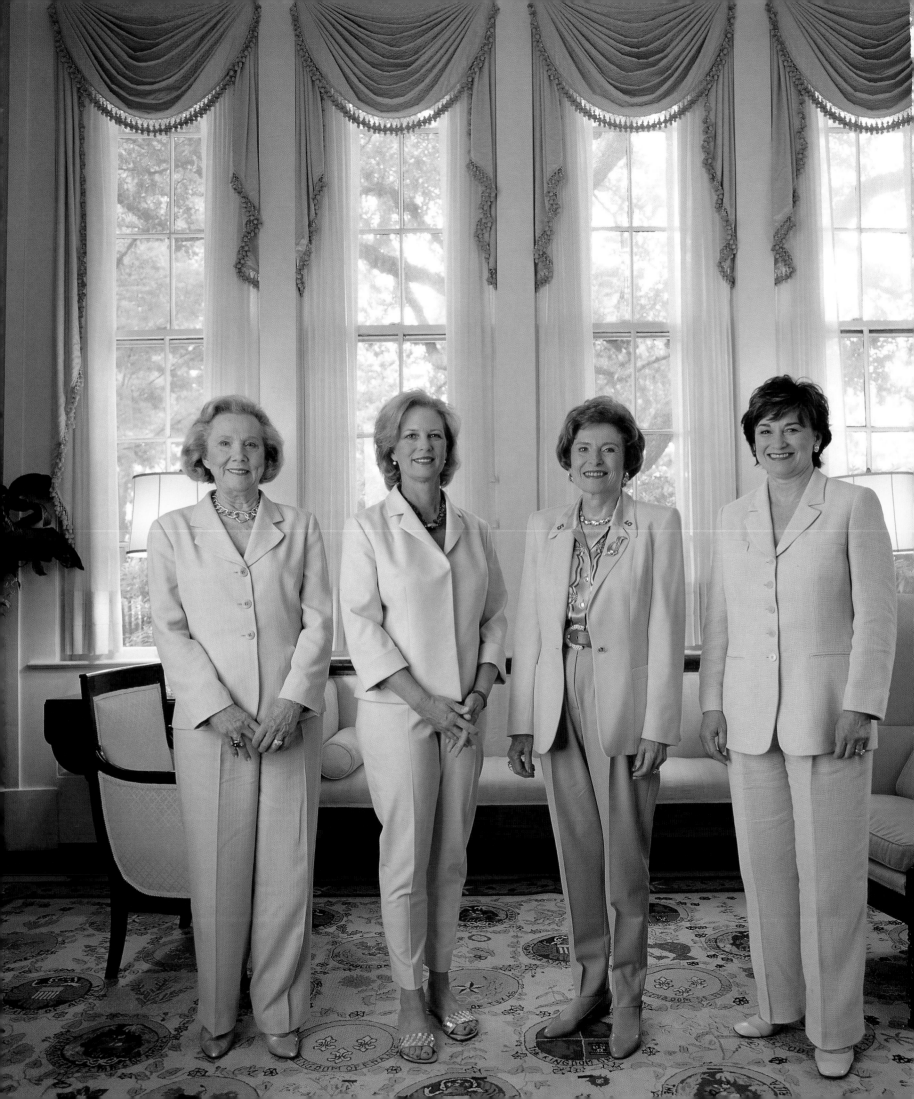

First Ladies *of* Texas

Former Texas First Ladies Nellie Connally, left, Rita Clements, second from right, and Linda
Gale White, far right, flank First Lady Anita Perry at the Governor's Mansion in Austin in
2002. The women met for a *Texas Monthly* photo shoot and brunch, during which they
discussed favorite recipes and reminisced about entertaining at the mansion.

Nellie Conally's husband, John Connally, served as governor from 1963–1969; Rita
Clements's husband, William P. Clements, Jr., served two non-consecutive terms, the first
from 1979–1983, and the second from 1987–1991; Linda Gale White's husband, Mark
Wells White, served from 1983–1987; Anita Perry's husband, Rick Perry, became governor
in 2000 when George W. Bush left the Governor's Mansion for the White House. Perry
remains governor, having won a four-year term in 2002.

Johnson Colleagues

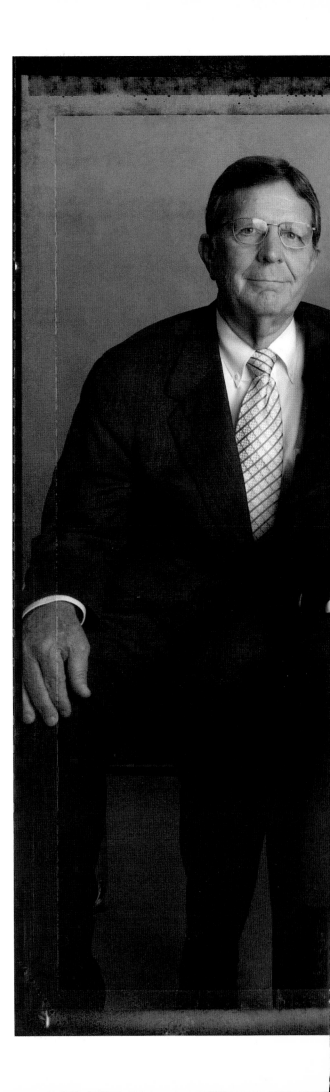

AUSTIN, 2000

Some of LBJ's Texas "inner circle" were photographed in 2000 for *Texas Monthly*. From left to right: Larry Temple, special counsel to the president, 1967–1969, now a lawyer in Austin; the late A. W. Moursund, longtime business partner, formerly a lawyer, rancher and businessman in Round Mountain, Texas; the late Walt W. Rostow, chairman of the Policy Planning Council for the State Department, 1961–1966, and national security advisor, 1966–1969, later a professor emeritus at the University of Texas at Austin; Ernest Goldstein, special assistant to the president, 1967–1969, retired as legal advisor to the Harry Ransom Humanities Research Center in Austin.

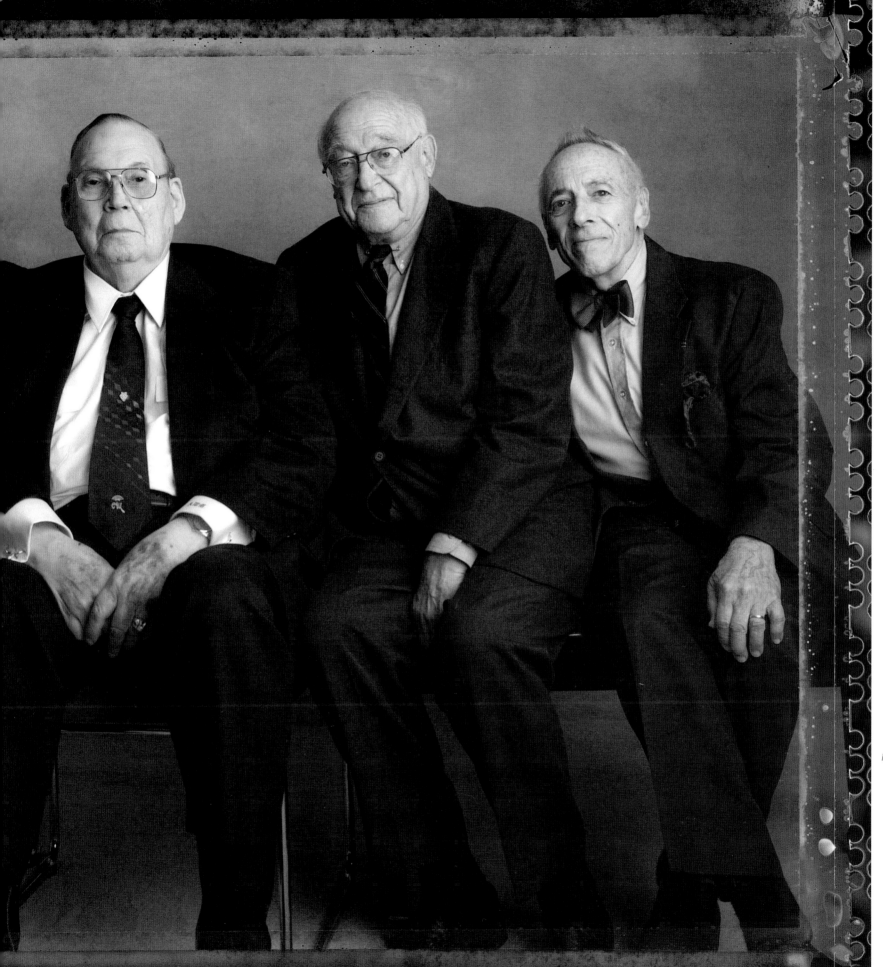

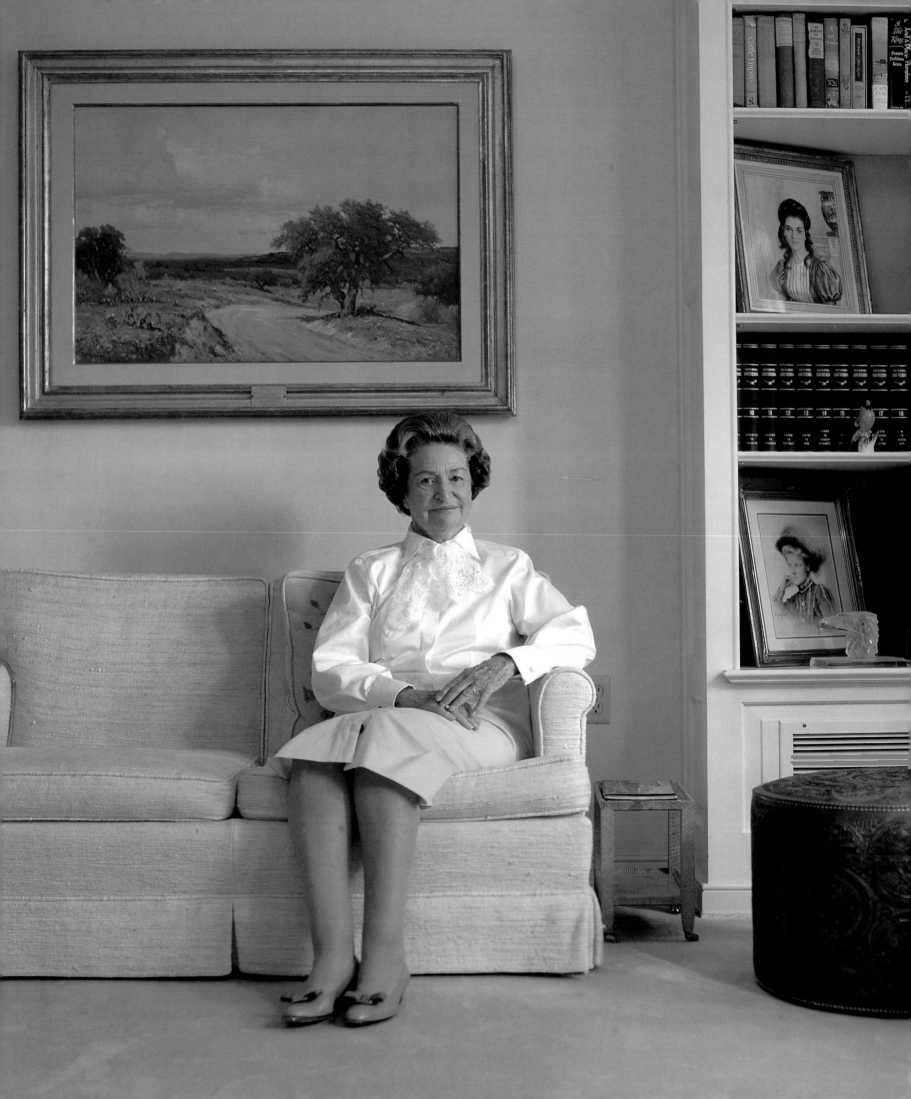

Lady Bird Johnson

Lady Bird Johnson was a president's wife, an accomplished first lady, but she has lived a lifetime on her own since then, making a distinct mark on the world—literally. Her dedication to beautification projects—specifically her founding of the National Wildflower Research Center, now the Lady Bird Johnson Wildflower Center, and her program to plant wildflowers along Texas roads and highways—has had a profound impact on the state, not only aesthetically, but environmentally. And her dream—to encourage the planting of indigenous species in yards, in parks, and along thoroughfares—has influenced individuals and environmental organizations around the world.

"My hope for what lies ahead in the field of landscape design . . . is not a revolution against the use of non-natives, but a resolution to educate ourselves about what has worked for Mother Nature through the ebb and flow of time, and to put that knowledge to work in the planned landscapes that are everywhere a part of our lives," she says in her Wildflower Center missive. "Beauty in nature nourishes us and brings joy to the human spirit. It also is one of the deep needs of people everywhere."

Claudia Alta Taylor got the nickname "Lady Bird" as a little girl when one of her nursemaids pronounced her "as purty as a lady bird." She was born December 22, 1912, in Karnack, Texas, to an affluent family. Her mother, Minnie Pattillo Taylor, died when she was just five, and Lady Bird was raised by her father, Thomas Jefferson Taylor—owner of a general store—with the help of her Aunt Ettie and the family servants. She had two older brothers, Tommy and Tony.

She attended the University of Texas when women were the exception on college campuses, earning a BA in history in 1933 and a degree in journalism the following year. She met Lyndon Baines Johnson, the future thirty-sixth president of the United States, in 1934 when he was a congressional aide. They were married later that year.

Lady Bird played an important role in her husband's political career. She borrowed from her inheritance to finance his first congressional campaign; and she ran his office when he served in the navy during World War II. After the assassination of President John F. Kennedy, she followed Jackie Kennedy, who had set a new, elegant standard as the feminine White House counterpart. But Lady Bird established her own identity, supporting the "war on poverty" and the Headstart program for preschool children. She began her beautification work in Washington, D.C., with her First Lady's Committee for a More Beautiful Capital.

Lady Bird and Lyndon Johnson had two children: Lynda Johnson Robb and Luci Baines Johnson. Lady Bird considers "home" the LBJ Ranch in Stonewall, Texas.

The Johnson Family

AUSTIN, 2001

Photographer Michael O'Brien describes how he created the Johnson family photo, which now hangs in the LBJ Library:

"*Texas Monthly* assigned me to photograph Lady Bird Johnson and her daughters, Luci Baines Johnson and Lynda Johnson Robb, for its August 2000 cover, and the larger Johnson family (some of whom weren't available at the time) for an inside spread.

"We decided that the easiest place to do the photography was at the LBJ Library. Everyone arrived and the portrait session took a couple of hours. It was wonderful seeing Mrs. Johnson delight in watching her great grandchildren scamper through the vast auditorium on the top floor of the library.

"*Texas Monthly* published the family picture over two pages inside the magazine. Shortly thereafter, I received a letter from Harry Middleton, then director of the LBJ Library, inquiring about the possibility of photographing the missing members of the LBJ family and digitally adding them to the original picture. He said that not only did Mrs. Johnson want a portrait of the whole, extended family, but also the LBJ Library needed an updated portrait for its "Family Album" exposition.

"I told Harry that I had never before attempted anything like this but would love to try. I was able to make photographs of the previously missing family members when the Johnson family gathered at the LBJ Ranch for the Christmas holidays. Then, I enlisted the high-tech help of Peter Yang, a young, gifted newspaper photographer adept at Photoshop software, to coach me in digitally composing the larger picture and particularly in positioning the additional family members. We simply added two more photographs—Senator Charles Robb, and the remaining members of Luci's family—and merged them into the original shot. Lady Bird was so grateful for the gesture that she presented me with some homemade jam.

"It was my first venture into digital photography, and I am truly amazed at the result. Today I look at the picture and cannot believe that it is actually three pictures combined into one."

1.	Ian Turpin	8.	Lyndon Nugent	15.	Lynda Johnson Robb
2.	Claudia Nugent	9.	Luci Baines Johnson	16.	Taylor Nugent
3.	Jeremy McIntosh	10.	Johnson Covert	17.	Tatum Nugent
4.	Rebekah Nugent McIntosh	11.	Claudia Covert	18.	Lucinda Robb
5.	Eloise McIntosh	12.	Nicole Nugent Covert	19.	Catherine Robb
6.	Brent Covert	13.	Lady Bird Johnson	20.	Charles Robb
7.	Nicole Nugent	14.	Jennifer Robb		

Harry J. Middleton

A U S T I N, 2 0 0 0

Harry Middleton, longtime director of the Lyndon Baines Johnson Library and Museum at the University of Texas at Austin, created the model for presidential libraries. Under his thirty-year leadership, the institution—one of ten presidential libraries administered by the National Archives and Records Administration— became one of the most prestigious, well-endowed centers for scholarly research and cultural endeavors in the country. It houses a staggering 45 million pages of historical documents from President Johnson's era.

But Middleton, who recently retired, has another, more sensational claim to fame: he is the one man responsible, besides Johnson himself, for the new, more heroic view the public holds of the former president. *Texas Monthly* calls him "the man who saved LBJ." In the early '90s, Middleton decided to break the fifty-year ban on Johnson's secret White House tapes and release them to the public; as a result, Johnson has been revealed as the master politician and complex, sensitive human being he was.

Middleton, a graduate of Louisiana State University, was well qualified for the directorship he took on in Austin in 1971. He first met Johnson in 1966, when he was writing the report of the Presidential Commission on Selective Service. Johnson liked him and hired him on the spot. From 1967 to 1969, Middleton served as one of LBJ's staff assistants, writing speeches for him during the latter part of the administration. He also worked with Johnson in the preparation of his memoirs.

Middleton began his career as a journalist. He was a reporter for the Associated Press in New York; news editor for *Architectural Forum*, a Time, Inc. publication; and a freelance writer for such high-profile magazines as *Reader's Digest*, *Cosmopolitan*, *Life*, *Collier's*, and *Sports Illustrated*. He has authored several books, including *Pax* (1958), *The Compact History of the Korean War* (1962), *LBJ: The White House Years* (1990), and *Lady Bird Johnson: A Life Well Lived* (1992). His awards include the Presidential Rank of Meritorious Executive in 1991; the Anti-Defamation League's Torch of Liberty Award in 1992; and the University of Texas Presidential Citation in 2001.

Middleton now serves as executive director of the LBJ Foundation, the organization that supports many of the LBJ Library and Museum's activities that are not funded by the federal government. A native of Iowa, he has considered Texas his home for many decades.

"I am a Texan by choice," he said. "Another thirty years and I'll get my citizenship papers."

133

Laura Welch Bush

When she was a little girl, Laura Welch Bush, a native of Midland, Texas, dreamed not of being a governor's or a president's wife, but of becoming a teacher. Before she even started elementary school, the first lady would line up her dolls in a pretend classroom and lecture and instruct them.

Mrs. Bush fulfilled her goal—she earned an education degree from Southern Methodist University in 1968 and worked as an elementary schoolteacher in Dallas and Houston—and went far beyond. In 1973, she received her master of library science degree at the University of Texas at Austin, putting it to use first as a librarian at the Houston Public Library and later as a school librarian at Dawson Elementary in Austin, the job she held when she met her future husband.

In 1995, during her tenure as Texas first lady, Mrs. Bush was instrumental in establishing the first annual Texas Book Festival. Now, as the wife of the forty-third president of the United States, she is an educator-at-large, pushing her national initiative called Ready to Read, Ready to Learn, which encourages regular reading with an adult for pre-school children. On September 8, 2001, Mrs. Bush launched the first National Book Festival with the Library of Congress in Washington, D.C., which featured authors from around the country and attracted thousands of participants. Just three days later, on September 11, 2001, while Mrs. Bush's husband was reading to schoolchildren at Emma E. Booker Elementary School in Sarasota, Florida, he was informed that a second airplane had hit the World Trade Center.

By all accounts, Laura Bush—though not avidly political—has been an asset to her husband's career. She is regarded as a genuine, sincere individual who is soft-spoken but strong. When her husband's formidable grandmother asked her, as a newlywed, what she did, Mrs. Bush replied that she read and she smoked. (She quit years ago.)

Mrs. Bush is active in promoting women's health issues, particularly breast cancer awareness. And she is the first president's wife to record a full presidential radio address—speaking out against the oppression of women and children by the Taliban in Afghanistan.

The Bushes maintain a strong connection to Texas with their ranch, the "Texas White House," in Crawford. Mrs. Bush, who is fond of gardening and long walks with her husband, considers their Texas home the most romantic spot on earth and prefers Texas to anyplace else.

"There's a certain wide openness about the space and the landscape, but also about the people," she has said. "A Texan is a really independent person with a lot of spirit."

George W. Bush

AUSTIN, 1999

George W. Bush, forty-third president of the United States, maintains a strong presence in Texas with the "Southwest Wing," his sixteen hundred-acre ranch in Crawford, Texas. The ranch, considered the "Texas White House," includes a creek, canyons, waterfalls, and meadows where deer and cows graze. The Bushes renovated an existing farmhouse and built a new home there; and Bush relaxes by fishing in a man-made lake that he's stocked with bass. He conducts some official business there, including CIA briefings, and he used the Crawford High School gym to announce Colin Powell as his secretary of state designee.

"When I'm not in Washington," he has said, "there's a pretty good chance you'll find me on our place in Crawford, Texas."

Bush, an Ivy Leaguer from an affluent family, is unquestionably his famous father's son. But in spite of his blueblood background, this Bush—who inherited a redeeming dose of his mother's warmth—comes across as an accessible, down-to-earth Texan. As the forty-sixth governor of Texas—the first governor of the state to serve consecutive four-year terms—he lived in the requisite palace in Austin but behaved like a family man. He kept dogs and cats in the Governor's Mansion and sent his twin daughters, Barbara and Jenna, to Austin High, a public school. Bush's wife, the former Laura Welch, is a genuine, sincere individual who worked as a teacher and librarian before the two met.

When he ran for president, Bush billed himself as a "compassionate conservative"—a calculated political label designed to appeal to both parties. He garnered humanitarian points for speaking Spanish to his Hispanic constituents and, unlike Clinton, earned popular respect for admitting that he had partied so much in the past that it forced a critical reckoning. As president, Bush is sincere but unapologetic, admits what he doesn't know, is not afraid to show emotion, and takes responsibility—for the economy, for foreign policy, and for the terrorist threat.

Bush was born in New Haven, Connecticut, and grew up in Midland, and Houston, Texas, where his father, the former president, worked in the oil business. Like the elder Bush, he attended Phillips Andover Academy in Massachusetts, then Yale University, graduating with a bachelor's degree in 1968. He served as an F-102 pilot for the Texas Air National Guard, attaining the rank of lieutenant, but was never called to Vietnam. He earned his MBA from Harvard Business School in 1975. Before his stint as governor, he worked in the oil business, launching Bush Exploration, an independent oil and gas company; ran unsuccessfully for the U.S. House of Representatives; worked on his father's successful presidential campaign; and became managing partner of the Texas Rangers baseball team in Dallas.

The First Family includes dogs Spot and Barney and a cat, India. The dogs often accompany the Bushes to the "Texas White House" in Crawford.

Red Adair

Paul Neal "Red" Adair is an old-fashioned American hero. Adair, son of a Houston blacksmith, is an innovator and a legend in the petroleum industry for fighting oil and gas well fires and controlling blowouts around the globe. He has developed the most reliable fire-fighting equipment in the industry.

Adair worked in various oil field jobs from 1938 until he went into the U.S. Army in 1945 to serve in the 139th Bomb Disposal Squad. At the end of World War II, he returned to Houston and went to work for Myron Kinley, the "original pioneer" of oil well fire and blowout control. Adair worked for Kinley until 1959, when he formed the Red Adair Company, Inc. Over some three decades, he and his men—at great personal risk—extinguished some of the most notorious oil well fires: the "Devil's Cigarette Lighter" blaze in the Sahara in 1962; the offshore fire at Bay Marchand, Louisiana, in 1970; the IXTOC#1 blowout in the Gulf of Mexico in 1979; the fire on the Piper Alpha oil platform in 1988; and most famously, 117 flaming oil wells in Kuwait, set ablaze by Saddam Hussein's Iraqi forces near the end of the Gulf War. Experts predicted the Kuwait firestorm would take three to five years to defeat; Adair and his men killed the fires in just nine months.

A. V. Jones, Jr., long-time domestic and international oilman from Albany, Texas, commented: "By fighting some of the world's worst oil well fires, Red Adair developed the reputation as *the* man who could put them out. Consequently, there was never a price negotiation when making the call to Red; it was a million dollars, up front—no questions. He'd let you know when you had used up a million dollars, and you would go from there. Typically, Red would fly into a location, no matter if it was Shackelford County, Texas, or Saudi Arabia. He would carefully but quickly size up his adversary, and soon a small army of men and equipment would arrive from all over the world. He was fond of saying things might not go the way he expected, but there were very few blowouts that he did not conquer."

For his heroism, Adair—who dropped out of high school to help support his four brothers and three sisters—has been honored by Presidents Carter, Johnson, and Bush; and he has received numerous awards, including the Outstanding Houstonian Award, the American Academy of Achievement Golden Plate Award, and the Franklin Institute's Walton Clark Medal. Adair also served as a consultant for the John Wayne film *Hellfighters* (1968), for which he and his men were the inspiration. The famous fire fighter is the subject of an authorized biography, *Red Adair: An American Hero.*

Since 1993, Adair has worked largely as a consultant.

"I grew up in Texas; I've lived here all my life," said Adair. "Even though I've been to every continent on earth except Antarctica, I've always called Texas home. It's the best place in the world."

John Bray

John Bray was born in Haskell County, the youngest of four children. He grew up on a farm in the Post community, where his chores included chopping cotton in the fields and "heading maize"—pulling the heads off the stalks and throwing them into a horse-drawn wagon. He attended the rural Paint Creek School, graduating in 1940. When he was a little shaver, and would get cross, his siblings would crank up the phonograph, play a lively tune, and his older brother would sweep him up in his arms and dance around the room with him—always putting him in a happy mood. This might explain Bray's lifelong penchant for dancing. He and his late wife, Marge, longtime *Fandangle* director, were like Fred Astaire and Ginger Rogers on a dance floor.

During World War II, he was stationed in the Philippines on the island of Samar, where he was a mail clerk in the U. S. Navy shore hospital.

In 1946, Bray returned home and went to work at the First National Bank of Albany, Texas, just fifty-five miles from where he grew up. He's been there ever since; and although the widower is "past retirement age," he is still a fixture at the bank, where his duties include helping with loans and IRAs and "just odds and ends that help the other officers and tellers."

He holds a degree from the Southwestern Graduate School of Banking at SMU, where his thesis was "Cattle and Oil, the Two Industrial Economies of Shackelford County"—and cattle and oil still dominate today.

Quiet and unassuming, a pillar of integrity, Bray is often called the most trusted man in Albany. For over fifty years he has quietly and efficiently served his community, participating in and supporting every civic endeavor as well as fulfilling his financial position in the daily business lives of Albany citizens.

Bray, a lanky gentleman who said with a chuckle that he stands "five foot, sixteen and a half inches," considers himself fortunate in his birthright.

"I'm proud to be a Texan," he said, "born and raised."

Annie Mae Hayes

Annie Mae Hayes (1924–2002) was manager and dispatcher for City Taxi in Waxahachie, Texas, for twenty-four years. But to friends and family, she was a great deal more.

"We worked together for years," said Bertha Johnson, another dispatcher at City Taxi. "Every time I think of her, I start to cry. She'd go out of her way to help anybody. When someone didn't have a place to stay, she always opened her door. Even though she had nothing, she'd say, 'You can come in and sleep on the floor.' She'd give you her last dime and do without herself."

Theodore Hayes, her only son, said his mother—who worked in her younger years as a nurse's aide at the Veteran's Hospital in Dallas—was a positive force.

"She could find something good in any kind of adversity, and she always had something good to say," he said. "She didn't meet any strangers. She was pretty as a button and had a heart as big as Texas."

Hayes's boss, Robert Baber, owner of City Taxi, mourns her loss.

"Annie Mae was known throughout Ellis County," said Baber, who's owned City Taxi for ten years. "She was a very religious person. She wasn't a crusader, but she was very outspoken in her way about lots of issues around Waxahachie, like school desegregation. It went very well here because of people like Annie Mae, because people *listened* when she talked. People of all kinds, mothers and fathers, would stop by the cab stand. And if they didn't catch her here, they'd catch her at church. Her way was not one of force; she was one who believed in the soft answer, the quiet spirit, and silence in the time of an uprising. It always brought forth the right kind of fruit. She would say, 'Always be in a position where you can turn the other cheek.' That was Annie.

"She was here until she just couldn't go anymore. We miss her greatly every day. Annie *was* City Taxi."

City Taxi opened in 1932, and Baber's late half-brother, E. D. "Pete" Overstreet, made the original sign, which still hangs outside the door.

"The old sign is hanging by a piece of wire just like it was when it was hung in 1933," said Baber. "I remember when Pete made it: he got a piece of light sheet metal, cut and painted it. He made all the little signs that hang inside the shop, too."

The place used to contain a restaurant as well, and was called Willie D. Johnson Restaurant and Cab Stand.

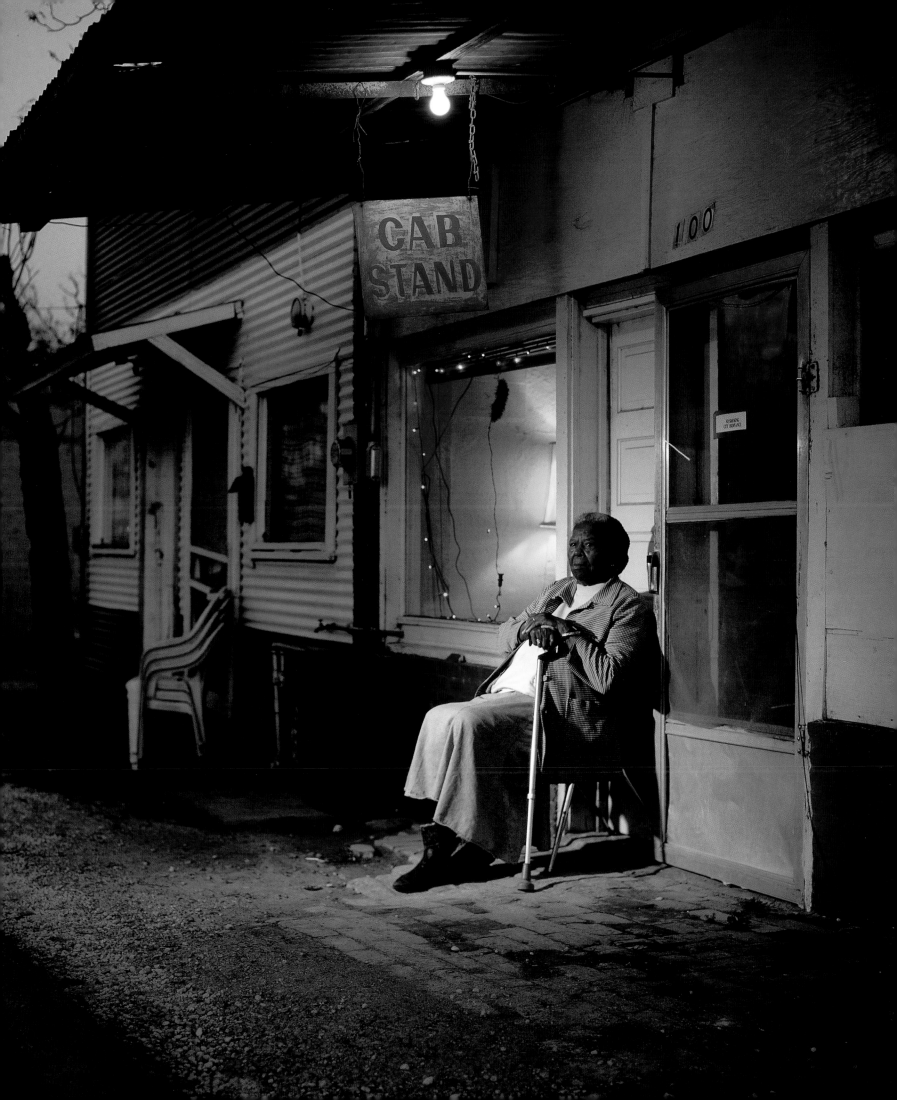

Karen Foster

L U F K I N , 1 9 8 9

Playboy Playmate Karen Foster appeared in the February 1990 issue of *Texas Monthly*. She posed in Ross Junkyard in Lufkin.

"When the picture was taken, I had recently embarked on an exciting journey with *Playboy* magazine," said Foster, *Playboy's* Miss October 1989, in 2002. "What a wonderful and rare opportunity for a small-town East Texas girl to be chosen to appear and represent one of the most well-known magazines in the world.

"What I like about this picture is its reality. It wasn't done in a studio somewhere. It was authentic East Texas, which is where I was born and raised."

Foster grew up riding dirt bikes with her family and practiced karate for seven years. Her dream, as a girl, was to marry Elvis. She graduated in the top ten of her high school class and was an accomplished twirler. She traveled to twirling competitions with her sister and mother and collected a handful of twirling trophies. Later, she attended the University of Houston, where she studied computer science and accounting and worked as a cheerleader for the Houston Rockets basketball team. She modeled on the side.

On her "Playmate Data Sheet" in *Playboy*, she wrote under "ambitions": "To accomplish all the goals I've ever set for myself and to never be sad or lonely."

Foster, who seems to have stayed on track, runs her own marketing business and spends her free time with her family, which includes her beautiful five-year-old niece, Falyn.

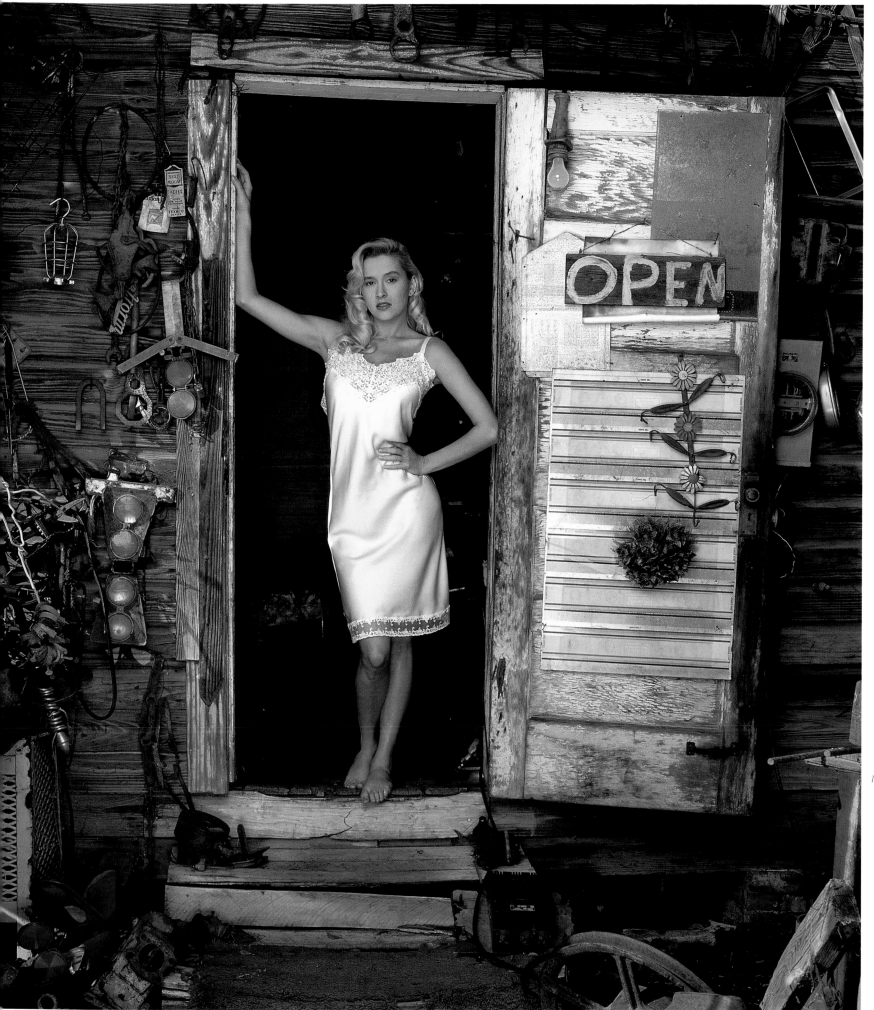

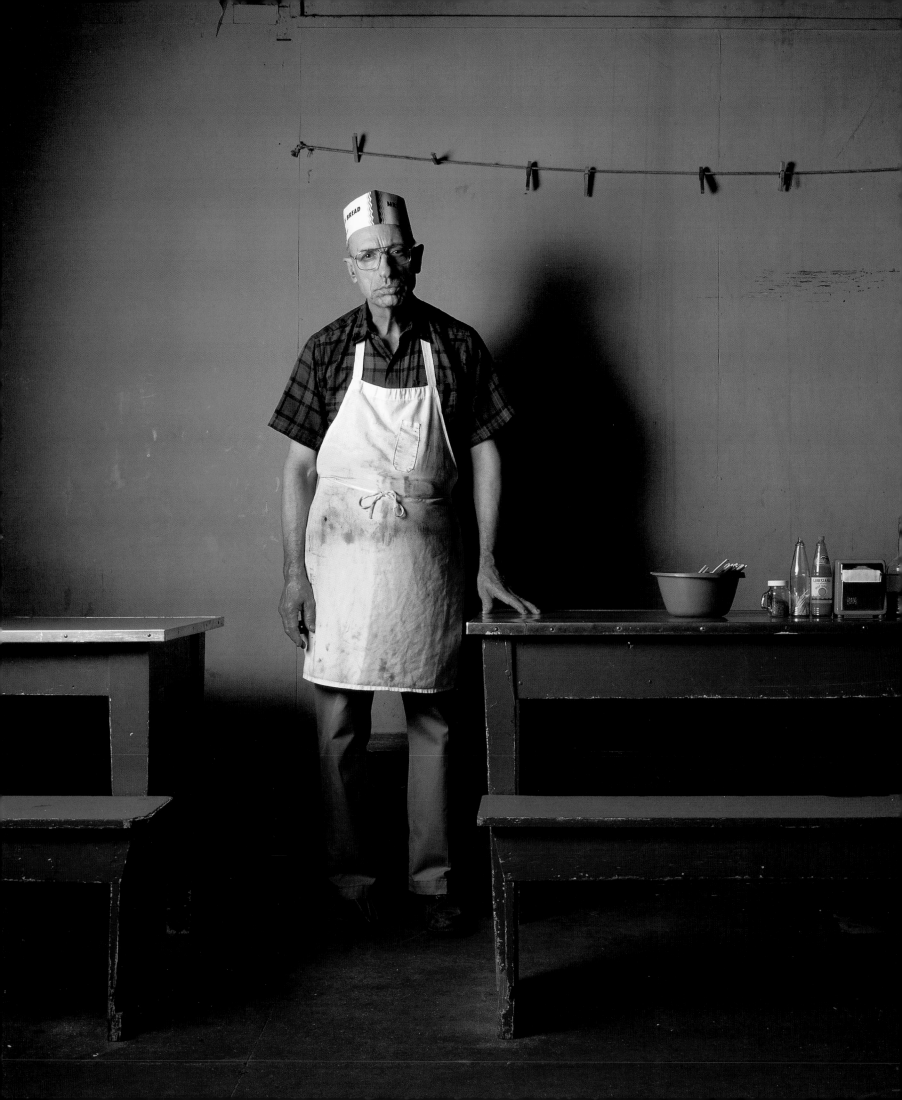

Monroe Schubert

Monroe Schubert, sixty-eight, is the "Barbecue Chef of LaGrange, Texas." Monday through Saturday, dawn to dusk, he tends the sweltering pits at Prause Meat Market, cooking enough brisket and sausage to feed a hundred people at a time. When he's finished cooking, he scrubs everything down.

"Monroe grew up tough," said Gary Prause, whose great-grandfather, Arnold Prause, opened the market in 1913. "But he'll give you the shirt off his back."

Schubert was raised in nearby O'Quinn, Texas, where he walked to a one-room schoolhouse every weekday, weather be damned. After his family moved up Farm Road 609 to LaGrange, Schubert got a job at the feed store grinding feed, loading it into a big truck, and delivering it to dairy farmers in the area. A few years later, he signed on with the Prauses. He's been with them for thirty-four years.

"You're not going to find someone like Monroe," said Mark Prause, Gary Prause's first cousin and another fourth-generation proprieter. "He's still going strong. He's one of the first ones here and one of the last to leave."

Wilson Pickard

Wilson Pickard (1917–2000) "popped off" and bought Ovilla Grocery on Halloween night 1944. He'd had experience in the wholesale grocery business and figured he'd like to be his own boss. Pickard and his wife, Juanita, ran the small store together until her death in 1996. He managed it alone until the day before he died.

"I just come down here to have something to do," he said at eighty-two. "I talk to these old whippersnappers who come in here and set all day. We solve all the problems."

Pickard was born on a farm a couple of miles outside Ovilla, "up on Bear Creek, by the water tower."

"The lady across the road, Minnie Young, delivered me," said Pickard, who was Ovilla's first mayor in 1963. "By the time the doctor got there, his job was done."

Small-town life may be relatively uneventful, but Ovilla had some excitement when some infamous outlaws roared through the area around 1930.

"I was around thirteen when Bonnie and Clyde came through town," said Pickard. "I saw Bonnie in the front seat of their car with a submachine gun across her lap."

Later, when the movie *Bonnie and Clyde* was made, the film crew used Pickard's grocery as a location.

Pickard is survived by two sons—Billy, a housepainter in Waxahachie, and Donnie, who's been Ovilla's fire chief for almost thirty years—and three grandchildren.

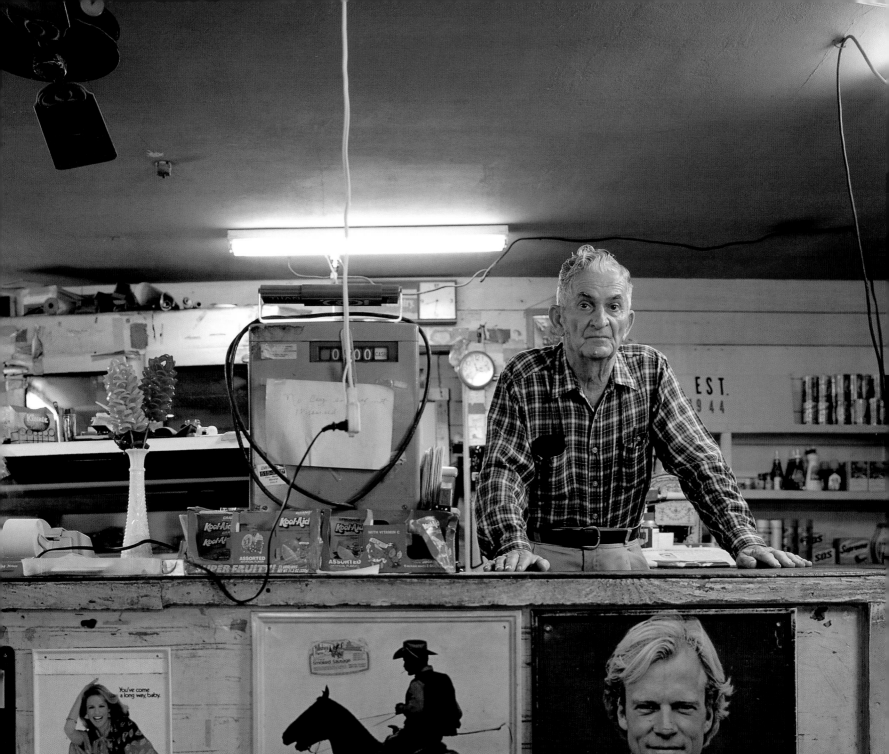

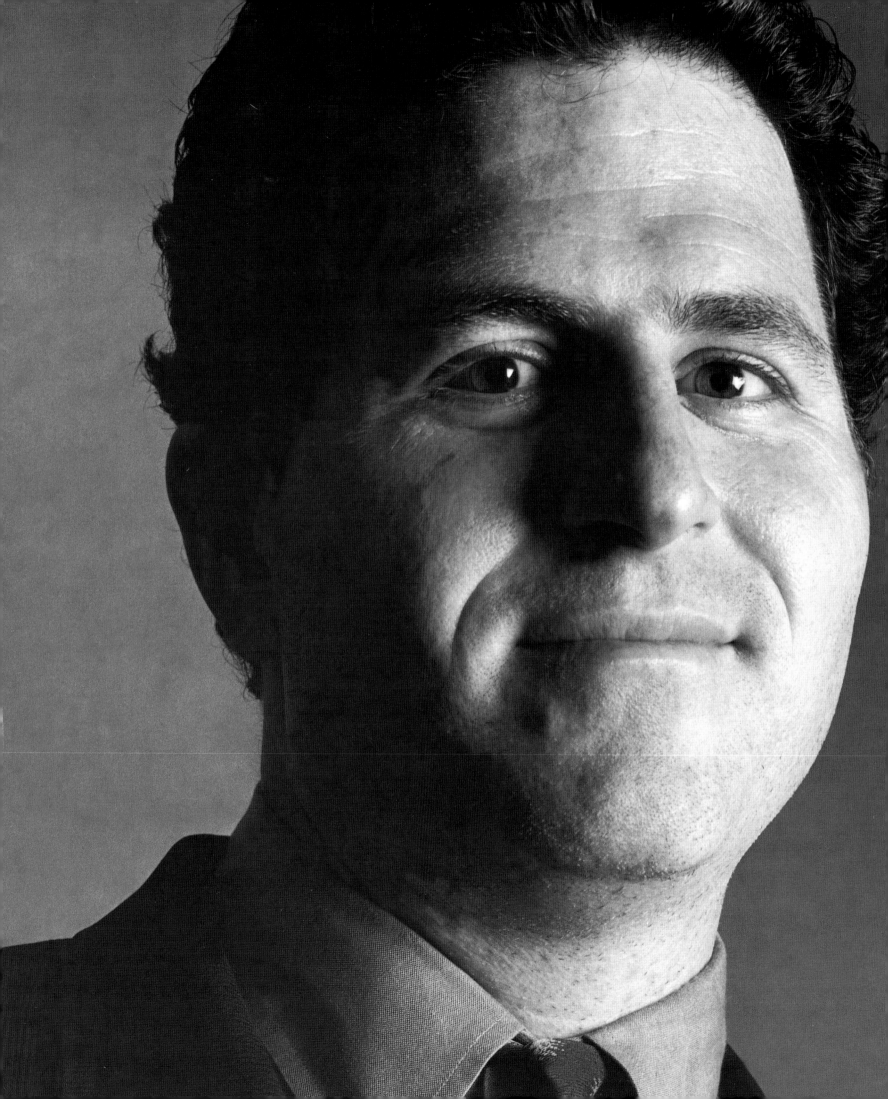

Michael Dell

AUSTIN, 1999

Michael Dell, still under forty, embodies the American Dream. His story is familiar to many, but it's interesting enough to warrant repeating. He was just nineteen, finishing his freshman year at the University of Texas, when he dropped out of school with just $1,000 capital to pursue his computer business, which he based on a unique but simple idea—selling custom-made computers directly to customers. By the time he was twenty-seven, he was the youngest CEO of a Fortune 500 company in history. Now, a decade later, Dell's company brings in $32 billion a year and employs 36,000 people.

Dell started the venture in his UT dorm room. His parents were worried about his grades, and he promised them he'd quit his part-time business and buckle down to school if his idea didn't pan out. But it did—in spades. By the end of that year, 1984, the company was making a bundle. So, Dell bid school farewell and set up official shop.

Michael Dell, whose role models are Henry Ford and Sam Walton, didn't happen in a vacuum. He was an entrepreneur long before he entered college. At twelve, he earned his first fistful of cash—$2,000—after he formed Dell's Stamps, a direct marketing company that offered a national stamp auction through the mail. At fifteen, he bought an Apple II computer, took it apart, and put it back together; though he didn't make money on it then, the experience was fodder for his company-to-be. When he was sixteen, he figured out a way to sell newspaper subscriptions through target marketing and earned a tidy sum— enough to buy a BMW.

To call Dell a pioneer in his industry is an understatement. His was the first personal computer company to offer toll-free technical support and on-site service—services that are now standard in the industry. Because Dell bypasses the middleman, dealing directly with the consumer, he has generally been able to sell computers—made to the customer's exact specifications—at a meaningful discount over other companies. He is not weighed down by the expense and logistics of operating retail stores. Dell is one of the first entrepreneurs to sell computers over the Web. It's not surprising that his company became the best-performing American stock of the 1990s.

Dell, who was born in Houston, lives with his wife, Susan, and four children in a hilltop, high-security compound in southwest Austin. Susan Dell, a quick study, runs her own custom-design dress company, Susan Dell, Inc. She, too, sets her sights high: among other prestigious commissions, she designed the inaugural ball gowns for the Bush twins.

The couple is known for its philanthropic efforts in Central Texas: the Dells established a health insurance program for children; they upgraded and expanded the X-ray facility— now called the Dell Children's Imaging Center—at Brackenridge Children's Hospital; and they helped rebuild the Austin Children's Museum, creating the Dell Discovery Center. Michael Dell has also written a best-selling book, *Direct from Dell*.

The Honorable William Wayne Justice

T Y L E R , 1 9 8 2

William Wayne Justice, son of an eminent trial lawyer who fought the Klan, and grandnephew of a posthumously decorated Confederate officer, had an innate destiny for the high road. In the face of prejudice and good ol' boy politics, he has made monumental reforms for human rights in Texas. His controversial rulings have been instrumental in desegregating Texas public schools and in outlawing overcrowding and inhumane conditions in the Texas prison system.

In *United States v. Texas* (November 1970), Justice—then a U.S. district court judge for the Eastern District of Texas—ordered the Texas Education Agency to assume responsibility for desegregating Texas public schools. It was one of the most sweeping desegregation orders in legal history and was the first of several provocative reform rulings that dramatically changed Texas public institutions, including state reform schools, facilities for the mentally retarded, and state prisons. His *Ruiz v. Estelle* (1972) determined that conditions of confinement violated the Eighth Amendment of the U.S. Constitution (the prohibition of "cruel and unusual punishment"). The ruling mandated that the state reduce overcrowding, improve prisoner rehabilitation and recreational programs, create a genuine medical treatment system, and refrain from practices deemed detrimental to prisoners' safety and welfare. *Ruiz v. Estelle* resulted in the opening of many new prison units and the overhaul of older prisons.

"I was aware that I was an object of hatred in many people's eyes, but my wife was the one who really suffered," says Judge Justice, who has been married to his wife, Sue, since 1947. "She was always highly regarded both as a person and a personality, but after I started making those kinds of decisions, it was like turning on a water tap: she was ostracized as the wife of a bad judge." Local beauticians refused to fix her hair, and the couple was shunned socially. Still, the judge held firm.

"I never did have the feeling that I was alone," says Judge Justice, who worked for many years in both Athens and Tyler, Texas, before moving to Austin, where he serves now as a senior U.S. district court judge. "I had a feeling that the poor people, the blacks, and Mexican-Americans approved."

His favorite case, though, was the lesser-known *Plyler vs. Doe* (1982). The Texas Legislature had passed an act allowing school boards to charge tuition for the children of undocumented aliens, and the Tyler School Board adopted the resolution, then set a high tuition.

"The school board was essentially telling these poor workers they couldn't send their children to school," he says. "It was prejudice, purely. I held that these children could go to public school without the payment of tuition. The Supreme Court affirmed my decision, five-four. Probably a million or more children have been able to get an education since then. That's the case I'm proudest of."

Justice, who graduated from the University of Texas Law School at Austin, has earned many awards in his career, including the NAACP Texas Heroes Award in 1997 and the Texas Civil Liberties Union Outstanding Federal Trial Judge Award in 1986. In 1982, he was deemed Outstanding Federal Trial Judge by the Association of Trial Attorneys in America. In 2001, the American Bar Association gave him the Thurgood Marshall Award, its highest civil rights commendation. Justice's life story is captured in *William Wayne Justice: A Judicial Biography* by Frank R. Kemerer.

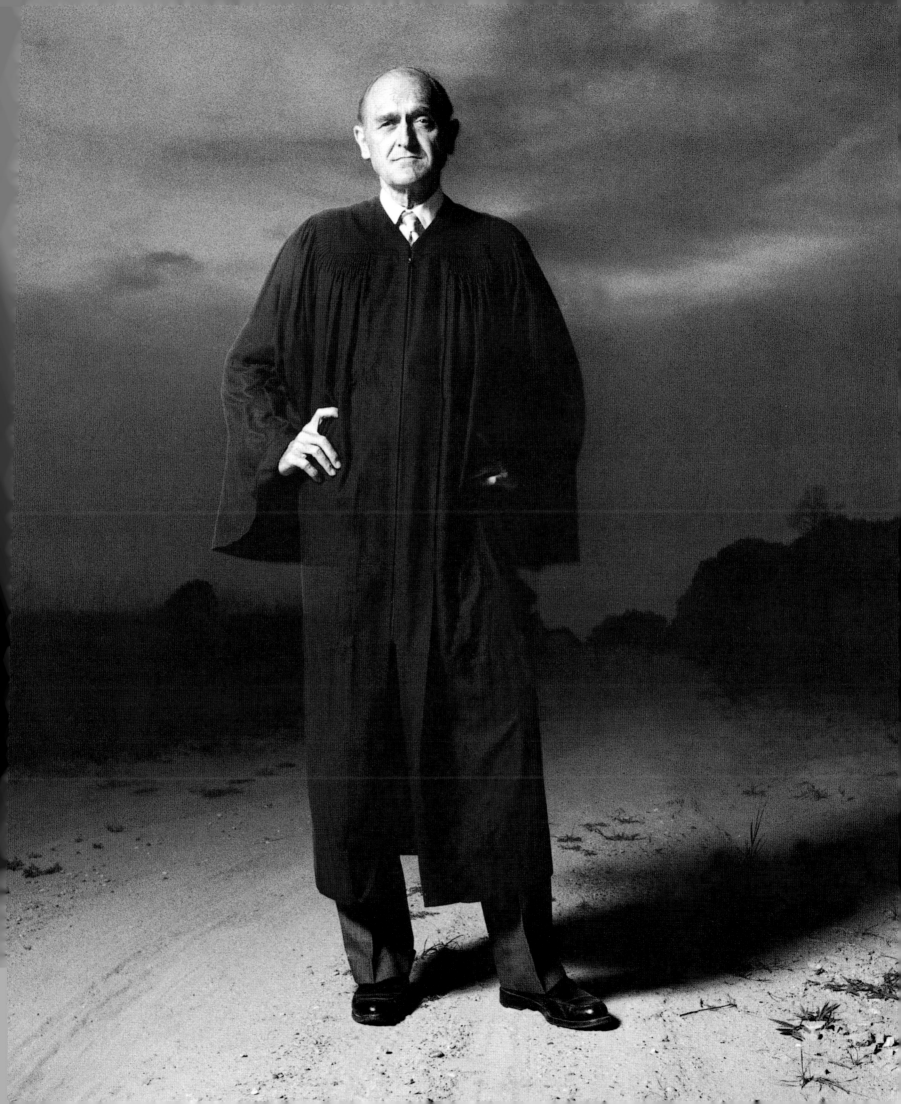

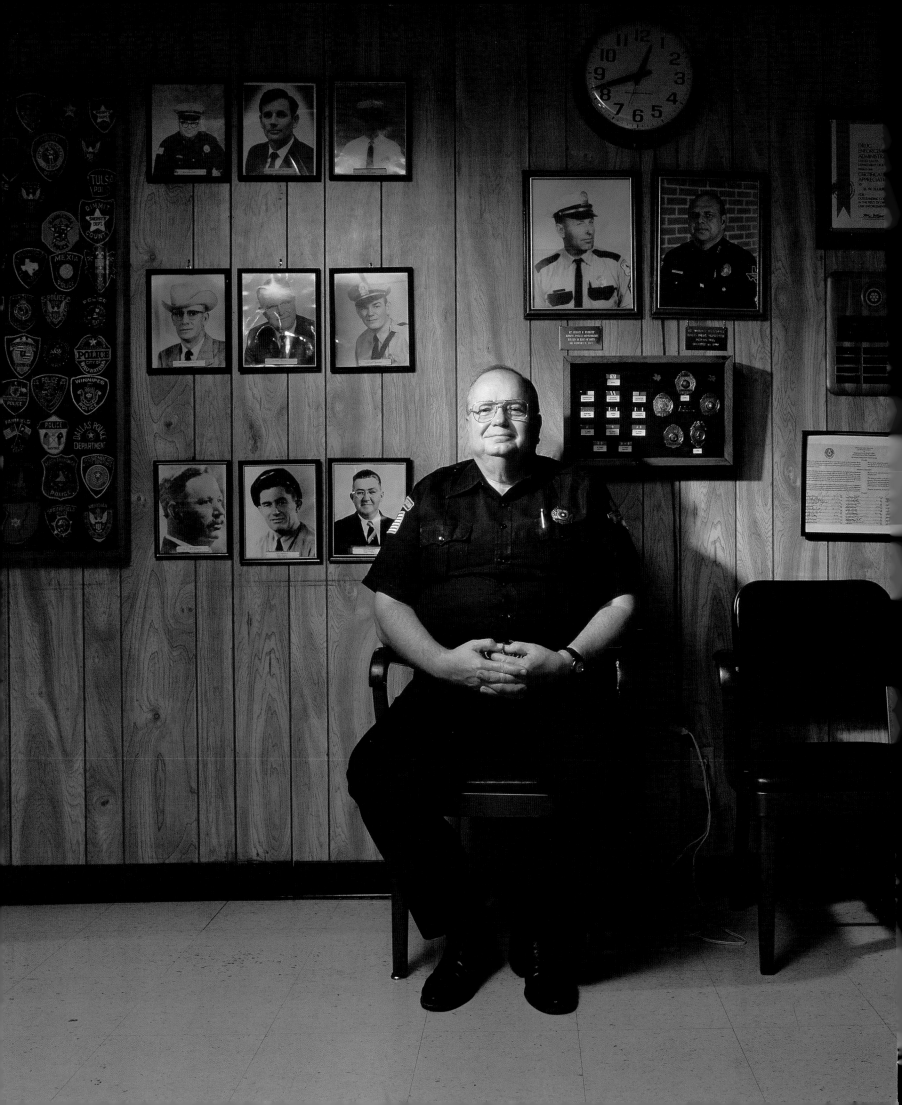

Dave Harris

Dave Harris was the police chief of Athens, Texas, for thirty-three years. He came up through the ranks, starting as a patrolman and working his way through sergeant, lieutenant, and assistant chief. When he retired in the fall of 2002, he had been with the force for some forty years.

"I'm a fifth-generation peace officer," said Harris, whose grandfather, Dan L. McDuffie, was a Texas Ranger killed in the line of duty, and whose father, Dave Harris, Sr., was deputy sheriff, chief of police, and justice of the peace for thirty years in New Boston, Texas, county seat of Bowie County. "You know, I believe policing is a calling."

Harris's two oldest sons are deputy sheriffs for Henderson County; and a nephew is an assistant chief in the INS Border Patrol in Washington, D.C. Harris was born and raised in New Boston, where his parents' home, built in 1895, served as ersatz police headquarters until a proper police station was built. Harris's mother, Nina, worked as police dispatcher—for no pay—and she helped out when needed at the courthouse, in the clerk's office, and during elections.

Harris said his most exciting adventure as police chief was the apprehension of the serial killer Carl Robert Taylor. He and his gang shot a police officer in California, and Taylor was believed headed toward Athens, where his mother lived.

"We caught him in bed asleep at his mother's place," said Harris. "He was exhausted from running from the California officers. Between him and his daddy-in-law, they had killed twenty-one people. I believe they based an *Adam-12* television episode on them."

Though Harris claims he "never really did anything spectacular," he felt it was important to carry on the family tradition.

"My folks created a legacy of honest, hard-working law enforcement," he said. "All I tried to do in my forty years was not mess up what they had laid out for us. Through all my years, I just tried to keep a lid on it. We tried to make Athens a good, safe place to live, to make it better."

In his retirement, Harris does consulting work for the city of Athens and spends more time with friends and family.

"I got a good wife and a good dog," said Harris, who dotes on Jessie Mac, his boxer, whom he raised on a baby's bottle. "She does *not* know she's a dog." Of his wife, Glenda, retired as bookkeeper for Brookshire's grocery, he also speaks fondly: "Glenda raised the kids while I had fun policing."

155

Flossie Lee Riley *and* Ben Jack Riley

ALBANY, 2002

Ben Jack Riley, delivered at home by Doc Harrell in Throckmorton County, Texas, in 1927, was sheriff of neighboring Shackelford County for twenty years. He cut a handsome figure in his signature white Stetson, gun, and holster, and everyone knew who he was.

"He was the good guy, all right," said his wife, Betty Jo.

Born and raised as a rancher, Riley took a break from the cowboy life to run for sheriff in 1972 after his eleven-year-old son, one of five children, died from being kicked in the neck by a horse. Losing a child, he said, "just does something to you," and he felt compelled to make a change. He won the election and kept the job until he retired in 1992.

"To me, it was one of the greatest things I ever did," said Riley, who, as a youth, worked alongside his brothers for fifty cents a day cutting prickly pears on ranches and burning off the stickers so the pads could be fed to cattle. "You make a lot of friends sheriffing. I knew most of the 254 sheriffs in the state of Texas. All I had to do to get help was call one of them and say: 'This is Ben Jack Riley and I'm the sheriff of Shackelford County and I got a little boy runnin'.' And they'd call back in a little while and say: 'Ben Jack, we got him. You can come on down and get him.'"

Riley said his experience as an air force MP in Japan during World War II helped prepare him as a lawman. As sheriff, he dealt with eleven murders over twenty years and a number of other crimes. When a local oilman was burglarized, Riley used his myriad contacts to track the thieves.

"It was the three Cromwell brothers who did it," said Riley. "They had a brother-in-law who worked cleaning the oilman's office. We found all his stuff in Portland, Oregon—mostly guns and expensive Indian blankets. The only things we didn't get back were a nineteen-inch color TV and a bottle of whiskey that the robbers drank while they were stealing."

Riley, who lives in town now next door to his mother, Flossie Lee Riley, has come full circle—and is back in the saddle again.

"You don't get ranchin' out of your blood," he said. "I built some horse corrals in town and I still cowboy a little—help people brand their calves. But now I'm gettin' to where I follow the herd, do the drag, while the younger fellows lead the herd."

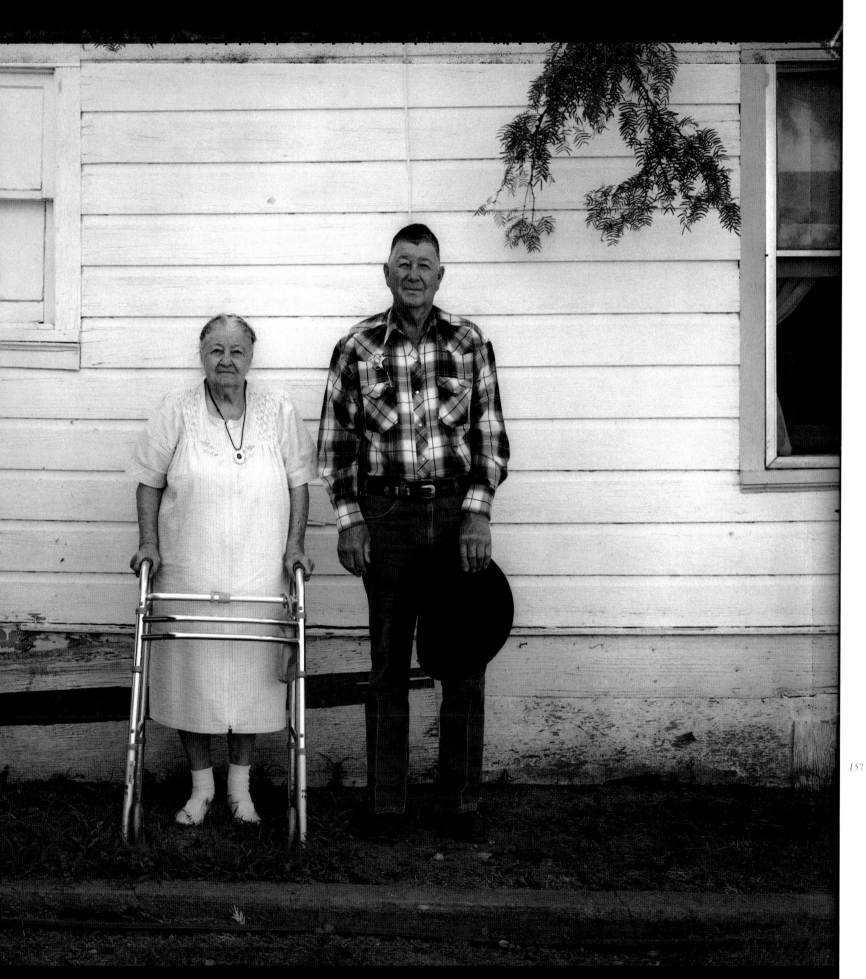

List of Photographs

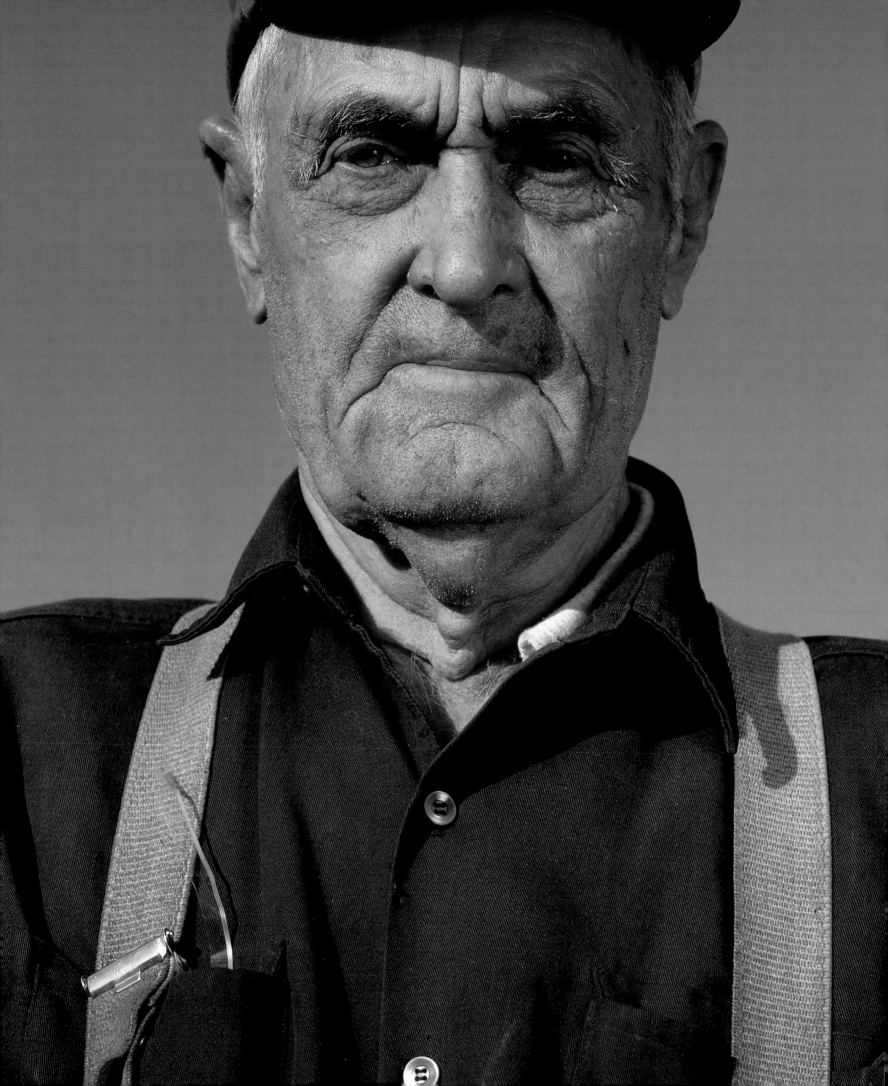